The Big Book of Watercolour Basics

David & Charles

A DAVID & CHARLES BOOK

First published in the UK in 2004
First published in the USA in 2004
as Big Fat Book of Watercolor Basics by North Light Books

Copyright © North Light Books 2004

Distributed in North America
by F&W Publications, Inc.
4700 East Galbraith Road
Cincinnati, OH 45236
1-800-289-0963

A catalogue record for this book is available from the British Library.

ISBN 0 7153 1879 9 paperback

Printed in China by SNP Leefung-Asco Printers Ltd.
for David & Charles
Brunel House Newton Abbot Devon

Visit our website at www.davidandcharles.co.uk

David & Charles books are available from all good bookshops; alternatively you can contact our Orderline on (0)1626 334555 or write to us at FREEPOST EX2110, David & Charles Direct, Newton Abbot, TQ12 4ZZ (no stamp required UK mainland).

Edited by Pamela Wissman, Bethe Ferguson, Gina Rath
Interior Designed by Anna Lubrecht
Cover Designed by Erik Vincent
Production by Mark Griffin

Metric Conversion Chart

To convert	to	multiply by
Inches	Centimetres	2.54
Centimetres	Inches	0.4
Feet	Centimetres	30.5
Centimetres	Feet	0.03
Yards	Metres	0.9
Metres	Yards	1.1
Sq. Inches	Sq. Centimetres	6.45
Sq. Centimetres	Sq. Inches	0.16
Sq. Feet	Sq. Metres	0.09
Sq. Metres	Sq. Feet	10.8
Sq. Yards	Sq. Metres	0.8
Sq. Metres	Sq. Yards	1.2
Pounds	Kilograms	0.45
Kilograms	Pounds	2.2
Ounces	Grams	28.4
Grams	Ounces	0.04

ACKNOWLEDGMENTS

The people who deserve special thanks, and without whom this book would not have been possible, are the artists whose work appears in this book. They are:

Sharon Hinckley
Butch Krieger
Jan Kunz
Phil Metzger
Judy Morris

Shirley Porter
Jack Reid
Patrick Seslar
Zoltan Szabo
Chinkok Tan

DEDICATION

This book is dedicated to Zoltan Szabo, a beloved teacher and great inspiration to artists everywhere.

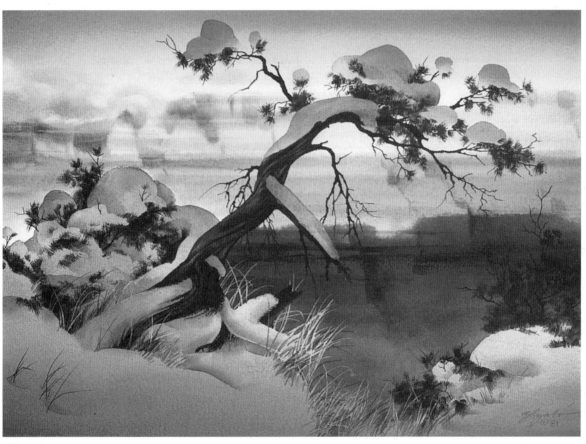

Show Stopper
Zoltan Szabo
15" × 22" (38cm × 56cm)

Table of Contents

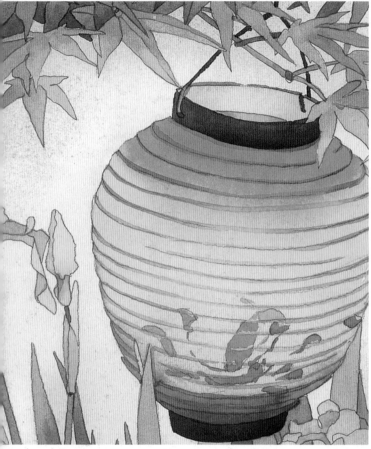

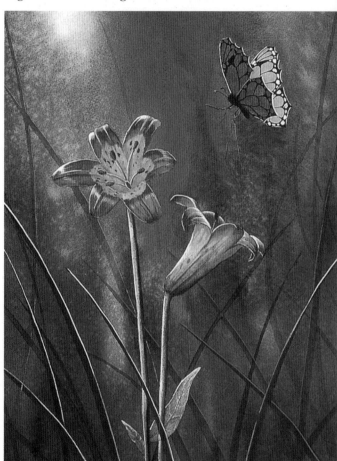

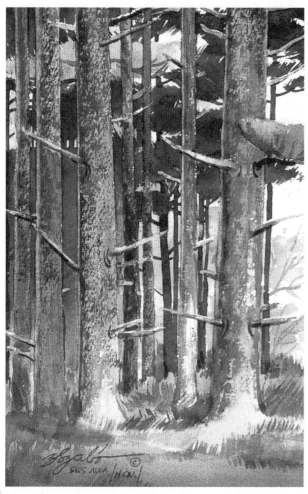

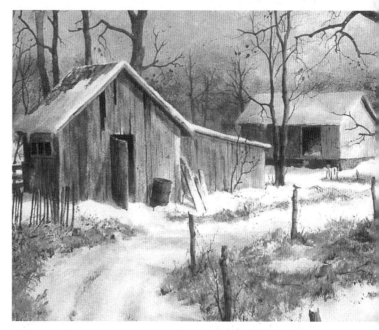

INTRODUCTION

Have you ever wished for a book on watercolor that was all-inclusive? One that was packed full of all the information you needed to get started and that could answer all of your questions as you face challenges along the way? Well, we have too, and that's why we've created *The Big Fat Book of Watercolor Basics*. This book is packed full of timeless information and expert advice from ten of North Light's favorite watercolor painters. Zoltan Szabo, Phil Metzger, Jan Kunz, Jack Reid, Sharon Hinckley, and many more artists graciously share their watercolor expertise. These artists have their own unique styles, offering you a smorgasbord of methods and ideas from which to choose. You'll learn about and try out the offerings, then you can pick your favorites. Before you know it, you will see your own personal painting style emerge as you create beautiful watercolor paintings.

This book is overflowing with tidbits of valuable information for the new as well as the seasoned painter—information that has proven successful for the featured artists and will work for you, too. We start with the basic necessities of watercolor then move into a techniques section that, with practice, will have you painting with confidence. You'll learn how to use different brushes and how to make a color wheel. You will also become informed about pigment, color, light, perspective and painting from photographs.

Learn to paint some of the most popular subjects such as: landscapes, flowers, birds, even people. A variety of exercises throughout the book encourage you to try your hand (or brush) at new techniques and ideas as they are introduced. You'll also find many step-by-step demonstrations that walk you through creating your own finished watercolor painting.

So grab your supplies—with the help of *The Big Fat Book of Watercolor Basics*, you are on your way to learning all the basics of watercolor painting and to finding your own painting style.

Pamela Wissman • Bethe Ferguson
Gina Rath

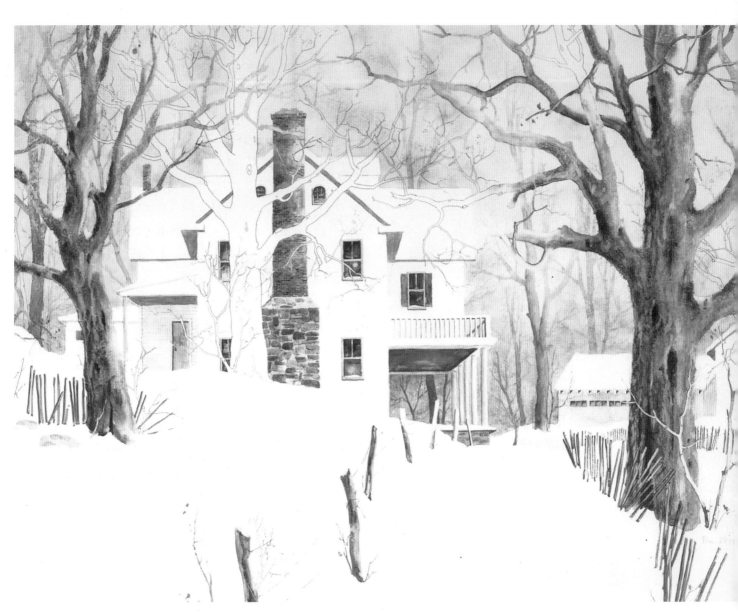

The White House
Phil Metzger
40" × 60" (102cm × 152cm)

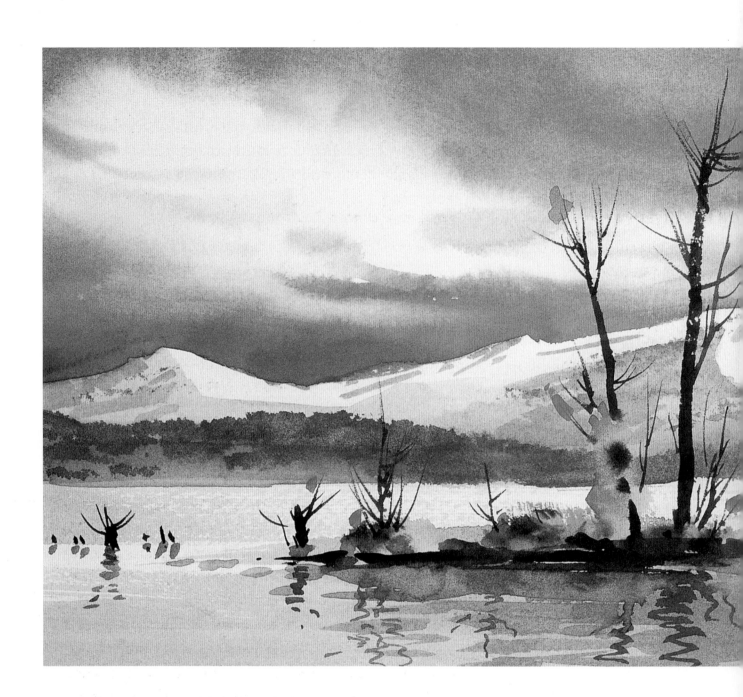

GETTING STARTED

Tools and how to use them are as important to a watercolorist as they are to a doctor, carpenter or any other professional.

Artists have always loved art supplies! It's hard to shop for supplies when you want one of everything. There's a wonderful variety of watercolor tools, equipment and materials available that can make painting easier and more fun. But at first glance it seems confusing because there are hundreds of brush choices, many kinds of paper and literally thousands of colors of paint.

You don't need to buy them all! You can make beautiful watercolors with a minimal amount of supplies. The more you paint, the easier it will be for you to discover which painting supplies are for you. Start with the basic supplies. Later, you may add masking fluid, watercolor pencils, sponges, stencil knives or ink pens to your arsenal. You may find salt, rubbing alcohol, bleach or soap techniques a necessity. You may love the effect of combining gouache or acrylics with your transparent watercolors. The fun is in the discovering.

Following is an introduction to many of the materials available for watercolorists as well as exercises for you to put into practice those tools and techniques described.

Early Snow
Zoltan Szabo
15″ × 22″ (38cm × 56cm)

General Supplies You Will Need

Here are a number of items no watercolor painter should be without. You can probably find most of them in your home right now.

1. Palette
2. Empty 35mm slide mount
3. Masking tape
4. Pencil, for sketching
5. White plastic eraser
6. Sketch pad
7. Mixing dishes, for tube watercolors
8. Facial tissue
9. Waterproof work surface
10. Spray bottle
11. Double water container
12. Heavy jar, to hold brushes

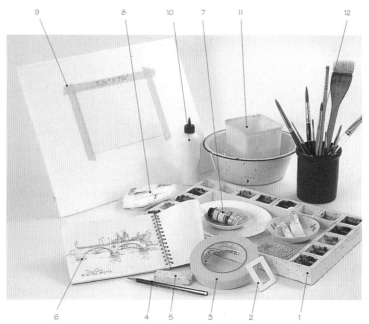

Work Surface

A solid waterproof work surface is ideal. This can be wood or Masonite, and even some plastics (such as Coroplast) may work. Experiment to see which surface works best for you. Coroplast is a plastic material that can be bought at your local sign store; it is light, sturdy and waterproof.

Water Containers

It's a common practice and a very good idea to place one water container inside another. This handy way to work will allow you to spend more time painting and less time fetching clean water. Rinse your brush first in the outside bowl, removing excess paint; then swirl your semiclean brush around the inside container for the final cleaning.

Blow-Dryer

Any old blow-dryer will do. Use this to speed up the paint's drying process.

Utility Knives

No watercolorist works without them. Use them to cut your paper and to add detail to your painting through a technique known as scoring. You'll need a common utility knife to cut your paper. It has replaceable blades and can be purchased at any hardware store. You'll also want a regular kitchen knife on hand. This is the one you never use because it's so dull it can't even cut water, but it's perfect for scoring.

Spray Bottles

Use these to spray mists of water onto pictures to keep the paint from drying or to ready an area for more paint.

Nesting Trays and Mixing Dishes

The nesting trays will hold your paint, and shallow dishes are wonderful for mixing. They have to be white: It's best for mixing paints because white is the ideal background against which to view color. Any white china container is suitable for mixing paints.

Palette

It's helpful to have a large, flat mixing area to mix big, juicy washes! A John Pike palette, with its large mixing area and lid that serves as an additional mixing area, meets these needs. It's made of sturdy plastic and has twenty wells for holding paint. After painting for an extended period of time your palette may get soggy; if you don't want to paint with a soggy palette, keep identical palettes allowing one to dry while painting with the other.

Examples on pages 10 and 11 by Jack Reid.

Watercolor Paper

Good-quality paper is expensive, but serious water-colorists always use 100 percent rag mouldmade paper. You can buy watercolor paper in three different surfaces: smooth (hot-pressed), medium (cold-pressed) and rough. The most commonly used paper is cold-pressed, which has enough texture to hold the paint but is smooth enough to allow you to paint with fine detail. Watercolor paper is available in different weights, which determines the density or thickness, and is available through mail order or from fine art supply stores. It's important to make sure that the paper you use is acid free.

To prevent buckling, lighter-weight paper (under 140-lbs. [300gsm]) should be stretched before it's painted. There are several ways to stretch watercolor paper. One way that is often used is to soak the paper thoroughly then lay it onto Masonite and use gummed tape to tape the edges down. Dab off excess water with a sponge and allow the paper to completely dry (usually overnight) before applying paint. Some painters prefer to staple their paper to stretch it, while others use heavier-weight paper (300-lbs., [640gsm] or above) so as not to have to bother with stretching at all. The heavier the weight the more expensive the paper, so while you are learning you may want to choose the lighter-weight paper. Just know that if you buy a heavy paper that won't buckle, you can count on getting reliable results every time.

There are many brands of quality paper, such as Arches, Fabriano, Saunders, Strathmore and Winsor & Newton, to name just a few. It's best to experiment with different paper weights, textures, brands and ways of stretching the paper until you find what works best for you.

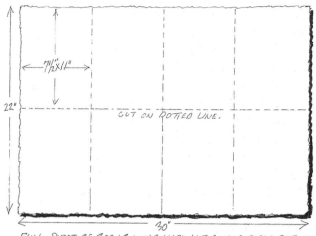

FULL SHEET OF 300 LB MOULD MADE WATERCOLOR PAPER CUT TO 8 PIECES 7½"X 11" OR 4 PIECES 11"X15"

To save money, you can purchase a large sheet (22" × 32" [56cm × 81cm]) of 300-lb. (640gsm) paper and cut it into eight 7½" × 11" (19cm × 28cm) pieces. Remember, you can always paint on both sides.

Paper Blocks

You can buy watercolor paper in blocks, which is very convenient but still quite expensive. A block usually has about fifteen to twenty sheets of 140-lb. (300gsm) paper gummed on four sides. But because it's only 140-lb. paper, it will tend to buckle. If you plan to go this route, buy small-sized blocks (about 7" × 10" [18cm × 25cm]) to keep the buckling to a minimum.

Brushes and Paints

Brushes

Sable brushes are often recommended for watercolor, but they can be very costly. These days, however, many excellent synthetic sables are available; try out a few types until you find one that feels right for you. You want a brush that holds a considerable amount of water and springs back to its original shape after being dipped in water. Most good art supply stores will help you with choosing a brush, and they will usually supply water for you to test a brush before buying. Very inexpensive brushes are not a bargain; they will leave hairs in your paint, and they won't return to their original shape.

There are three essential brushes that you'll find useful to begin with: a small round brush (a no. 4 is a good size), a medium round brush (nos. 8, 10 and 12 are good sizes to consider) and a 1-inch (25mm) flat. The flat brush is used for large areas and washes, and the round ones are for filling in and detail.

Two other brushes that you may find helpful are the lettering brush (sometimes called a single-stroke brush) and the script liner (also called a rigger brush), which is used for detail line work.

Practice!

You need to use good materials when you paint. The best supplies won't guarantee a masterpiece. However, quality materials will do more to help than hinder your painting progress. Quality materials combined with practice will make you a better painter.

Paints

Paints are very personal. Spend time experimenting with different paint brands and different colors. Try paints from several manufacturers to find the ones that work best for the price you are willing to pay. The same color doesn't work the same way for every artist. Your choice of the paints that eventually end up on your palette will be the result of trial and error. They work for you now, but don't be afraid to try new colors.

Paints Have Personality

Every color has a personality. Each is different from the other, not only in hue, temperature, intensity and value, but in how they act when they are applied to the paper. It's important to know a few of their traits.

Artwork on pages 12 through 15 was created by Judy Morris.

Watercolor Characteristics

Watercolor pigments have remained brilliant for centuries. Our paints today are made from minerals and animal products that are especially rich in pigments. Manufacturers carefully select and purify these materials to ensure their permanence.

Will the Color Last?

A very important characteristic of paint is its light-fast rating. Some brands use "I" for excellent, "II" for very good, "III" for fair and "IV" for fugitive (fugitive colors fade when exposed to light). Other brands use stars: "★★★★" for excellent, "★★★" for very good, "★★" for fair and "★" for fugitive. Many brands use numbers or letters for their ratings. Choose paints that fall into the "excellent" or "very good" category. If you use fugitive colors, you may have a bright painting today and a dull painting tomorrow!

What Grade Is the Paint?

Watercolors come in grades. *Student grade* watercolor paints contain less pure pigment and more fillers and extenders. *Professional grade* watercolors contain the highest quality of pigments that produce the best flood of color and maximum clarity of color. *Artist grade* is usually somewhere in between.

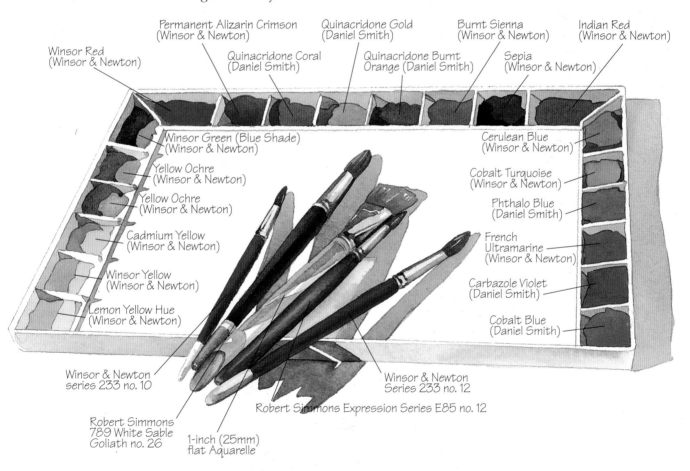

A Sample Palette

This palette is a sample of what many watercolor artists use, which you may find helpful. The colors on this palette are arranged like a color wheel: The yellows are together on the left side of the palette; the reds, at the top; and the blues, on the right. You will quickly develop a system that works best for you. While you will probably use some colors much more than others, they will all prove useful when you paint.

How Transparent Are "Transparent Watercolors"?

Watercolor paints can be transparent, semitransparent or opaque. Transparent colors allow more of the reflected light from the paper to come through. Opaque colors kill some of the reflected light from the paper.

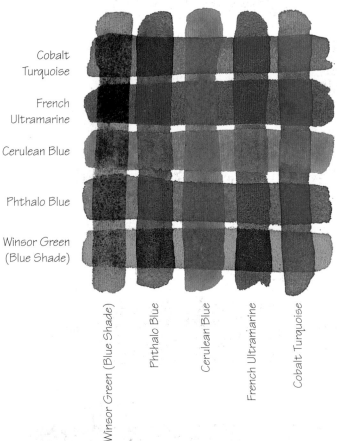

Cobalt Turquoise

French Ultramarine

Cerulean Blue

Phthalo Blue

Winsor Green (Blue Shade)

Winsor Green (Blue Shade)
Phthalo Blue
Cerulean Blue
French Ultramarine
Cobalt Turquoise

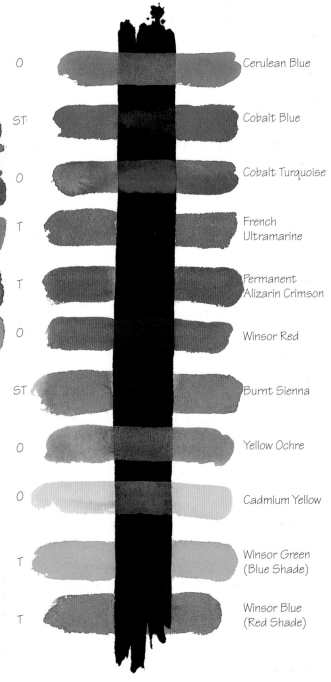

O — Cerulean Blue

ST — Cobalt Blue

O — Cobalt Turquoise

T — French Ultramarine

T — Permanent Alizarin Crimson

O — Winsor Red

ST — Burnt Sienna

O — Yellow Ochre

O — Cadmium Yellow

T — Winsor Green (Blue Shade)

T — Winsor Blue (Red Shade)

Transparent and Opaque Colors Working Together
Create a "plaid" using transparent and opaque colors to see how they work together. You will find that transparent colors, even when they are overlapped, allow the white of the paper to shine through. Overlapping opaque colors kills the luminosity. Compare the square created by the two stripes of French Ultramarine with the square created by the two stripes of Cerulean Blue. Layers of French Ultramarine remain transparent, while layers of Cerulean Blue are opaque.

Testing for Transparency
It's simple to test the transparency of your paints. First, paint a stripe of black India ink on watercolor paper. Let it dry completely. Brush a wash of the color you are testing across the stripe of dried ink. The paint will partially cover the black that is underneath, disappear completely or be somewhere in between. You will clearly see which paints are transparent (T), semitransparent (ST) or opaque (O).

Which Colors Stain?

Staining colors do just that: They stain the paper. While they are still wet they mix beautifully together and can be adjusted even on the surface of the paper. But when they dry they become part of the paper! You can glaze over dry, staining colors again and again and they won't dissolve, fade, bleed or mix with the fresh wash.

Find the Staining Power

Determine the staining power of a color by brushing a wash of the color you are testing on a clean piece of watercolor paper. When it has dried completely, use a clean, damp sponge to see how much of the dried paint you can remove. Those colors that seem to be a permanent part of the paper are staining colors. Try not to get staining colors where you don't want them!

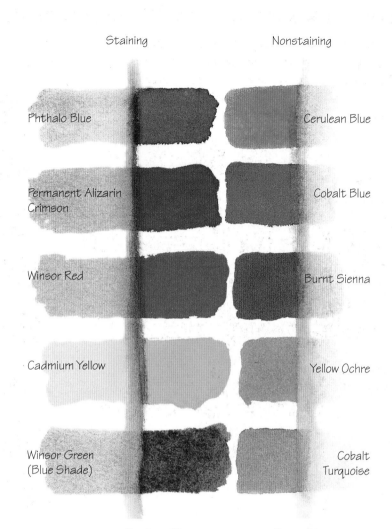

Staining	Nonstaining
Phthalo Blue	Cerulean Blue
Permanent Alizarin Crimson	Cobalt Blue
Winsor Red	Burnt Sienna
Cadmium Yellow	Yellow Ochre
Winsor Green (Blue Shade)	Cobalt Turquoise

Removing Dry Paint

Sometimes you paint over an area you wanted to remain white. Removing dried pigment is possible if you've used a nonstaining paint. In these samples a circle stencil and a damp sponge were used to remove as much pigment as possible. As you can see, it is possible to remove almost 100 percent of the pigment from Cerulean Blue and Burnt Sienna, both nonstaining colors. The staining colors, Winsor Red and Winsor Green (Blue Shade), have left the paper permanently colored. The white of the paper is gone!

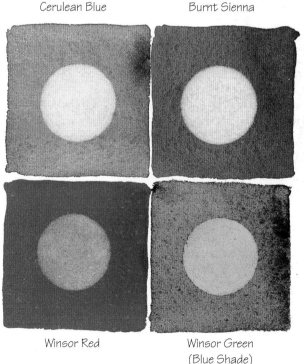

Cerulean Blue Burnt Sienna

Winsor Red Winsor Green (Blue Shade)

Know Your Paints

Do you need to know these characteristics? Maybe. Is it important to know the technical qualities of every tube of paint? Probably not, unless, for example, you love Winsor & Newton Cerulean Blue. It's a nonstaining, opaque paint. If you switch brands to Daniel Smith Cerulean Blue you'll find it is a low-staining, semitransparent paint. The two Cerulean Blues won't produce the same results, and if you understand the characteristics of each, you'll know why.

Let's Paint!

Now that you've been introduced to the materials you need and the paint, it's time to paint! You're probably a little nervous about getting started because you don't yet know how to use the paint or the brushes. All you need for now are brushes, some cheap newsprint or an old newspaper (not watercolor paper yet) and one color of paint. You'll learn some simple concepts: Flat (square-shaped) brushes paint square objects, and round-tipped brushes paint round objects. Large brushes paint large objects. That may sound like an oversimplification, but it never occurs to a lot of people.

Painting with the right-size brush means you paint with the fewest number of strokes. That means you'll still be loose and spontaneous. Once you learn how to control a brush, you can use it to paint all sorts of shapes at will.

Preparing to Paint!

Pick up a brush and hold it so it's comfortable for you—just relax and hold it gently—imagine it's a small tube of toothpaste. Don't try to paint perfectly; simply experiment with what the various brushes can do. What happens when the brush is full of paint? What happens when it runs out of paint? What effects do you get? Play around, and become free and spontaneous; that's what painting is about.

Think of the brush as an extension of your hand. Humans are tool users. Great athletes become great because they master their equipment—a golfer and his club, a hockey player and his stick, a tennis player and her racket. The same is true of a painter and her brush—get comfortable and get acquainted with your brush. Let's lay out some cheap newsprint and get down to business.

Artwork on pages 16 through 37 was created by Jack Reid.

Step 1: Mix the Paint
This is just like cooking. Squeeze a dime-size amount of paint into a shallow mixing dish. Add enough water to make a medium-thick wash.

Step 2: Load the Brush
Use the brush (a no. 14 round is shown here) to mix the water into the paint. You want an evenly mixed solution so as to prevent blotches. Always make a bigger mix than you think you need.

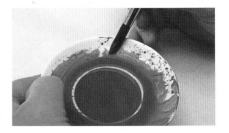

Step 3: Roll the Brush
Once your brush is loaded, roll it against the side of the dish, applying a gentle pressure to remove any excess paint that might drip onto your work surface—or your lap.

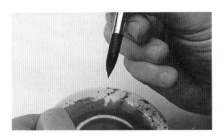

Step 4: Make Your Point
Rolling the brush will give it a nice point for stroking in fine detail.

Practice Using the Round Brush

Practice painting with a round-tipped brush to see what it can do. Paint straight, squiggly and curved lines with every size of brush. Remember: Relax, and have fun.

Banana

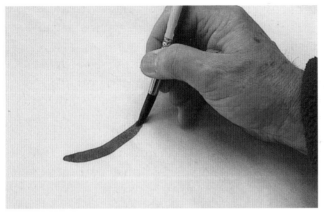

If ever two things were meant to go together, they are brush and paper. Make sure you're comfortable. Take your loaded brush and, with some authority, press it against the paper and begin to drag it away to the right. Let up on the pressure as you approach the end of your line.

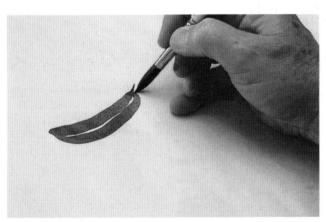

By drawing a similar line just over the top of the first one, the banana takes form.

Waves on Water

By pressing down on the brush, releasing the pressure, dragging the brush and then repeating this cycle, you can produce the effect of waves on water.

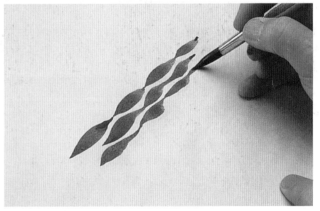

Press, release; press, release. It's that simple.

Maple Leaf

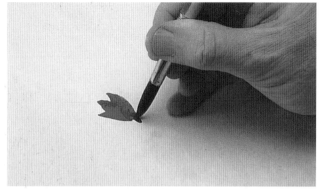

Using the same press and release technique, paint a maple leaf.

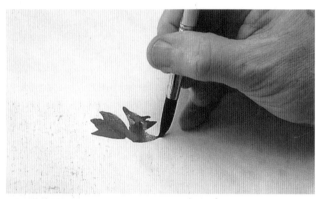

Notice how you can paint a point of the maple leaf simply by releasing the pressure on the brush.

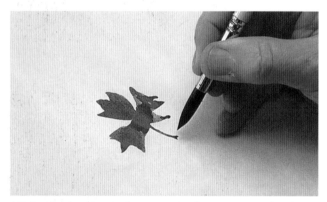

The brushes are designed to come to a fine point, exactly what you need when doing detail work, such as this leaf stem.

Pinecone

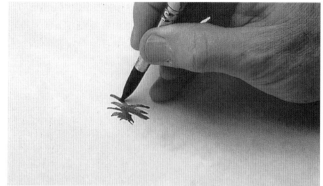

You've painted a maple leaf, now try painting a pinecone.

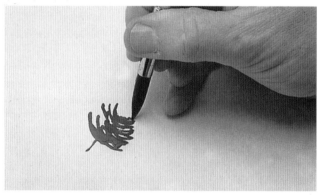

Have some fun with it. Lighten up!

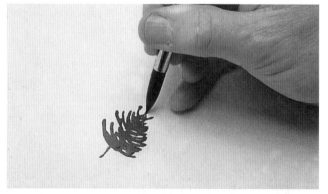

You'll find that by working on newsprint you can have a bit of fun. Painting on the more expensive paper can be intimidating to the beginner; that's why you should stick with newsprint for now.

Practice Using the Flat Brush

Hopefully you've used up all your prepared paint in creating objects with the round-tipped brush. Go mix some more paint, because now it's time to experiment with a ½-inch (12mm) flat brush. Flat brushes are used to paint everything from bricks to barn doors—anything that has a straight edge. The flat brush produces all kinds of interesting shapes.

By turning the brush on its side you can vary the width of your line.

. . . dotted lines . . .

Practice making these shapes.

. . . any rectangular shape.

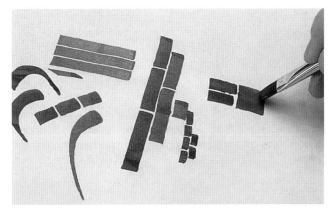

Boards, bricks . . .

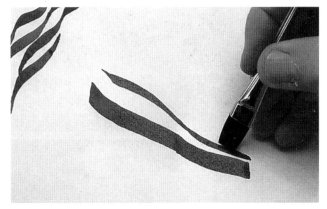

Compare this narrow tree trunk to the fat one beside it. See how rotating the brush slightly in your had produces an entirely different effect? The technique is subtle; the effect is blatant.

Practice Using the Lettering Brush

The lettering brush was designed for lettering, not painting. It is sometimes referred to as a single-stroke lettering brush.

The best way to discover the power of this brush is to practice with it against the stock listings from your newspaper. The tight symmetry found on these pages will steady your hand.

In loading up the lettering brush, you will notice that it holds more paint than its ½-inch (12mm) square-tipped sibling.

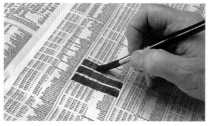

Paint a series of lines side by side. Don't worry if your lines are a bit uneven, they're bound to be. This is why you're practicing!

When you come to the "end of the line," so to speak, make a clean break. Release pressure and gingerly raise the brush.

Try painting the letter *A* or any figure composed of angled lines.

This is a tough one. It looks easy but it's not. This is a good exercise to practice curves and to see what the lettering brush can do.

After you have completed a number of these strokes, try to paint a windowpane, chimney, board fence, bricks or another rectangular shape.

Practice Using the Script Liner

Notice the long hairs on a script liner (rigger brush). They hold a lot of paint, so you can cover long stretches. This is the brush you'll be using for long, thin objects, such as tall grass. Other objects that you may want to paint, such as wire fences or saplings, require the detail that only the script liner affords.

In order to get comfortable with the script liner, look around you and draw objects that require spe-cialized details. You might try an electrical cord, your dog's hair or the leaves on a fern. Just remember: If you want pinpoint accuracy, the script liner is the one to use.

Each brush can be used to paint a family of related objects. You are limited only by your imagination. It's not the brush that does it—it's your control of the brush.

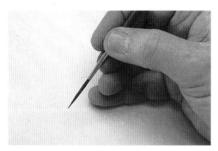

When using this brush, try to think of how many subjects you could paint: grass, twigs, saplings, hair and wire, to suggest a few. Try to come up with some other ones.

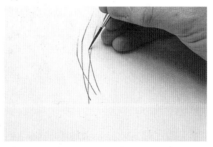

The script liner is great for painting grass. With a series of short, sharp upward strokes, the stalks have been painted.

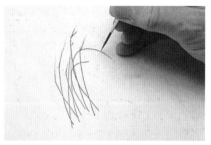

With a series of downward strokes, you can hook the grass; and with these strokes, it comes to life.

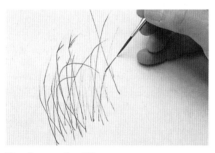

Need more detail?

Wire Fence

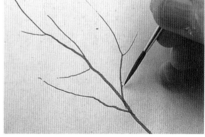

Sapling

Exercise
Flat Wash

Now it's time to use your flat brush. A flat wash is one color painted over all or part of the paper and is one of the most basic techniques used in watercolor painting. Spend some time practicing this technique so you can lay an even, flat wash.

Tape a piece of watercolor paper to your board. You want the paint to flow gently downward, so tilt your board to about a 15-degree angle. Sketch a simple house and landscape. Using a mixing bowl and a 1-inch (25mm) flat, mix a medium value of Ultramarine Blue. Mix more than you think you'll need to cover the entire piece of paper, so you don't run out halfway through.

Paper
5" × 7" (13cm × 18cm) piece of 300-lb. (640gsm) rough-surfaced watercolor paper

Brush
1-inch (25mm) flat

Palette
Ultramarine Blue

Step 1: The Flat Wash
Load your brush. Be sure the board is tilted at an angle, then drag the loaded brush across the paper starting at the upper-left corner. Don't lift the brush until you've run off the other side of the paper. Don't go over it twice.

Step 2: Overlapping
Thanks to gravity, excess paint collects along the bottom edge of the line you just painted. Remove the excess by touching the the bottom wet edge of the first pass with the top bristle edge on the second pass; continue this until you have covered the entire paper. Reload your brush after each pass. Wipe your brush with a clean tissue, then run the brush along the bottom to remove excess paint. Lay your painting flat and let it dry.

Exercise
Graded Wash

It's quite simple: A graded wash is a field of color, painted over all or part of the paper, that gradually fades away or gets stronger depending on how you look at it. A graded wash is done just like the flat wash, with the work surface tilted and each stroke overlapping the wet bottom edge of the previous stroke. But here's the difference: You start with clear water and gradually add more and more color to your mixing bowl, making each stroke darker. (Or, conversely, you start with pigment and gradually add clean water.)

This will be an extreme example of the graded wash. Begin by taping the paper to your work surface and then penciling in the drawing shown below.

Paper
5" × 7" (13cm × 18cm) piece of 300-lb. (640gsm) rough-surfaced watercolor paper

Brushes
1/2-inch (12mm) flat
1-inch (25mm) flat

Palette
Ultramarine Blue

Miscellaneous
dull knife (optional)

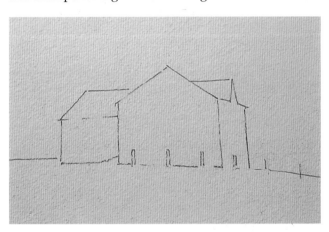

Step 1: Pencil Sketch

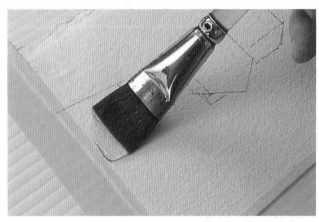

Step 2: The First Stroke
First you need to do a flat wash of clean water. Turn the drawing upside down and tilt it slightly toward you. Load your 1-inch (25mm) flat with clean water and with a long, steady brushstroke drag it from left to right across the horizon line. Just make one pass.

Step 3: The Second and Third Strokes
Make a pale mix of Ultramarine Blue. Load your brush with it, and stroke it in just below the area of the previous stroke, remembering to overlap the bottom edge of that stroke.

Strengthen your mix by adding in more Ultramarine Blue from your tube. Just as before, drop in this third stroke over the bottom wet edge of the previous stroke.

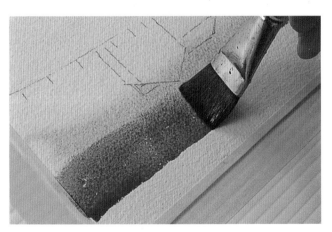

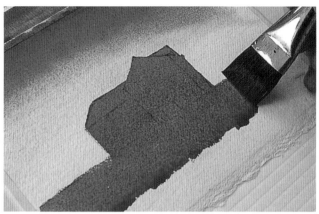

Step 4: The Last Stroke

Finally, pump the value of the mix to near maximum, then stroke in the final pass. Lay the painting down flat and let your graded wash dry. After it has dried, flip your painting around and have a look. What you'll see is a sky.

Step 5: Flat Wash

Still using the same brush and high-value mix, paint in the barn and foreground. Let your work dry.

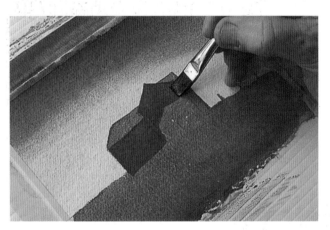

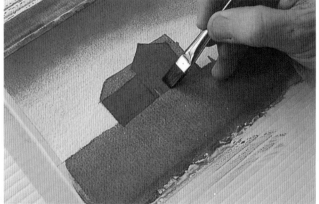

Step 6: Glazing

Using your $\frac{1}{2}$-inch (12mm) flat and the same mix, apply another coat of paint over the barn. Do not paint over the sunward roof and wall.

Step 7: Fence Posts

Lift the paint where you'll want to place the fence posts that are in front of the barn. You'll paint those posts by not painting them, so to speak. Merely rest the side of your clean brush on the paper for a fraction of a second. Paint the remaining fence posts to the right.

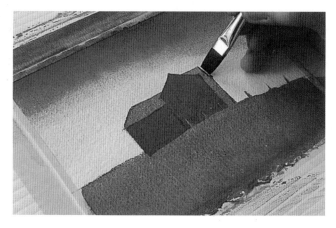

Step 8: Dormer Detail

By utilizing the side edge of your ½-inch (12mm) flat, drop in a shadow on the eaves of the dormer window.

Step 9: Fence Posts Again

Go over the remaining fence posts once again to increase their value.

Step 10: Scoring

Scratching a dull edge into wet paint can create some pretty dramatic effects. To suggest barn boards, use the scoring end of your ½-inch (12mm) flat (or a dull knife) to score the barn with straight lines. But don't score in all the boards; less is more.

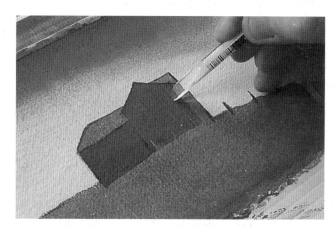

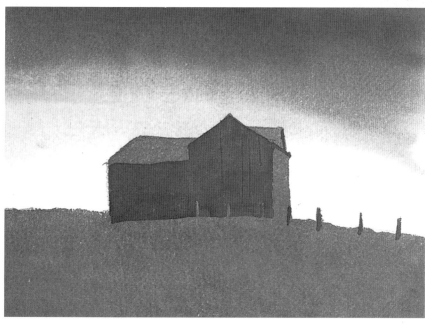

Barn
Jack Reid
5½" × 7½" (14cm × 19cm)

Exercise
Wet-Into-Wet Technique

The wet-into-wet technique means precisely what it says: putting wet paint on wet paper. The thickness of the paint and the wetness of the paper will determine the level of control you have over what you're painting. In any wet-into-wet painting, it's a good idea to use rough-surfaced paper because the paint settles better. The trick is to make the color dark enough and avoid overwetting the paper. You will also discover that you have to move swiftly before the first wash dries. Timing is crucial when executing a wet-into-wet.

In this exercise, we're going to paint a very simple scene of two pines in grass. Tape the paper to your work surface. Base your simple drawing on the completed picture on the facing page.

Paper
5" × 7" (13cm × 18cm) piece of rough-surfaced 300-lb. (640gsm) paper

Brushes
½-inch (12mm) flat
1-inch (25mm) flat
no. 8 round

Palette
Burnt Sienna
Ultramarine Blue

Miscellaneous
dull knife (optional)

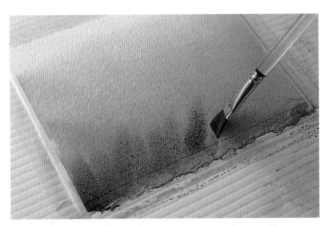

Step 1: Grass
Cover the entire paper with a graded wash of Burnt Sienna. While this is still wet, stroke in a mixture of Burnt Sienna and Ultramarine Blue along the bottom with random upward strokes using your flat brush. This gives you a brown-gray grass. In this case you have a brown of medium value.

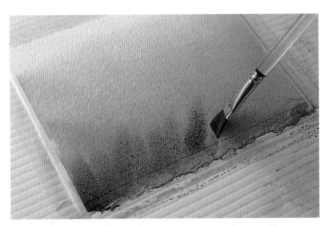

Step 2: Tree
While the graded wash and the wet-into-wet grass are still wet—you have to be fairly quick here—take the square tip of your flat and paint the pine tree in.

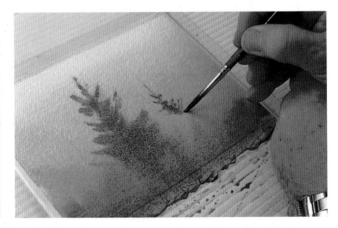

Step 3: Another Tree
With a slightly lighter value of the Burnt Sienna and Ultramarine Blue and with your no. 8 round, paint in a smaller pine tree in the distance.

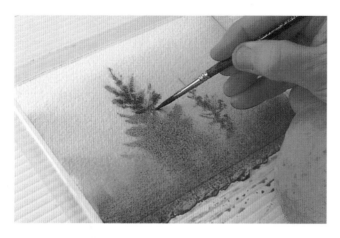

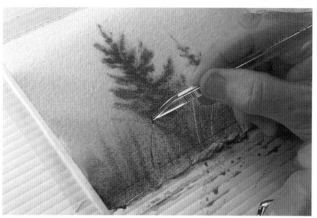

Step 4: Reinforcement
With a heavier pigment and your no. 8 round, add a little more detail to the large pine, "spidering" the edges. This creates the illusion of the fir tree as seen from a distance.

Step 5: Scoring
Take the blunt edge of your 1-inch (25mm) flat and score or scratch in some of the grass while it's still wet. You can use your dull-as-dishwater paring knife here, if you want.

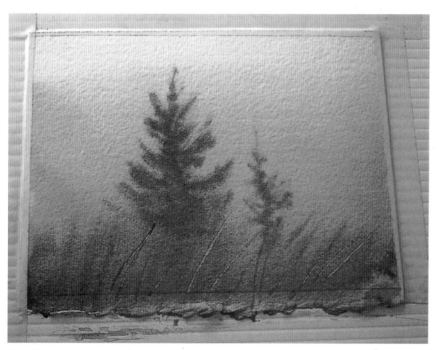

Two Pines
Jack Reid
5½" × 7½" (14cm × 19cm)

Inspiration and Perspiration
You can see that when using the wet-into-wet technique you have to move fast. It's fairly simple, but simple doesn't mean easy. You have to work at it. Practicing this picture will teach you how important time is to achieving the desired effect. Time really is the essential factor when doing a wet-into-wet. Just remember this: Success in painting breaks down to about 10 percent inspiration and 90 percent perspiration. If you didn't get it right the first time, do it again and again and again.

In Some Situations, One Must Learn to Paint Quickly
There's an old story of two painters who were painting a scene on the edge of a duck pond. One painter was an old pro; the other, her student. After a few hours, the pro was finished with her picture. Turning to have a look at the student's progress, she saw that all he had managed to paint was the feet of one duck. When she asked him what his problem was, he replied, "Gosh, you gotta be fast to paint ducks!"

Exercise
Dry-Brush Technique

The dry-brush technique involves painting with a brush that is almost empty of paint (almost dry). As you drag the brush across the paper, it runs out of paint and creates a mottled effect. This exercise will incorporate washes and wet-into-wet, as well as dry-brush painting. Begin by taping the paper to your work surface and then penciling in the sketch.

Paper
5" × 7" (13cm × 18cm) piece of 300-lb. (640gsm) rough-surfaced watercolor paper

Brushes
1/2-inch (12mm) flat
1-inch (25mm) flat
no. 8 round

Palette
Burnt Sienna
Ultramarine Blue

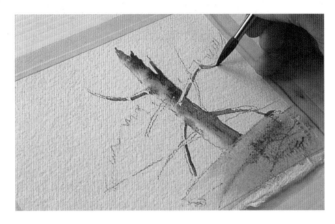

Step 1: Graded Washes
The first graded wash, at the bottom right, will end up resembling driftwood. Make a light brown mix of Burnt Sienna and Ultramarine Blue and use your 1-inch (25mm) flat to wash in the driftwood, with lighter values at left. Adding a little Burnt Sienna to your mix, do the graded wash on the tree. Add water at left on the side facing the light. With your round, paint in shadows on the branches.

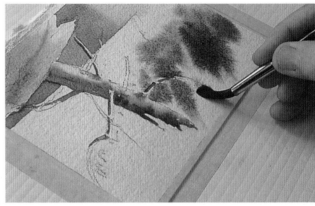

Step 2: Wet-Into-Wet Clouds
Flood the area to the left of the tree with clean water (turn your paper upside down). Mix your colors into a blue-gray. Apply the mix with your round as shown here. Paint around the tree's branches. Make sure your clouds don't run into each other, or your sky will be black. Give the lake detail. Do a graded wash of Ultramarine Blue, medium value. Remember to paint around the branches.

Step 3: Background Trees
With your round and a dark mix of Burnt Sienna and Ultramarine Blue, fill in as shown.

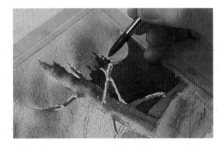

Step 4: Background Mountains
Using the blue-gray mixture from step 2, do a graded wash on the background mountain.

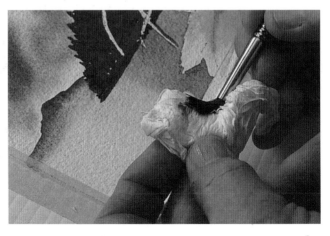

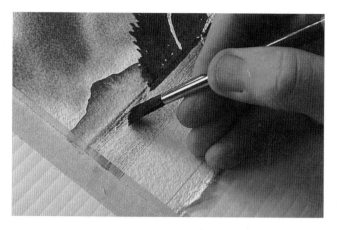 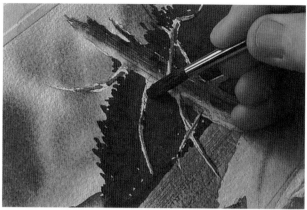

Step 5: Drybrushing

Load your ½-inch (12mm) flat with a medium value of Ultramarine Blue. Remove most of the paint from your brush with a tissue for drybrushing. Drag your dry brush over the water horizontally. If you have to squish your brush into the paper to get the paint out, you've removed too much paint. Continue drybrushing to the bottom of the paper. The horizontal lines indicate the shadows of the clouds above.

Step 6: More Drybrushing

Splay the tip of your no. 8 round with some thick brown paint. Remove most of it with a tissue. Add branch shadows, trunk texture and driftwood at the base of the trunk.

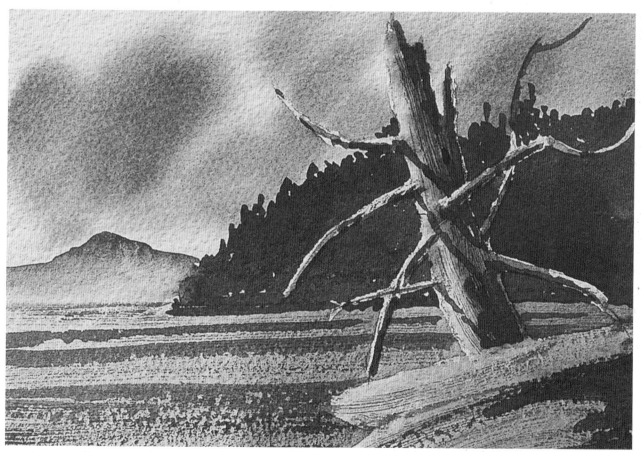

Dead Tree and Lake
Jack Reid
5½" × 7½" (14cm × 19cm)

Step-by-Step Demonstration: Tonal Value Using One Color

This is an exercise in monochrome painting—painting with one color. You'll discover how contrasting tones of the same color can help you achieve dramatic effects.

The chart on this page is a value scale from one to eight, with one always representing white and eight representing the deepest value of the color. It doesn't matter how many levels a scale has; it merely illustrates the idea that every color has a range of values from light to dark.

Any color's value can be adjusted in exactly the same way. It's simple with watercolor. If you want to *reduce* value (or intensity), add more water; if you want to *increase* value (or intensity), add more pigment. But remember, this takes place in either a mixing bowl or on your palette. Never attempt to add water or squeeze raw pigment directly onto your painting.

Keep Your Value Chart Close at Hand
Keep the value chart at right in the front of your mind. You can also make a simple black-and-white photocopy of the value chart and pin it up in your painting room for quick reference.

How to Adjust Value
You will use two methods of value adjustment: (1) adding extra pigment to the mix; and (2) glazing. Glazing, or laying one coat or wash of paint over another wash after it has dried, is the most common method of increasing value.

You will be using only one color, Sepia, in this exercise. The only difference is the value of Sepia. All illustrations are approximately 5" × 7" (13cm × 18cm).

Time to Start
Enough theory! Excessive analysis produces artistic paralysis. See for yourself how the following series of illustrations come to life simply by adjusting the values in the monochrome paintings.

Practice
Pick a color, any color, and practice adding water to it until you can control the values.

Brushes
no. 8 round
1/2-inch (12mm) flat

Palette
Sepia

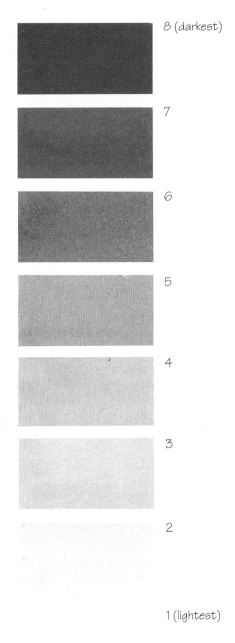

8 (darkest)

7

6

5

4

3

2

1 (lightest)

Value scale in Sepia

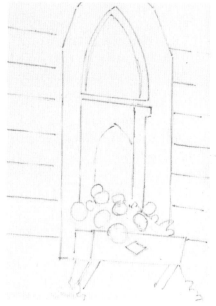

Step 1: Pencil Sketch

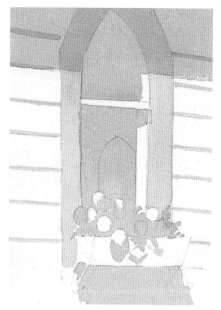

Step 2: First Value Wash
With a value of about three, paint the window and frame, some detail around the flowers and the shadow of the flower box. When this is dry, use the same value and glaze in the shadow of the building along the top and the shadow of the clapboard.

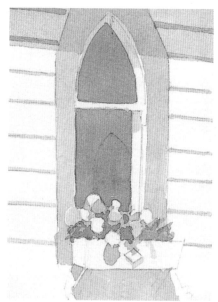

Step 3: Glazing for Detail
Still using the same value, add detail to the flowers with a pointed brush, again by glazing. Notice how this bumps the value up to approximately four or five on your scale. Flowers come in different colors so paint them with different values to suggest this color contrast.

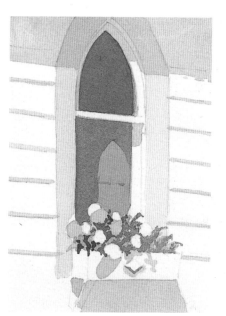

Step 4: Final Glaze
Using a value of about five, paint over the window again with your flat, being careful not to paint over the other church window showing inside. By not painting over the second window it stays at a lower value, and this contrast suggests that light is coming through it. Glaze again to add a little more detail to the flower leaves. And that's it—a simple exercise in tonal values!

How Far Can You Go?
Tonal values are extremely important to all paintings. Take time to practice reproducing different tones in your artwork; it will pay off in a big way.

Once you feel confident with painting tonal value, hang on to that information, and get ready to introduce more color!

Step-by-Step Demonstration: Combining Two Colors

Now that you understand the importance of tonal values and some of the striking effects you can achieve by adjusting them, the time has come to introduce another color. The following three demonstrations, using two, four and five colors, will give you an opportunity to perfect values and develop a sense of color coordination. You will paint the same scene for each exercise. The scene isn't so important; the important thing is using color!

Paper
5" × 7" (13cm × 18cm) 300-lb. (640gsm) rough-surfaced watercolor paper

Brushes
1-inch (25mm) flat
½-inch (12mm) flat
no. 4 round
no. 8 round
lettering brush
script liner

Palette
Burnt Sienna
Ultramarine Blue

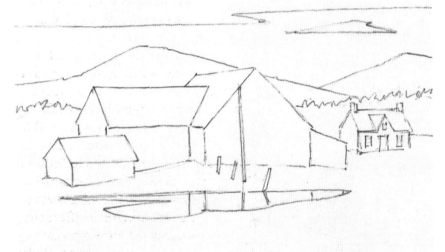

Step 1: Pencil Sketch
Attach the watercolor paper to your work surface and pencil in the basic drawing.

Step 2: Flat Wash
Prepare a value-three wash of Burnt Sienna. Load your 1-inch (25mm) flat and apply a flat wash to the entire sky, puddle, posts and areas of the buildings as shown. Let dry.

Then prepare a value-three wash of Ultramarine Blue and, with clean 1-inch (25mm) and ½-inch (12mm) flats (where appropriate), paint in the mountains, roofs and foreground. Don't paint the posts. (You'll notice here a blue blot on the far side of the puddle. That was a mistake made when the artist sneezed, but since this is just an exercise, it's not a problem.) Let dry.

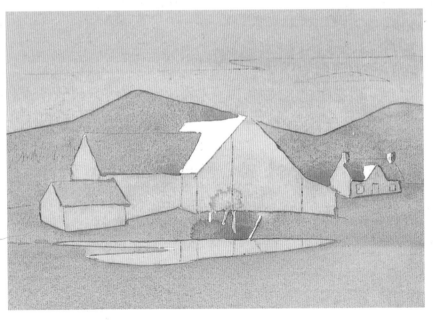

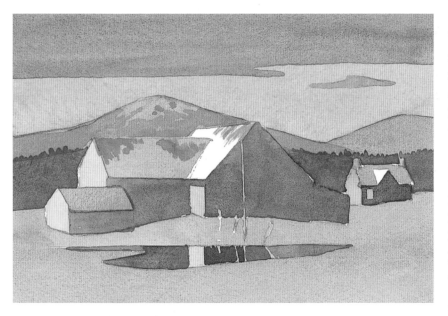

Step 3: Glazing

Using the same mix of Ultramarine Blue, load your no. 8 round and glaze the mountains, avoiding areas of the principal peak to suggest snow cover. Let dry.

Use a clean 1-inch (25mm) flat and the same mix to glaze in those areas of the sky as shown. Notice that by painting over the Burnt Sienna with Ultramarine Blue the color mixes right on the paper, rendering a shade of blue-gray for cloud cover.

Now mix equal parts of Ultramarine Blue and Burnt Sienna to a value of about four. That should give you a brownish color. Glaze in the trees, the faces of the buildings and the reflections in the puddle. Let dry. Be mindful not to paint over the lit window in the house, the leftward facing walls of the buildings and their reflections in the puddle. Also, leave that missing barn board on the side of the barn.

Once this has dried, go back to the puddle and reglaze. As reflections are always darker than the objects reflected, we have to increase the value in the puddle. We do that by glazing. Let dry.

Prepare a small value-five wash of Burnt Sienna and use your no. 4 round to stroke in the areas shown on the barn roofs to get that rusty look. Let dry.

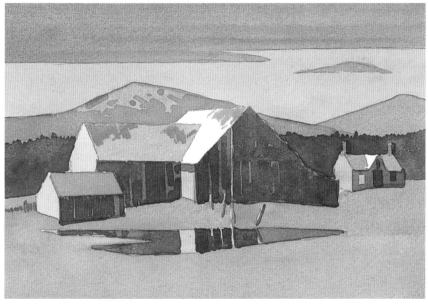

Step 4: Barn Boards

Returning to the two-color mix, load your lettering brush and apply vertical strokes to the barn, holding the brush on its side. This is glazing, once again. By giving the suggestion of misshapen boards, we kill the monotony of the bland, textureless surface. Next, loading your script liner with the same mix, apply some detail to the fence posts (and their reflections), the house face and the two chimneys.

Step-by-Step Demonstration: Combining Four Colors

For this exercise use a four-color palette. The goal to keep in mind: Perfect the values and develop a sense of color coordination.

Paper
5" × 7" (13cm × 18cm) piece of 300-lb. (640gsm) rough-surfaced watercolor paper

Brushes
1-inch (25mm) flat
1/2-inch (12mm) flat
script liner
no. 8 round
lettering brush

Palette
Burnt Sienna
Ultramarine Blue
Raw Sienna
Viridian

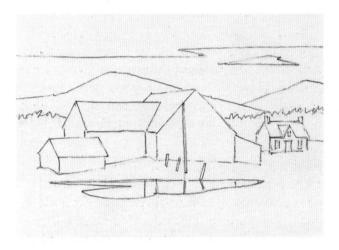

Step 1: Pencil Sketch
Attach the paper to your work surface and pencil in the basic drawing.

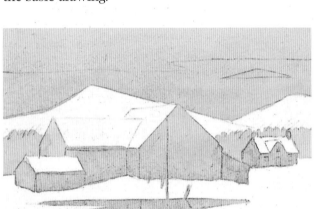

Step 2: Initial Wash
Prepare a value-three mix of Raw Sienna. Using your 1-inch (25mm) flat, apply a flat wash to the entire sky (you can use a larger flat brush, for quickness). Next, using your 1-inch (25mm) and 1/2-inch (12mm) flats, apply the same flat wash to the trees, building and puddle as shown. Let dry.

Step 3: Glazing the Sky
Mix equal parts of Burnt Sienna and Ultramarine Blue into a brown-gray to a value of four. Using a clean 1-inch (25mm) flat, paint in the clouds. To achieve the effect seen in the horizon portion of the sky, mix a high value of Burnt Sienna and glaze in the section as shown. Let dry.

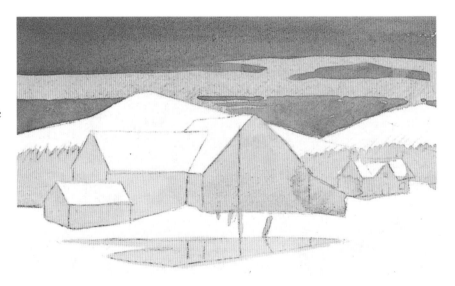

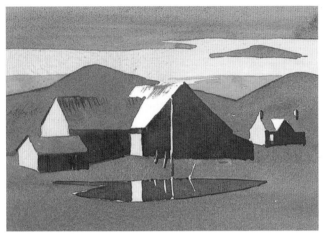

Step 4: Glazes and Blue Wash

Prepare another mix of Ultramarine Blue with a small amount of Burnt Sienna to dull its intensity, and apply a flat wash to all white areas except the leftward facing roofs of the barn and house. Set this wash aside as you'll need it in a moment. Let dry.

Now mix equal parts of Burnt Sienna and Ultramarine Blue to a value of four and, using your flats, glaze over the puddle and left facing walls of the barn and house. While this dries, load your script liner, remove the excess paint and stroke in the rust detail on the corrugated roof and posts as shown. Let dry.

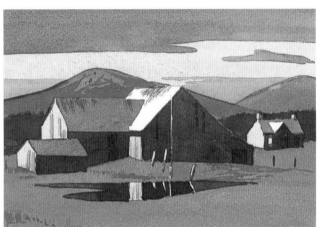

Step 5: Finishing Glaze and Details

Prepare a value-four mix of Viridian with a small amount of Burnt Sienna to soften the intensity and, using your round brush, glaze in the trees.

Use the Ultramarine Blue/Burnt Sienna mix from step four and glaze over the mountain behind the barn. Leave the crest at a light value to suggest snow. You don't want to leave the snow pure white or it will detract from the white on the barn roof.

Go back to your brown-gray mix from step 3, load your lettering brush and glaze in the missing barn boards and the openings on both the barn and house. A couple of new posts have also been added on the right using a lettering brush. Remember to darken the values in the puddle. Let dry.

Mix a small value-four wash of Burnt Sienna, and use your script liner to stroke in the detail shown on the leftward facing barn walls and the corresponding reflections. Add an equal amount of Raw Sienna to this mix—keeping it at a value of four—and stroke in the grass and mud with your script liner.

Step-by-Step Demonstration: Combining Five Colors

Now that you have refined your values and experimented with various hues and shades, let's go with a five-color palette that will really pull this painting out of the bag.

Because this will be the final version of this subject, increase the size of your paper to roughly 6" × 8" (15cm × 20cm). This final version should really sing with color.

Remember, this is the final version, so do an especially good job. You just might decide to hang this painting when you're done.

Paper
6" × 8" (15cm × 20cm)
 300-lb. (640gsm) rough-
 surfaced watercolor paper

Brushes
1-inch (25mm) flat
½-inch (12mm) flat
script liner
no. 8 round
lettering brush

Palette
Burnt Sienna
Ultramarine Blue
Rose Madder Genuine
Aureolin Yellow
Cobalt Blue

Step 1: Pencil Sketch
Begin by carefully sketching the basic pencil drawing.

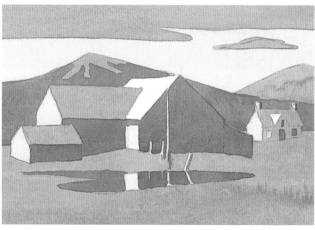

Step 2: Initial Wash
Mix a value-three wash of Aureolin Yellow with just a tiny amount of Rose Madder Genuine so it's not a pure yellow. Using your 1-inch (25mm) flat, apply a flat wash to the entire sky area and other parts of the picture as shown. Let dry.

Step 3: Flat Wash and Glazes
Prepare a value-three mix of Cobalt Blue with a tiny bit of Rose Madder Genuine, which will give the mix a slightly purple cast and warm the cold intensity of the blue. Using 1-inch (25mm) and ½-inch (12mm) flats, apply a flat wash to the clouds, mountains and buildings, but stay off the puddle reflections, left facing roofs and walls. Let dry.

Then glaze over the principal mountain as shown, remembering to paint around a small area at the peak to suggest snow cover. With a value-four mix of equal parts of Ultramarine Blue and Burnt Sienna, glaze in the shadow areas on the barn, posts, puddle, door, windows and chimneys on the house. Let dry. Keep this mix handy because you'll need it in a minute.

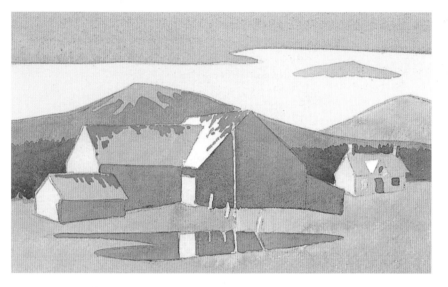

Step 4: Detail

With your round and a value-four mix of equal parts of Aureolin Yellow, Cobalt Blue and Burnt Sienna, glaze in the trees as shown. Now prepare a value-six mix of Aureolin Yellow, Rose Madder Genuine and Burnt Sienna in equal parts. Burnt Sienna on its own won't give the desired luminosity. Now paint over all the rusty areas of the corrugated roof.

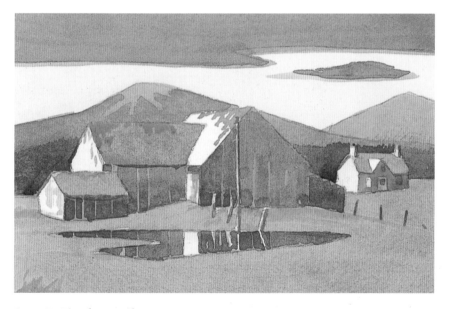

Step 5: Final Detail

With the mix of Ultramarine Blue and Burnt Sienna from step three, use your lettering brush or ½-inch (12mm) flat to glaze in the missing barn boards, house face and post edges. Insert new posts right. Add a little water to your value-six mix of Aureolin Yellow, Rose Madder Genuine and Burnt Sienna from step 4. Using your script liner, glaze in details on the left facing barn walls. Prepare a value-three mix with equal parts of Aureolin Yellow, Cobalt Blue and Rose Madder Genuine for a gray. Glaze the clouds. Let dry. With a value-three mix of Rose Madder Genuine, stroke in around the cloud edges.

Summary

If you've been diligent in following these steps, you will have learned the importance of establishing values and something of the subtle relationships between colors. Values are the foundation of any painting.

You're probably pretty tired of painting barns. Start rooting through your old photo albums—or go outside, and nature will surely offer up a subject. Whatever you do, look closely with an eye to tonal value and color. Soon you will develop your own palette of preference.

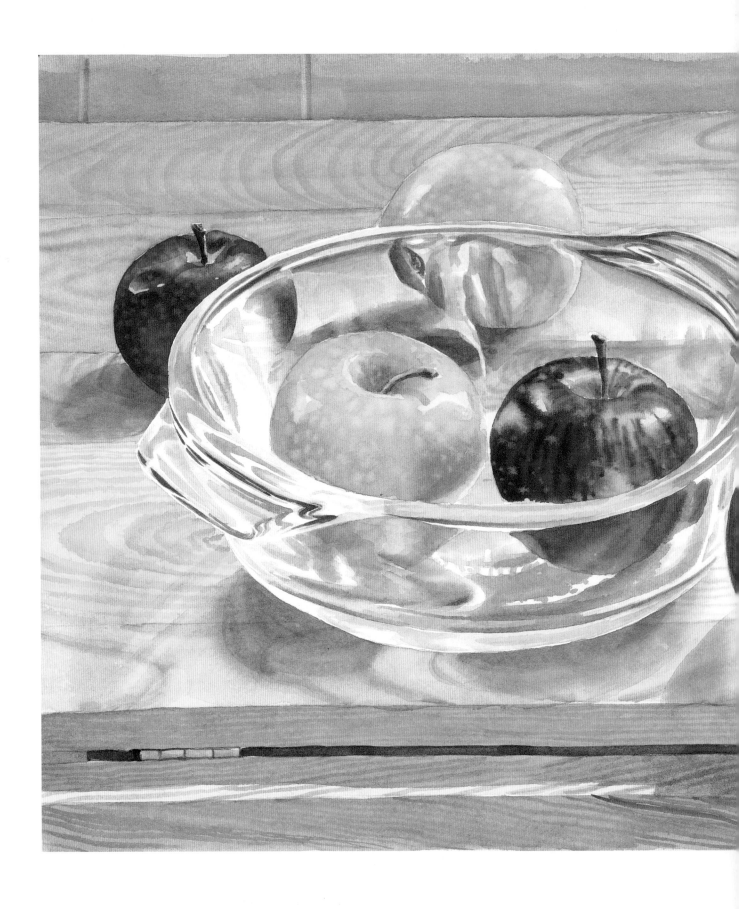

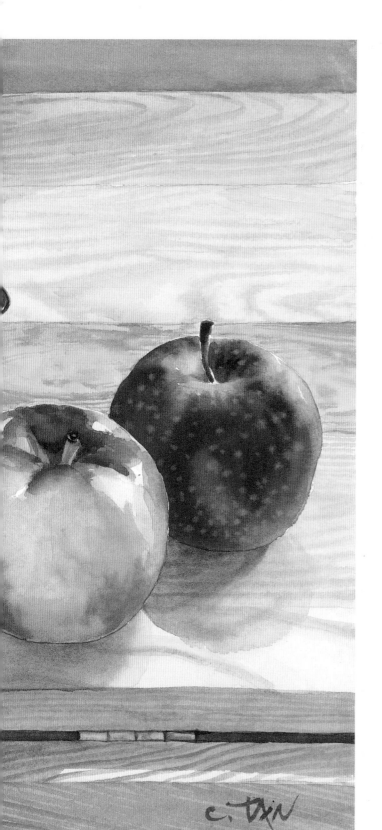

UNDERSTANDING LIGHT

Light has inspired artists from the earliest recorded drawings found in the caves at Lascaux, France, until today. The study of light has changed art history. The search to capture light has inspired artists to make radical changes in tradition. Seeing and recording light has been a steady inspiration for artists worldwide. Rendering light on canvas or on paper has been subtle and it has been bold, but it has never been ignored.

Understanding light is your key to making a painting dimensional. In this chapter you will learn about the different types of light, the significance of shadows, and how to see and paint light-filled paintings.

Apples and Glass Bowl
Chinkok Tan
11" × 16" (28cm × 41cm)

Designing Light-Filled Paintings

When light is your inspiration you need a few simple design tools to help turn that initial inspiration into a good composition. You want to showcase light using the best underlying design possible because, just as a skeleton gives shape to the human form, the underlying composition is critical in making a painting work. Following are some helpful design basics.

Artwork on pages 40 through 43 was created by Judy Morris.

Focal Point

When we learned to read, our eyes were trained to move from left to right. That is the easiest path for our eyes to follow. For that reason, the most effective composition to read is a horizontal format with the focal point above and to the right of center. Showcase the light in your paintings by placing the most contrast between light and dark above and to the right of the center for the best impact.

The Golden Mean

Subject matter may require more choices for a focal point in your paintings. The Golden Mean gives you these choices. Divide your paper into thirds, horizontally and vertically, and place shapes with the most contrast between light and dark at one of these intersections.

Don't Divide in Half

Always avoid dividing your composition in half horizontally or vertically. It's hard to achieve balance when you have to work with two halves that are the same weight.

Design Success

The success of each painting depends on the light it emits. By properly placing the focal point and following the rules of design, you can showcase the light in your paintings.

Light Direction Reveals Form

The position of the light source determines the form of the object upon which the light falls. Lights, darks and shadows change when the light source changes position. By knowing the characteristics of lighting from the front, side and back you can let light reveal the form best suited for your paintings.

Front Light

When the light source is in front of an object, details are flattened and texture and form seem to disappear. Lights and darks are reduced to a minimum. Shadows fall behind the object and usually appear quite small, insignificant and not very dramatic.

Side Light

Lights, darks and textures are exaggerated when the light source is at the side. Shadows are dramatic and create strong patterns. Sidelight reveals form and depth in the most descriptive way because contrasts are exaggerated.

Back Light

Backlight also simplifies the textures and values because most of the object is in the shade. The very light areas are found only around the outline of the object. The details are vague and less noticeable. The shadow becomes an important shape in the foreground.

Make Use of Natural Light

The sun and moon are sources for natural light. The kind of light they produce varies from bright sunlight directly overhead on a clear day to just the barest hint of light coming from the sliver of the crescent of a new moon.

You can also make use of natural light indoors.

Many artists plan a studio where the windows face north and provide clear and consistent light. (In the southern hemisphere the studio windows should be placed to the south.) North light allows you to paint throughout the day without worrying about the light changing.

Sunlit Colors
Create the feeling of intense sunlight by putting your richest colors in the shadows and painting lighter values of the same color when they are in the direct sunlight.

Sunlight
The main light source for outdoor painting is the sun. When the light from the sun is bright and crystal clear, there is a precise distinction between the object it falls on and the shadow it creates. The edges of the shadows are clear and crisp. But bright sunlight also washes out color. Colors will be weak on the surfaces where the light falls and rich in the shadows. Compare the intensity of red in the sunlight and in the shadows of the tablecloth.

The Picnic
Judy Morris
18" × 20" (46cm × 51cm)

Capture Reflected Light

The ability to see and capture reflected light not only brings luminosity to your paintings but adds color harmony as well. Almost every surface (but not black velvet!) reflects colored light to some degree. The color of the reflected light depends on the surface colors surrounding the objects you are painting. If you are painting outside on a clear, sunny day, blue from the sky or greens from surrounding foliage will be reflected in the shadows of the objects you are painting. If you are painting indoors, the colors from surrounding objects will be reflected in the shadows.

Different surfaces reflect light differently. White or colored objects reflect light differently than shiny or clear objects. Learn to see reflected light by placing a variety of different objects on colored pieces of fabric. You will be surprised how much reflected light you will see!

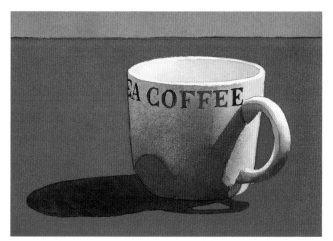

White Objects and Reflected Light

This white cup reflects the red light from the fabric it is sitting on and the blue light from the sky above. The most intense reds are found in the darkest shadows. Notice how the blue from the sky is reflected on only the top surfaces of the handle and on the left side of the cup. There is no red reflected inside the cup because the inside of the cup gets reflected light only from the blue sky above. Painting the letters shades of dark red instead of black intensifies the feeling of reflected light. The shadow is painted a solid, dark shade of red.

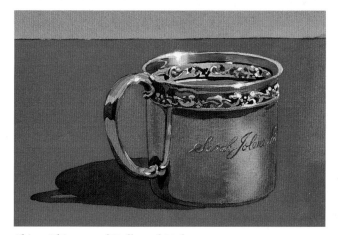

Shiny Objects and Reflected Light

Shiny objects reflect the most light! This painting of a silver cup proves silver is a "shine" and not a "color," and the form is defined only by the lights, darks and colors it reflects. The main body of the cup is red, but the red of the cup is not as intense as that of the surface it is sitting on. Notice the blue reflected on the top surfaces of the handle and the filigree surrounding the lip. Red is reflected on the bottom surfaces. Again, no red is reflected inside the cup because the inside of the cup gets reflected light only from the blue sky above it. The shadow is also a solid, darker shade of red.

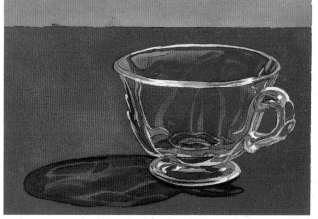

Clear Objects and Reflected Light

The form of clear objects is defined more from the reflected color above than from the surface on which it is sitting. The red surface is seen through the clear glass of the cup and remains intense. Slight variations of red add sparkle to the glass. Blue reflected from the sky, white highlights and a few darks define the rest of the cup. The shadow of a clear object is not solid! Light shines through the glass and creates a pattern of light and dark shapes that echo the feeling of transparency.

Experiment With Artificial Light

If you want complete control over the way light falls on the subjects you are painting, then paint indoors under artificial lights. You will be able to adjust the intensity, direction and even the color of the light. You can create dramatic still-life arrangements and the light won't move and change the shadows!

If you paint indoors, use daylight-simulation bulbs or fluorescent striplights that imitate natural daylight. The colors you use when you paint will look the same as they would look in natural light.

When the primary source of artificial light comes from a single direction, the contrasts and shadows are intensified. Form is more clearly revealed as shadows move across surfaces. Light from a single source adds more drama to a composition.

The focus of a still-life arrangement changes depending on whether the light comes from the left or the right. Experiment with artificial light placement to find shadows and highlights that will be assets to your painting.

Examples on this page were created by Chinkok Tan.

Light your subject from the left side . . .

. . . the right side . . .

. . . or from the top . . .

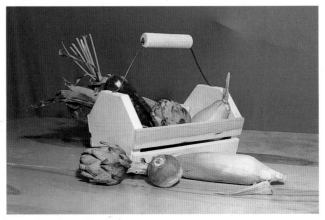

. . . but never light your subject from the front! All of your subject will be in high light, creating no contrast in values.

Tip

Do not light your subject with more than one light source. Multiple sources will cancel out each other's shade shapes, creating conflicting planes, shadows and reflected light. You will get caught up in trying to manipulate all of the subtle light values that result.

Light Defines Form

Light falling across an object creates value contrasts that help define the form of that object. When light falls across spherical or smooth objects the changes in value are gradual and give the impression of roundness. When light falls across objects full of planes and angles the changes in value are sharp and precise. Light falling across an object and the resulting shadows are the "keys" that unlock the visual suggestion of volume and form.

Artwork on pages 45 through 63 was created by Judy Morris.

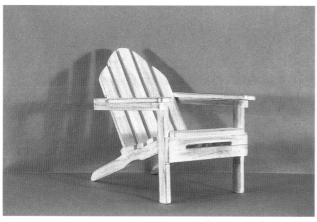

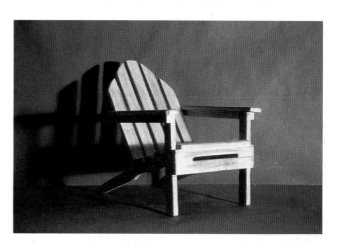

Sharp Angles and Planes
Two photographs of this doll-size Adirondack chair are excellent examples of how light helps define objects with sharp angles and planes. When there is no obvious light source the range of values is limited (left), and though the shape of the chair is visible, it is not as clearly defined as it is with directed light (right).

Round and Smooth Surfaces
There are no sharp edges and angles when directed light falls across round and smooth surfaces. The value changes are gradual and soft and can be rendered best by using the wet-into-wet technique. Careful observation of the way light falls across forms is crucial to visually describing the objects you paint. The kind of edge (sharp or soft) that light creates defines form.

Significant Shadows

Light Source and Shadow Direction

When painting light, the significance of shadows cannot be ignored. Without shadows, whether they are strong or subtle, painting light would be impossible. Understanding and painting shadows is the single most powerful way to suggest the feeling of light.

You must paint believable shadows. It is easy to do when you paint indoors using an artificial light source because the shadow doesn't move. Painting on location is a different story. The sun moves, and so do the shadows. You have to be quick in capturing the shadows that suggest the feeling of light. Don't be discouraged by a moving shadow. An easy method of making sure cast shadows are consistent with the light source is to use parallel lines to mark the long edges of the shadow shapes.

Shadows Anchor Objects

Whether you are painting a landscape on location or a still life in your studio, shadows anchor your subject to the surface in which it is placed. The shadow of a tree, for instance, helps describe the contours in the field of grass in which it is growing. The shadow created by light falling across a still life defines the tabletop on which it is placed. The main function of a shadow is to anchor the object and give it solidity.

Shadows Reveal Light

Shadows are tricky! As shadows move across the landscape, they hide and reveal light. The same subject can take on a completely different personality depending on the movement of shadows. An ordinary scene is suddenly stunning, prompting you to think, "Where did that come from?"

Shadows on a Wall
Use parallel lines drawn at a 45-degree angle for a shadow that is cast on a vertical wall in the mid afternoon sun. The long edges of the shadow are consistent because they are parallel.

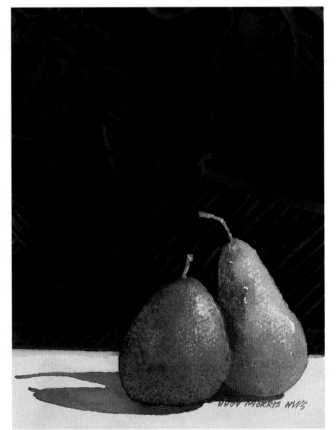

Shadow Information
The simplest way to give an object the feeling of solidity is by adding a shadow. The shadow from the pears not only indicates that the light source comes from the right, but it tells the viewer that the surface the pears are sitting on is flat.

A Pair
Judy Morris
9" × 6" (23cm × 15cm)

Checking Your Contrasts

The most important technical part of painting light that must be conquered is understanding and effectively using value, the lights and darks that create contrast in your paintings. Train yourself to see and evaluate the value changes in your painting. Check values when the painting is in progress. Check values when you think you're finished. You'll find that sometimes even small adjustments in contrast can make a big difference in painting light.

Copy Machine

To check for value contrasts, it helps to make a black-and-white copy on a copy machine.

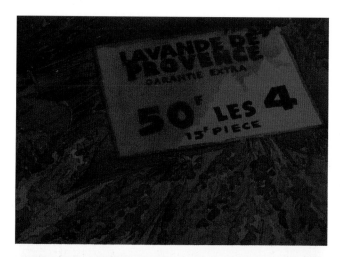

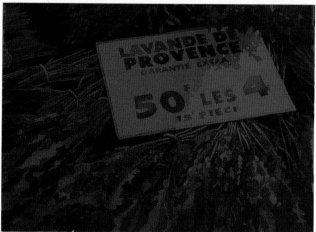

Red Cellophane Shows Contrast
The paintings on pages 52 and 53 were photographed here through red cellophane. Look how the red neutralizes the color and emphasizes contrast or lack of contrast. Try to give your paintings as much contrast as shown in the lower image.

Squint Your Eyes

The easiest and handiest method of checking value contrasts is squinting your eyes when you look at your work. Your eyelashes act as a feathery screen, causing the color to neutralize. You will see less color and more value.

Look in a Mirror

Stand ten feet away from a mirror and view your painting backwards. The color won't disappear, but since you're looking at your work from a distance and backwards, you will see it with a fresh eye. If parts of your painting disappear or run together, strengthen the contrasts to define the shapes.

Look Through Red Plastic

View your work through a piece of red plastic or cellophane. The red neutralizes everything into shades of red. Again, if any shapes in your painting disappear or run together, you need to intensify contrasts.

Tracing Paper

Place several layers of tracing paper over your painting. It's like putting your painting in a fog. If you can see your painting through the fog, you have enough contrast.

Video Camera

You see images in black, white and shades of gray through the viewfinder of most video cameras. If you own a video camera, look through the viewfinder to check your values. You may not even have to turn the camera on.

Sunglasses

Put on your sunglasses—the darker the better (inexpensive plastic wraparound dark glasses made for post-surgical patients are the best). You will be looking through the green or gray of the lens, but the color in your painting will be neutralized; it will be easier to focus on value.

Digital Camera

If you have a digital camera, use it. Put the image of your painting in your computer then change the color option to make a black-and-white image and check the contrast. Technology works!

Weak Contrasts

To help you understand the importance of contrast, here is painting that has some common mistakes. The subject is fun. The drawing is good. The design works. The use of contrast is not as good as it could be. Let's critique it.

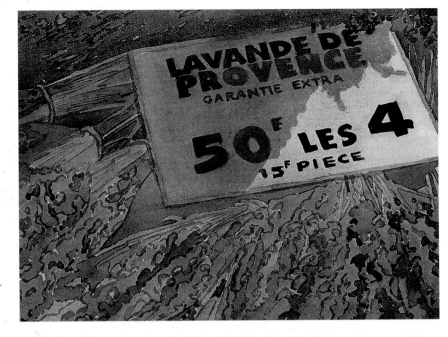

Check contrasts by making a black-and-white copy of your painting.

There is not enough contrast to see individual stems.

The shadow color is flat.

These blacks are not repeated anywhere else in the painting.

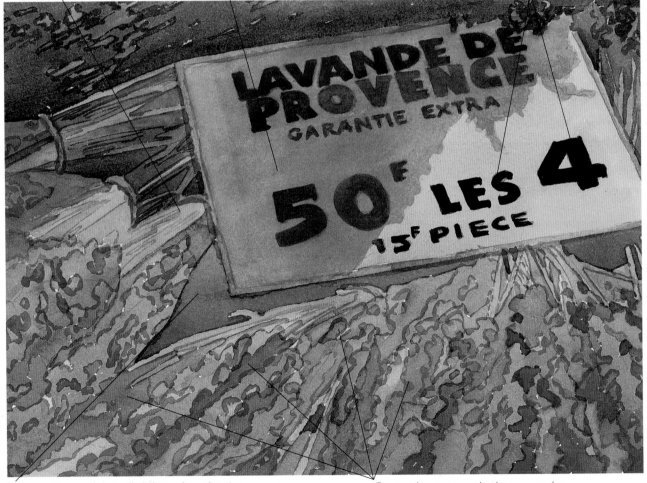

This "dark" area is actually lighter than the sign.

The purples are mostly the same value.

Strong Contrasts

This version of the same painting on the facing page sparkles with sunlight. It's the same drawing. It's the same design. The technical problems of using contrast have been solved.

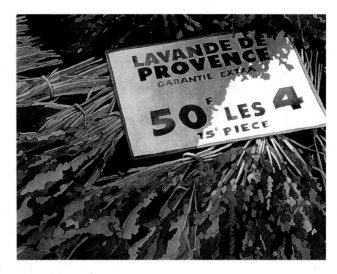

A black-and-white copy of this painting proves contrast is necessary to catch light

Contrast allows you to see individual stems.

The shadow is interesting because the color changes.

Paying careful attention to the edge of the shadow heightens the contrast.

The darkest lettering is in the shadow where it should be.

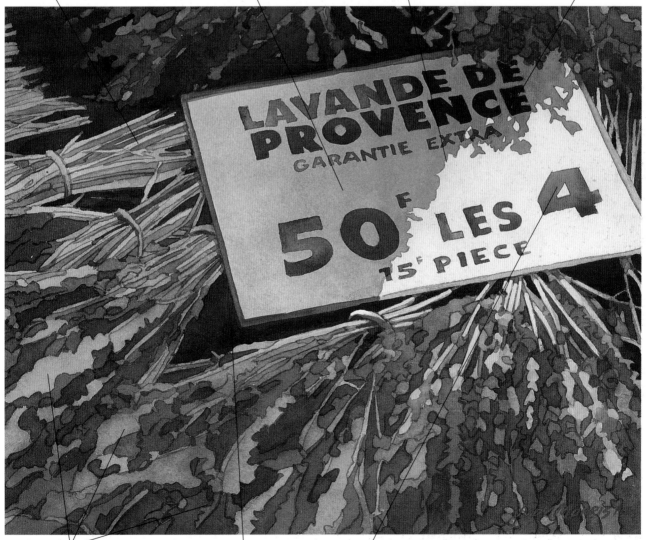

There is a good variety of light and dark purples.

The space behind the sign is very dark to show depth.

Painting the "4" lighter emphasizes the feeling of sunlight.

Lavande de Provence
Judy Morris
10½" × 12½" (27cm × 32cm)

Composition and Contrast Create Light

Once you understand the concept of catching light with contrast, you are ready to paint! Look for subject matter that will not only be fun to paint but that offers you the opportunity to emphasize color and value contrasts arranged in a composition designed to showcase light.

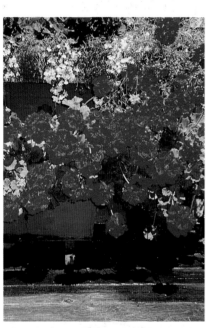

Use a Reference Photo
Use the reference photograph to create a design and value plan for the painting.

Focal Point

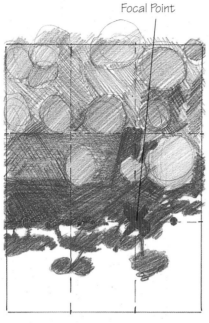

Design Value and Focal Point
Make a rough value sketch using light, middle and dark values.

Divide your paper into thirds horizontally and vertically (the Golden Mean), and place the focal point at the intersection where the right and bottom lines cross. Putting the most contrast near the "X" emphasizes the shadow that showcases the light. Fill the dark, middle and light values in with a soft lead pencil to support the focal point.

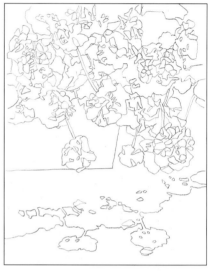

Complete a Drawing
Create a drawing plan by simplifying the flower, leaf and shadow shapes into a contour drawing. It is important to carefully draw the edge of the shadow because that line divides the dark of the shadow from the light of the foreground, creating both the focal point and the illusion of strong sunlight.

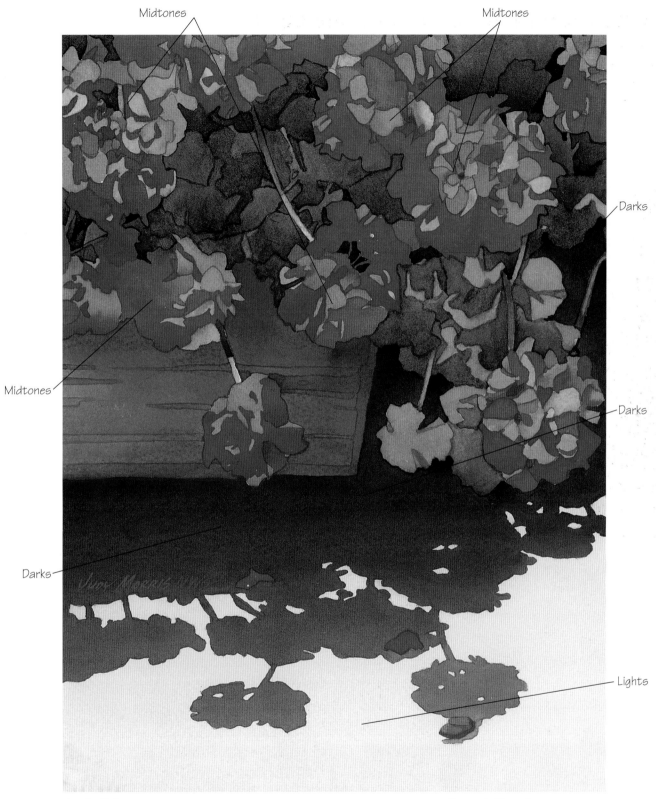

Midtones

Midtones

Darks

Darks

Midtones

Darks

Lights

Apply Color
Editing the photograph and making a value and design plan allow you to place the contrast where it's needed. The dark shadow shape against the light foreground captures the feeling of sunlight.

Jacque's Geraniums
Judy Morris
13½" × 10" (34cm × 25cm)

51

Seeing Light

Finding images to paint is like shopping. Sometimes it's a chore. The fit isn't quite right or the color isn't good. Sometimes you settle for something less than perfect. Sometimes you come home empty-handed. But sometimes you find it! What a feeling of satisfaction that gives! "Seeing" a painting for the first time evokes exactly the same feeling, maybe more so, depending on how much you like to shop. It's the most inspirational part of the painting process. It's like magic! Your mind's eye takes over, and you start painting in your head. The image is etched into your brain, and you have to get it on paper. But what made you see an image in the first place and know it would become a painting? It was probably the light.

What to Look For

How do you see light? Look for light shapes, shadow shapes and contrasts. You might even find them when you're not looking for them. Be prepared to catch that light.

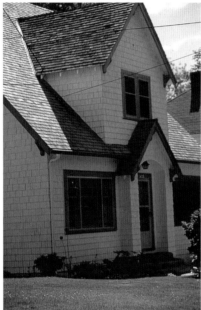

What Was There
This house isn't very noticeable on an ordinary day.

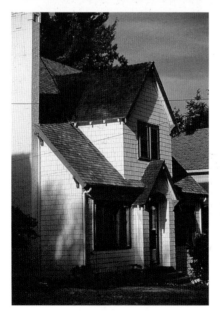

Light Changed It
Early one morning the house was transformed just as the sun was peeking through the trees. Wow!

Changed by the Light
The light changed an ordinary house into simplified shapes of light and dark that could not be ignored.

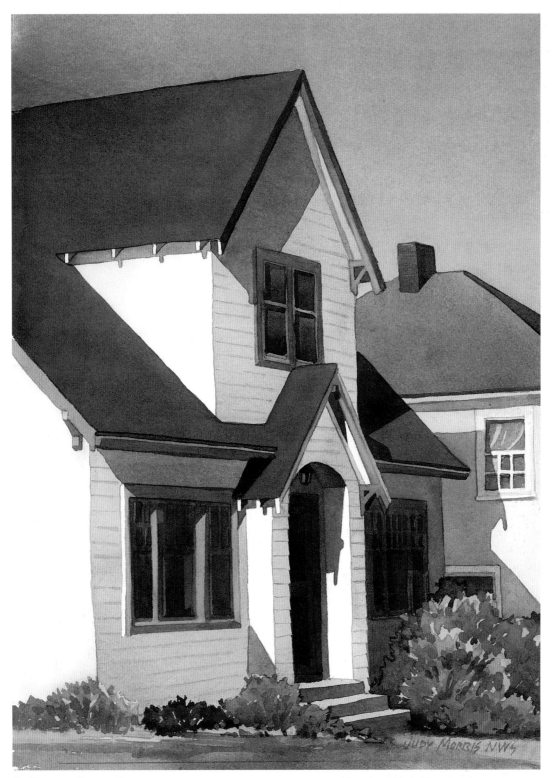

Ordinary to Dramatic
Light can transform an ordinary object into a dramatic object —
don't miss an opportunity for a beautiful painting.

House on Main Street
Judy Morris
16½" × 12" (42cm × 30cm)

Shadows and Time of Day

Light from the sun reveals subjects to paint from sunrise to sunset. Every hour of the day has its own unique light that produces shadows and colors relative to that time. Geographic location, seasons and weather conditions also influence light, but the time of day remains the dominant factor in determining the shape of the shadows. The timing in finding the right light is all-important.

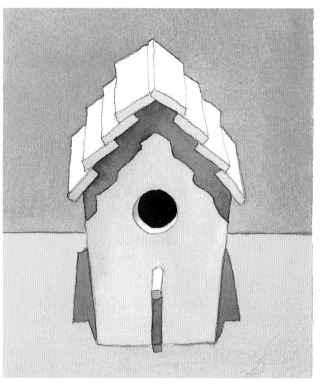

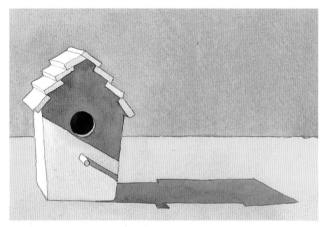

Morning or Evening Shadows

Because the sun is lower in the sky in the early morning and late afternoon, shadows are stretched and become longer and more dramatic at those times. If dramatic shadows appeal to you, search early or late in the day for subjects to paint.

Midday Shadows

Light during the middle of the day is more directly overhead, and midday shadows fall directly under objects. The shadows are smaller but not necessarily less important than shadows found at other times during the day.

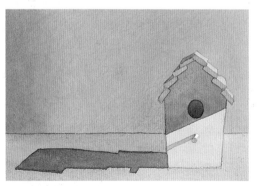
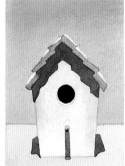

The Color of Light

As the sun moves across the sky from dawn until dusk shadows are not the only aspect of light that changes: The color of light changes in subtle but distinct ways as well. The early light of dawn begins with soft, clear colors ranging from violet to blue-greens. As the hours march on the color of light gets brighter and more harsh until midday, when contrasts are the strongest. Gradually the softness returns with golden grays in the late afternoon. Sunsets may come alive with rich blues and violets and deep crimson.

Perfect Lights

Monet, on a quest for perfect light, once surveyed the countryside, looked at the sun and then at his watch and said, "I'm half an hour late. I'll come back tomorrow."

Painting the Light From the Sky

Every painter knows the importance of the interaction between the permanent features of the land and the ever changing sky. What happens in the sky influences what is put on all paper or canvas. The sky determines not only the flow of light but the colors, textures and values that set the mood of a painting. The variety is practically endless!

Bright, Sunny Skies

Shadows play a major role in conveying the impression of bright sunlight. The more contrast there is between the shadow and the object that causes the shadow, the more intense the sunlight seems. While bright, sunny skies produce strong shadows, they also wash out color. The combination of strong shadows and washed-out color is typical of what happens on bright, sunny days.

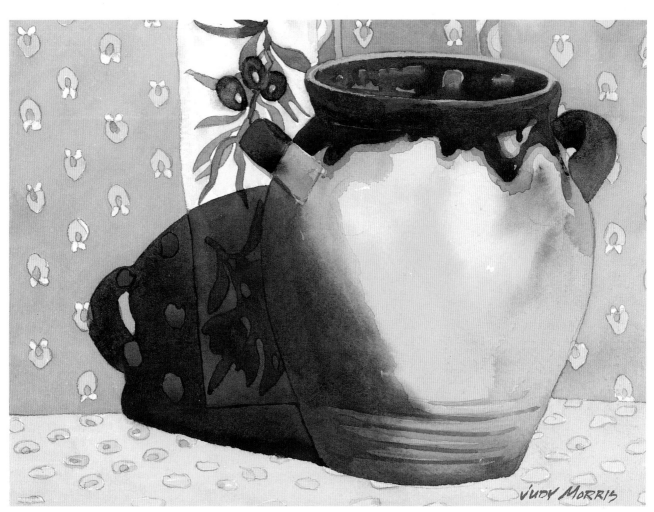

On a Bright, Sunny Day
Shadows are intensified and colors are washed out in bright sunshine. The cast shadow and the shadow that define the shape of the pot are severe. Notice, in the cast shadow, how the detail of the branch of olives is simplified into a single shape. The eye sees contrast more than color.

Pot From Provence I
Judy Morris
9" × 12" (23cm × 30cm)

Overcast Skies

Shadows are diminished or even eliminated under overcast skies, and color becomes the focus in the atmosphere. On a completely overcast day, the natural light levels are relatively low, therefore, color intensifies and becomes brighter.

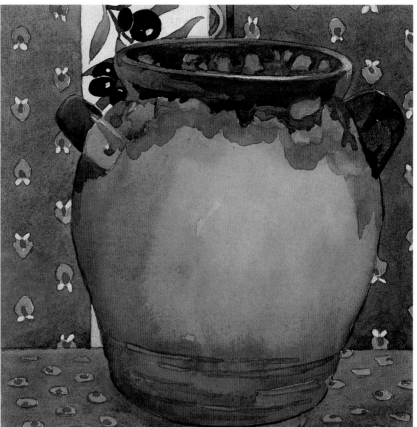

On an Overcast Day
The colors in this demonstration painting are rich, and the shadows are practically eliminated. Underpainting with Burnt Sienna established a richness of color that is typically found on an overcast day.

Pot From Provence II
Judy Morris
9" × 9" (23cm × 23cm)

Cool Underpainting

Warm Underpainting

Combination Underpainting

Underpaint for Rich Color
Use the technique of underpainting to achieve really rich color when you are painting objects under an overcast sky. Use a wash of Cerulean Blue and French Ultramarine if the objects you are painting are cool in color. Use a wash of Burnt Sienna if the objects are warm in color. If you have both warm and cool colors in the same composition, paint the areas accordingly.

Interior Lighting

There are as many painting possibilities inside as there are outside. (There will never be enough time!) The feeling of light, the atmosphere, the mood and the subjects change, but paintings of interiors remain as fascinating as outdoor paintings. People are often included in interior paintings. However, if people are absent in interior paintings, their presence will still be evident. There may be an open book, a window curtain, a piece of furniture, beautiful dishes or even a sink full of dirty dishes. The human touch is obvious in every interior painting.

The kind and quality of light in interior paintings are as varied as those found outdoors. High-key indoor paintings summon light, airy, cheerful and delicate moods, while low-key indoor paintings suggest dreariness, mysteriousness and a sense of melancholy. Light coming from an open window or door brings in cool colors with bluish undertones. Light coming from an interior source, such as a candle, a lamp or the glow from a fire in the fireplace, casts a warmer but dimmer glow.

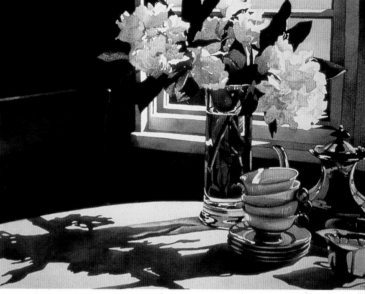

Shadows

The cool, clear light falling on this table came from the east. When strong sunlight, such as in this example, shines into an interior, the biggest bonus is the shadow! This shadow, cast from light falling on the flowers, dishes and silver, is the motive for the painting. Capturing the warm glow in the shadow that reflects the brownish, more neutral colors from the interior of the room makes the shadow even more compelling.

After the Tea
Judy Morris
18" × 24" (46cm × 61cm)

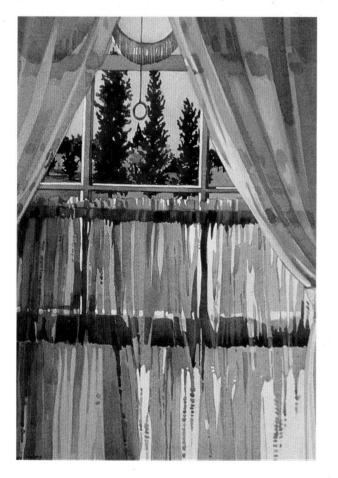

Views

A view through a window or door, with the viewer inside looking out, offers the opportunity to paint an intriguing double image. In this case, the window provides not only a frame for what is happening outside, but the patterns of light and dark suggest sunlight filtering through the curtain, creating a wistful mood. Changes in this scene would occur from day to day, even hour by hour, as the light source outside changes. The mood that light evokes changes as quickly as the light itself.

Country Club Drive
Judy Morris
24" × 18" (61cm × 46cm)

Step-by-Step Demonstration: Painting Lamplight

When there is a single light source, a sense of illumination is best achieved when nearly monochromatic (tints and shades of one color) or analogous (tints and shades of three adjacent colors on the color wheel) color schemes are used. It is important that all the objects in the painting have the same undertone because they are all bathed in the same light. Strong value contrasts accentuate a single light source by directing the eye to the light source.

This small lamp shines a wonderful golden glow on the books and small plant. The subtle reflections on the table surface and the highlights on the edge of the table make the glow from the lamp convincing.

Paper
Arches 300-lb. (640gsm)
 cold-pressed watercolor
 paper

Brushes
1-inch (25mm) flat
no. 6, 8 and 12 rounds

Palette
Cadmium Yellow
Indian Red
Cerulean Blue
Sepia
Burnt Sienna
Carbazole Violet
Winsor Green (Blue Shade)
Winsor Red

Miscellaneous
no. 2 pencil

Step 1: Pencil Sketch

Use a no. 2 pencil to reproduce this image on your watercolor paper.

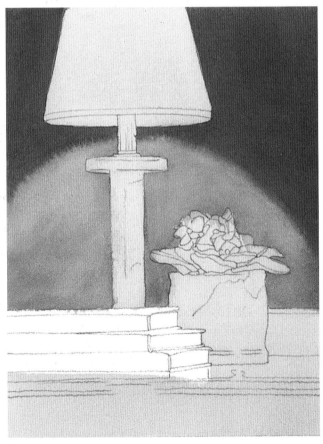

Step 2: Establish Illumination

Use your flat (it covers more area than a round brush) to apply a pale wash of Cadmium Yellow over everything except the books (a Cadmium Yellow wash on the books would lower the intensity of the Winsor Red that will eventually be painted). This wash becomes the light created by the lamp. Let it dry. Use the same brush and apply an Indian Red/Cerulean Blue wash, starting at the top of the paper and stopping when you get to the semicircular line that defines the arc of light. Before this wash dries, use your no. 12 round charged with clear water to run a line of clear water at the bottom edge of the wash. The edge of the wash will soften and form a diffused edge along the arc of light.

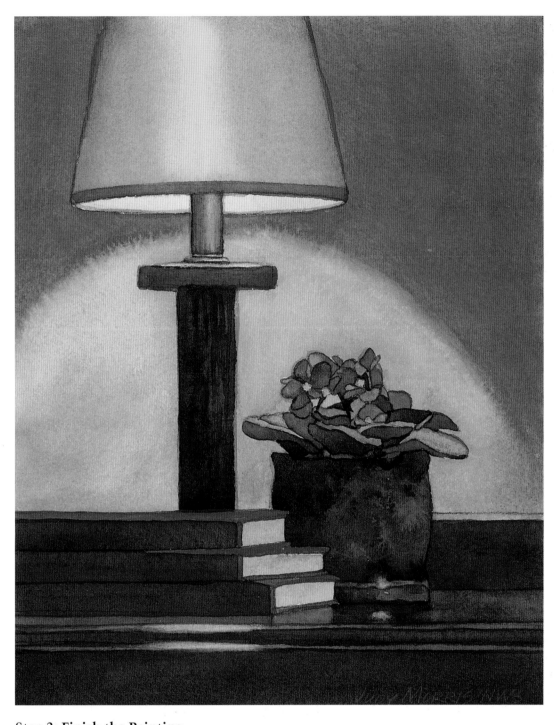

My Violet
Judy Morris
9½" × 7½" (24cm × 19cm)

Step 3: Finish the Painting

Mix Sepia with Cerulean Blue and Burnt Sienna to paint the lamp base, flower container and tabletop with your no. 8 round. Mix Carbazole Violet and Burnt Sienna and paint the flowers with your no. 6 round. Use this same brush to paint the leaves with a mix of Winsor Green (Blue Shade) and Burnt Sienna.

Use pure Winsor Red and paint the parts of the books in direct light. Mix Indian Red and Burnt Sienna with Winsor Red to paint the parts of the books in shadow.

Use the brush-lift technique to make the highlights on the table edge. Use your no. 6 round and run a line of Winsor Red around the lamp, the edge of the violet container and under the lamp shade to soften edges into the background.

59

Step-by-Step Demonstration: Painting Light From Within

Unusual lighting presents many challenges. Solving these challenges comes from careful observation. How is form defined by the unusual light? How does the light influence colors and values? If the unusual light casts shadows, inspect their edges and direction. Feel the mood unusual light creates. Being critical and aware will reveal answers—and the challenge of painting unusual light will be resolved!

Light coming from a lantern presents a special challenge. It is important to capture a diffused glow that does not create shadows.

Paper
Arches 300-1b. (640 gsm)
 cold-pressed watercolor
 paper

Brushes
1-inch (25mm) flat
no. 6, 8, 10 and 12 rounds

Palette
Cerulean Blue
Cadmium Yellow
Winsor Red
Winsor Green (Blue Shade)
French Ultramarine
Burnt Sienna
Yellow Ochre

Miscellaneous
no. 2 pencil

Step 1: Pencil Sketch
Use your pencil to reproduce this image on your watercolor paper.

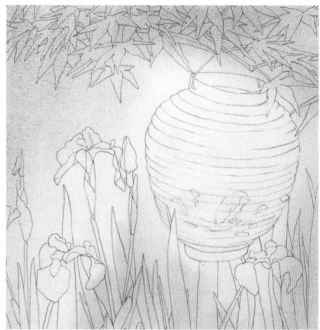

Step 2: Base Wash
Use your flat to apply a wash mixed from Cerulean Blue, Cadmium Yellow and Winsor Red over the entire surface of the paper. Concentrate the Cadmium Yellow in the lantern area, the Cerulean Blue where the leaves are placed, and the Winsor Red below the lantern. Let the wash dry completely.

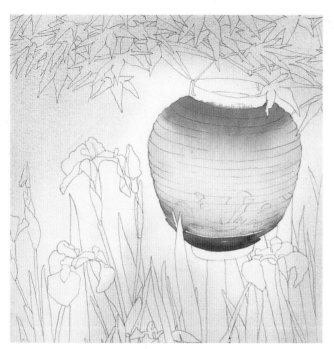

Step 3: Create Lantern Color

Use your no. 12 round to apply a wash of Cadmium Yellow around the edge of the lantern. Gradually blend clear water into the wash toward the middle of the lantern. Touch your brush in Winsor Red and pull it across the top of the lantern, letting the red flow freely into the yellow wash. Use the same brush and paint the two bottom folds of the lantern Winsor Red. Let it dry.

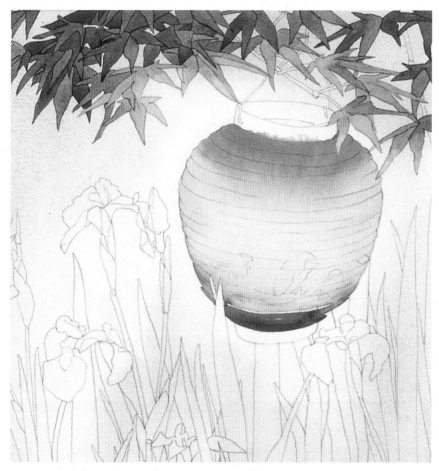

Step 4: Paint the Tree Leaves

Let the underpainting dictate the color of the leaves. Where there are blue undertones, mix blue-greens with Winsor Green (Blue Shade) and Cerulean Blue for lighter leaves; Winsor Green (Blue Shade) and French Ultramarine for darker leaves. Paint yellow-toned greens with a Winsor Green (Blue Shade)/Yellow Ochre mix. Use your no. 6 round for painting the smaller leaves and your no. 8 or no. 10 round for the larger leaves.

Step 5: Paint the Iris Leaves

Using the same colors and techniques you used in step 4, paint the iris leaves.

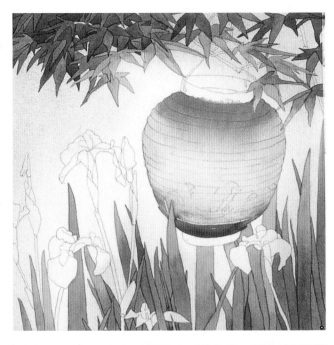

Step 6: Paint the Iris Blossoms

Use your no. 8 round to paint the water iris with tints of Cadmium Yellow. Add clear water for the lighter petals and add more pigment for the darker petals. Add a touch of Winsor Red for color depth in the centers and on some of the edges of the petals. Mix Winsor Green (Blue Shade) with Cadmium Yellow and paint the buds with your no. 8 round.

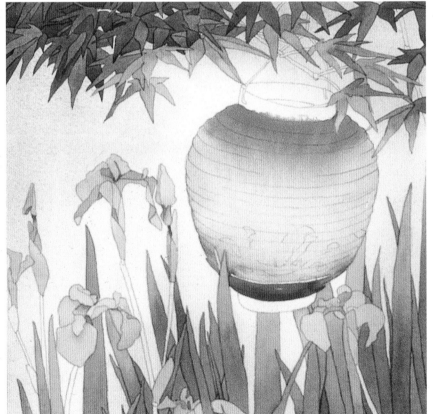

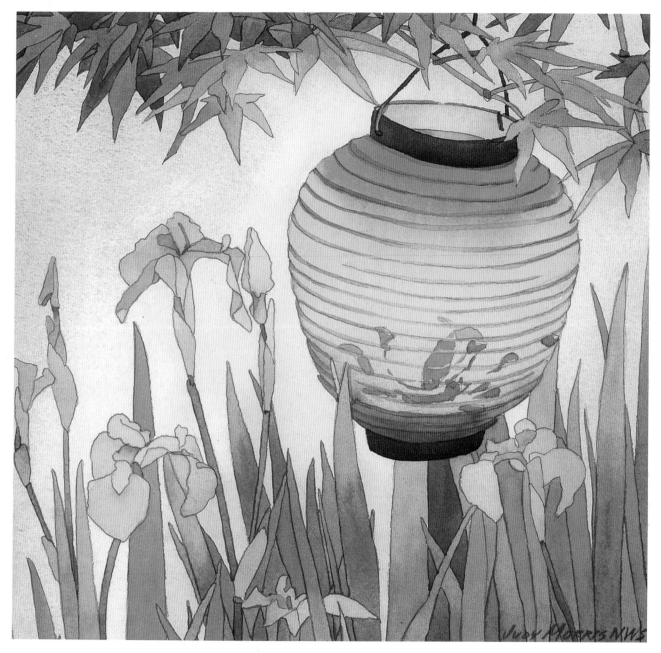

Step 7: Finish the Lantern and Stems

Use your no. 8 round to paint the inside of the top of the lantern Cadmium Yellow and Cadmium Yellow mixed with Winsor Red. Use the same brush and paint the "ribs" of the lantern with a mixture of Cadmium Yellow and Winsor Red. Paint the design on the lantern with the same brush and colors. Mix Winsor Red, Burnt Sienna and French Ultramarine for a dark color and paint the top and bottom of the lantern.

Bring some warmth to the top of the composition by using your no. 6 round to paint the stems in the trees with Burnt Sienna. Add French Ultramarine to the Burnt Sienna and paint the wire the lantern is hanging from. Mix Burnt Sienna, Winsor Green (Blue Shade) and French Ultramarine and paint the iris stems with the same brush.

The last adjustment is to strengthen the design by painting the empty space directly below the lantern a dark green. Mix Winsor Green (Blue Shade), Cerulean Blue and Burnt Sienna to make the correct color and fill in that space with your no. 8 round. Your lantern glows with soft, interior light!

Patio Spirit
Judy Morris
13" × 13"
(33cm × 33cm)

WHAT IS COLOR?

Color is a sensation we experience when our eyes are struck by light waves of varying lengths. Like music, color is a vibratory phenomenon. Violet, at one end of the spectrum, has a very short wavelength (number of vibrations per second); in musical terms it might be compared to a high screech. Red, with the longest wavelength, is analogous to a deep note on a bassoon.

Sunlight, or white light, contains a balanced mixture of all wavelengths of the visible spectrum. Isaac Newton first discovered the nature of light when he used a prism to divide different groups of color waves. You see this same phenomenon in the colors of a rainbow or in streaks of color glinting through crystal.

In chapter one, the topic of color was introduced; now you will have a chance to make a color wheel and to become more familiar with the attributes of pigment and color.

Sun Worshippers
Jan Kunz
22" × 30" (56cm × 76cm)

What Is Pigment?

Colored objects contain *pigment,* which absorbs certain rays of color and reflects others. A banana is yellow because pigment in the banana's skin reflects yellow rays and absorbs all the other colors. A red apple reflects only red rays and absorbs all the others, and so on.

Our paints today are made from minerals and animal products which are especially rich in pigments. Manufacturers carefully select and purify these materials to ensure their permanence. French Ultramarine was originally made by grinding lapis lazuli, a semiprecious stone, and then purifying it. Today French Ultramarine is produced synthetically. Permanent Sap Green is made from the juice of iris flowers; and Sepia, a dark brown-black color, is made from the ink sacs of cuttlefish. Watercolor pigments have remained brilliant for centuries. When we paint we use purified pigments that reflect the color waves we want to use and absorb all the others.

All artwork on pages 64 through 97 was created by Jan Kunz.

The yellow apple appears yellow because it contains pigments that reflect yellow light and absorb the rest of the light.

Step-by-Step Demonstration: Make a Color Wheel

Hue is the term used to name a color. It has nothing to do with whether the color is light or dark, strong or weak. Yellow, red and blue are three different hues. We can also identify variations of hues within a single basic color, such as yellow-green or yellow-orange.

A good way to understand how colors relate to one another is to make a color wheel. Every hue has a special place on the color wheel. Hues located close to one another are harmonious because they each contain some of the same color. Hues separated from one another are less closely related, and those located on the opposite sides of the color wheel (complementary colors) have nothing in common. When colors opposite one another are mixed together, they form a neutral gray.

The primary colors are red, yellow and blue. We call these *primary hues* because they cannot be made from the combination of any other pigments. The secondary colors are orange, mixed from red and yellow; green, mixed from blue and yellow; and purple, made by mixing blue and red. All of the other colors are combinations of the primary and secondary colors.

On the following pages is an exercise in making a color wheel. It's to your advantage to take the time to make one and become familiar with watercolor pigment and color mixing.

Reasons to Make a Color Wheel

1. Familiarize yourself with the mechanical layout of the color wheel.
2. Gain a clear understanding of how hues on the color wheel relate to pigments on your palette.
3. Learn how to mix hues you don't have.
4. Locate and understand the concept of complementary colors.
5. Gain practice in brush control.

Paper
a good quality watercolor paper

Brushes
no. 8 or 10 round (or your favorite brush)

Palette
Permanent Alizarin Crimson
French Ultramarine
Cadmium Orange
Cadmium Red
Cadmium Yellow
Hooker's Green
Cobalt Blue

A color wheel consists of twelve equal spaces with one directly at the top and one at the bottom. Make your drawing on good watercolor paper. You'll want to refer to this wheel often, so be aware that the paper you use greatly affects the color and quality of your work.

Draw your own wheel, or trace the one you see here. Before painting any section, be sure the paper is dry; this prevents colors from running together. Use a blow-dryer to speed up drying, but hold it back far enough so the surface dries evenly.

Use just enough water so the pigment flows on smoothly and is not pasty. If necessary, move your paper around for easy access to the areas you are painting.

Your color wheel should consist of twelve equal spaces with one directly at the top and one at the bottom.

Step 1: Paint the Primary Colors

Use a clean brush and clear water to thoroughly dissolve Cadmium Yellow (A), then paint the top wedge shape. Be careful to stay inside the lines, and fill in the area until it is at its most brilliant. Next, leave three spaces blank, and put Cadmium Red (B) in the fourth space on the left. Finally, paint Cobalt Blue (C) in the fourth space down from the yellow on the right side of the color wheel.

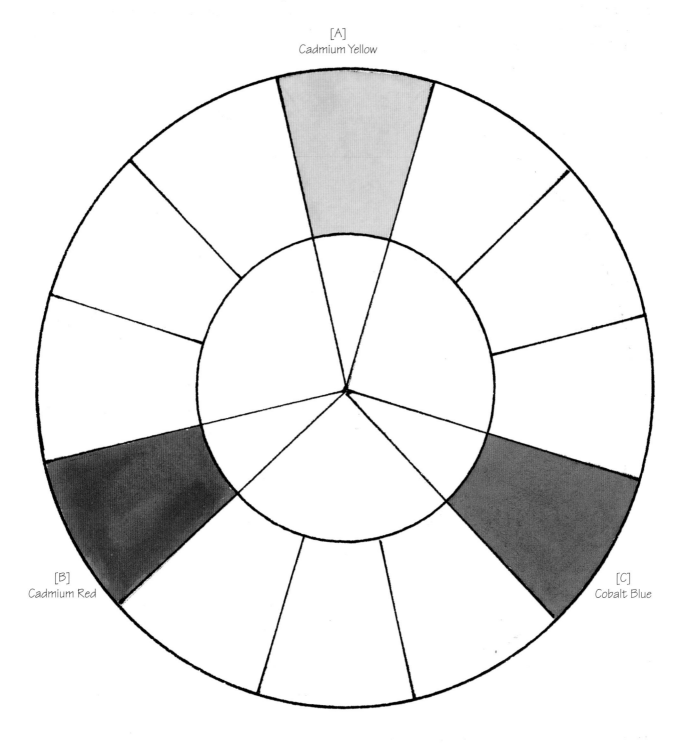

[A]
Cadmium Yellow

[B]
Cadmium Red

[C]
Cobalt Blue

Primary Colors

Step 2: Paint the Secondary Colors

Orange
Orange is the combination of yellow and red. It belongs in the center space between these two colors, leaving a space on either side. You can create orange by painting Cadmium Yellow into the space and adding Cadmium Red. Mixing on the paper is one of the most important practices in watercolor painting because it gives the most brilliant results.

Green
You have two choices for the center space between yellow and blue. Paint a small square of Cobalt Blue on a scrap of watercolor paper. Before it dries add Cadmium Yellow, and study the result. You'll notice the color is rather gray, so instead of mixing your own green, use Hooker's Green to fill this space. Hooker's Green is brilliant and capable of producing dark values.

Violet
The last secondary color is violet. It's a combination of blue and red and belongs in the center position at the bottom of the color wheel. This time, try painting Cadmium Red onto a scrap of watercolor paper, then add Cobalt Blue. Try the same experiment using French Ultramarine and Permanent Alizarin Crimson (you can begin with either one). The second combination results in a more beautiful violet. Dry the colors thoroughly.

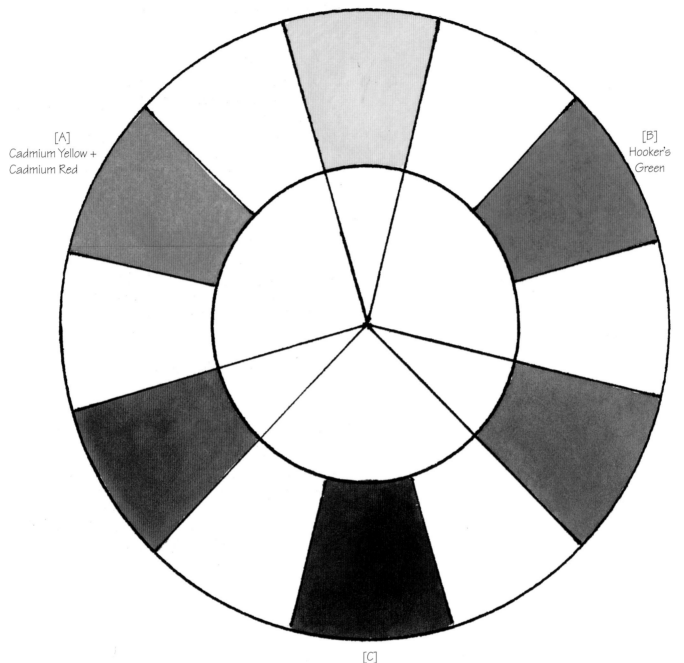

[A]
Cadmium Yellow +
Cadmium Red

[B]
Hooker's
Green

[C]
French Ultramarine +
Permanent Alizarin
Crimson (equal parts)

Secondary Colors

Step 3: Paint the Tertiary Colors

Tertiary colors are made by mixing a secondary color with a primary color. These colors are next to each other on the color wheel and are closely related. They are called analogous colors.

Yellow-Orange

In the space between yellow and orange, paint Cadmium Orange onto the paper then add Cadmium Yellow. Keep adjusting the colors one at a time until you arrive at a mixture halfway between yellow and orange.

Red-Orange

After that section dries, use the same method to fill in the space between Cadmium Orange and Cadmium Red using a combination of these two colors.

Yellow-Green

Now let's go to the right side of the yellow space and mix yellow-green. Put Cadmium Yellow onto the paper and add Hooker's Green. The yellow-green should be halfway between the two adjacent colors.

Blue-Green

Blue-green lies between green and blue. The color should be more toward blue. Paint Cobalt Blue on the paper and add Hooker's Green.

Red-Violet and Blue-Violet

Violet is a mixture of Permanent Alizarin Crimson and French Ultramarine, so use the same two pigments to mix red-violet and blue-violet. In the space between red and violet, paint Permanent Alizarin Crimson and add a small quantity of French Ultramarine. Fill in the space on the other side of violet with blue-violet, made by painting French Ultramarine on the paper and adding a small quantity of Permanent Alizarin Crimson.

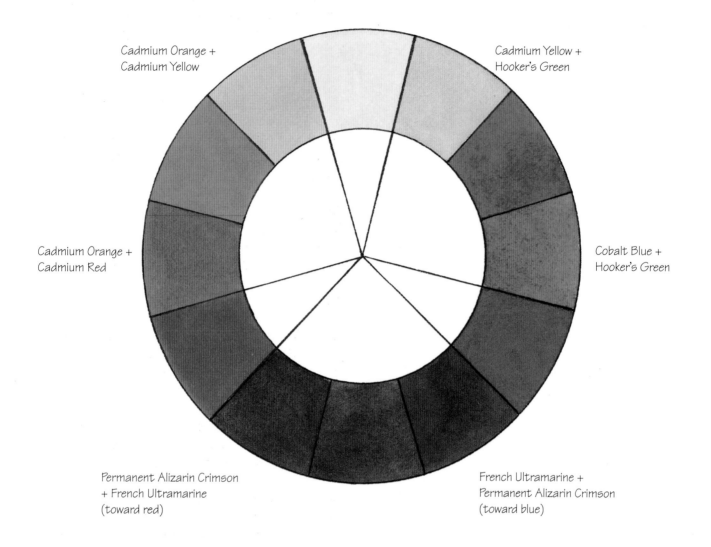

Cadmium Orange +
Cadmium Yellow

Cadmium Yellow +
Hooker's Green

Cadmium Orange +
Cadmium Red

Cobalt Blue +
Hooker's Green

Permanent Alizarin Crimson
+ French Ultramarine
(toward red)

French Ultramarine +
Permanent Alizarin Crimson
(toward blue)

Tertiary colors complete the color wheel. When your color
wheel is finished it should look like this. The color wheel is
an important tool, and we'll be using it a great deal.

Temperature: Warm and Cool Colors

When artists speak of warm and cool colors, they are talking about qualities of hue. We associate red, orange and yellow with fire and warmth. Ice has a bluish cast, and cold water can be green or blue. These associations account for our emotional responses to all colors.

Colors between these warm and cool extremes seem neither very warm nor very cool, and the temperature differences become subtle. We sense that a green hue appearing more yellow is warmer than green that seems more toward blue, so we speak of warm greens and cool greens. Generally, any hue is warmed by the addition of yellow and cooled by the addition of blue.

Warm

Cool

74

Warm

Cool

Warm

Cool

Warm and Cool Colors

If you divide the color wheel in half between yellow-green at the top and red-violet at the bottom, you'll see the hues on the left side are warmer in color temperature than those on the right. Also notice that colors on either side become cooler as they approach the bottom of the wheel.

Warm Version

Cool Version

Cadmium Yellow

Raw Sienna

Cadmium Red

Permanent Sap Green

Cadmium Yellow + Cobalt Blue

Permanent Alizarin Crimson

Burnt Sienna

Hooker's Green

Same Hue, Different Temperatures

It's possible to buy warm and cool versions of the same hue. Cadmium Red is warmer in color temperature than Permanent Alizarin Crimson. Permanent Sap Green is warmer than Hooker's Green, and Winsor Green (Blue Shade) is cooler still. Here are warm and cool versions of the same painting.

Value

The word *value* (see page 30) refers only to the lightness or darkness of a color. For an artist, value is by far the most important dimension of color. It's impossible to overemphasize this simple fact. Once you understand value, you're three-quarters of the way to becoming a good painter. Mistakes made in hue or intensity are far less serious than errors in value.

Value Relationships

Keep in mind that whether you are outdoors or in the studio, the same value relationships that exist on one object will be seen on all other objects. This rule only fails if there are mirrorlike reflections or reflected light on the shadow side. But for now, it's better to maintain consistency rather than interpret slight differences in shading. All things being equal, the cast shadow is slightly darker than the shaded side.

Sunlit and Shadow Sides

There's another value rule so unchanging that it can almost be called a law of light: When a white box is held against the sky, the side in direct sunlight is lighter than the blue sky and the shaded side is darker than the sky. If you intend to paint a house or any architectural structure, it's important to establish the value relationship between the sunlit side and the shadow side. Once this is done, it's the key to the other value relationships.

Value Scale

It's obvious you need some means of measurement in order to arrive at consistent value relationships in your painting. This isn't as difficult as you may think. The average human eye sees about eleven distinct variations in value, including black and white. You can construct a value scale or chart with off-white (the value of your paper) at 1 and black at 10. By comparing the values in your paintings with this chart you can ensure consistent value relationships. Some artists consider their value scales as important as their brushes!

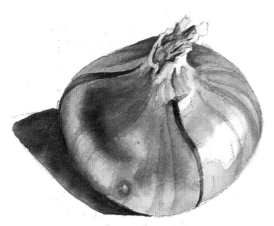

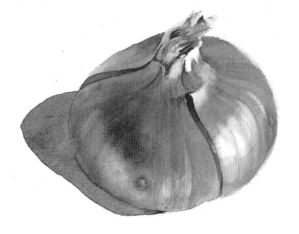

An Example of Value
These onions demonstrate what is meant by value. The onion on the left is colorless and contains only values. The brown onion on the right contains all the properties of color: hue, value and intensity.

Make a Value Scale

Paint Graded-Value Strips

You'll need several scraps of watercolor paper for this project. Use Payne's Gray or black pigment to paint the first piece of paper as dark as you can make it. Add water to the pigment and paint another scrap a bit lighter. Continue this process, making each swatch of gray lighter and lighter until the last scrap of paper is barely tinted. Be sure the paint is dry before you make your selections, because watercolor pigments dry lighter than they first appear. You may need to add more color to paint new pieces. Don't be satisfied until you have evenly graded values of gray.

Assemble the Strips

Trim your selections and mount them on a stout piece of card or hinge them at the top so they fan out and the values flow smoothly from light to dark. Mark each strip with the proper number, starting with 1 for white and ending with 10 for black.

Here's a photo of Jan Kunz' value scale. She considers this value scale as important a tool as her brushes.

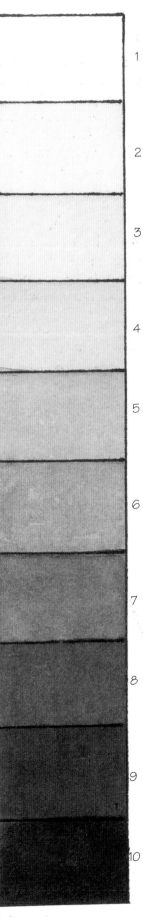

Value Scale

Determine the Value of a Hue

Now it's time to relate the hues on the color wheel to your value scale. Squint your eyes until they are almost closed, then move your value scale around the color wheel until you find a place where it's almost impossible to distinguish between the color and the gray scale. Mark that color with the number on your value scale to identify the darkest value of that particular pigment. Even though some colors, such as yellow and orange, are at their most intense, they're very light in value. We speak of these colors as having a short value range. On the other hand, Permanent Alizarin Crimson has a long value range. Keep practicing until you can easily determine the value of a hue. If you're having trouble, it's probably because you're not squinting hard enough.

Value Range
Value range refers to the number of values you can mix between the darkest value, straight from the tube, and the lightest value when mixed with water. Notice that the color becomes more intense as the value increases.

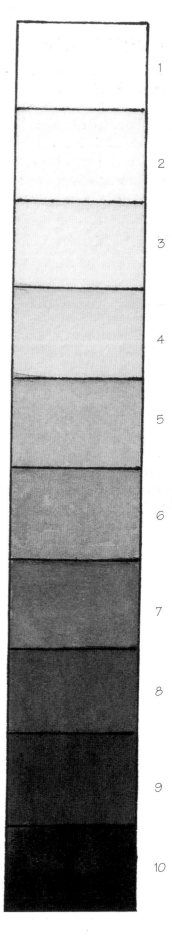

A Color Wheel is a Helpful Tool

Don't worry if the value numbers on your color wheel aren't the same as those shown here. The pigment brand and the amount of water used make a difference. The point is you'll have a starting place to judge the values of the pigments in your palette and on your paintings.

Intensity

Intensity refers to a color's strength, purity or saturation. We've all observed intensity changes in familiar-colored objects: a colored shirt fading with repeated washings, colors in the distance appearing less intense than colors at hand, brilliantly colored leaves of autumn gradually turning gray-brown before falling to the ground.

Most colors are at their maximum intensity right out of the tube, but you'll seldom use colors in their pure state. There are several ways to change the intensity of watercolor pigments. The intensity of any pure color is diminished by mixing it with it's complement (across the color wheel) or by adding black.

Tip
The sky is not pure blue, nor is a grassy field pure green. The colors we see surrounding us are full of subtle grays. As you progress in painting, you'll discover that no matter what the subject, the intensity of most colors will have to be adjusted.

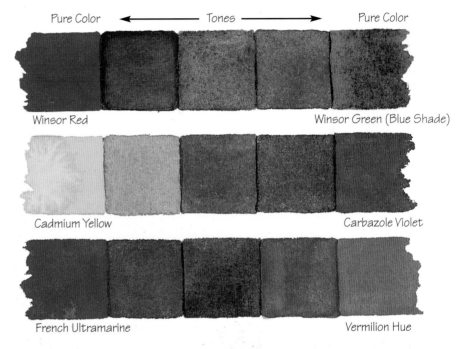

Pure Color ← Tones → Pure Color

Winsor Red — Winsor Green (Blue Shade)

Cadmium Yellow — Carbazole Violet

French Ultramarine — Vermilion Hue

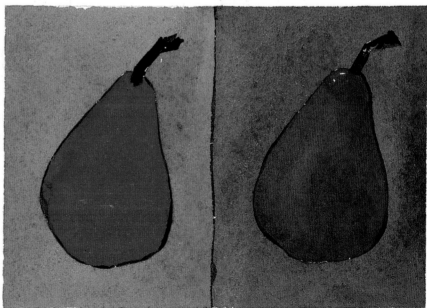

High Intensity — Low Intensity

Squint Your Eyes
The intensity of color in the strips here was reduced by the addition of black. Squint your eyes and notice that the value remains similar throughout the entire length of the bar. Only the intensity of the color was changed.

Exercise
Discover Grays by Mixing Colors

Paint a swatch of red onto a clean piece of watercolor paper. Immediately add water around the edges of the puddle to reduce it's concentration. Add other colors one at a time, varying the intensity with the addition of water or by adding complementary colors. Notice the variety of beautiful grays you've made. Continue experimenting, and make note of the combinations you like for future use.

Alizarin Crimson

New Gamboge

Raw Sienna

Cobalt Blue

Rose Madder Genuine

Burnt Sienna

Winsor Green (Blue Shade)

Winsor Blue (Green Shade)

Cadmium Red

Tip
As you continue to paint in watercolor you'll discover the trick is in the amount of water you use. The only way to get it right is to practice. Don't get discouraged; just keep trying. Every painter has to learn for himself, and you can do it!

Beautiful Grays

Grays or neutrals are created by combining colors from opposite sides of the color wheel. On the previous page, you saw how beautiful grays can be created by laying complementary colors next to one another and allowing them to blend on the paper.

An otherwise dull gray passage can be made more interesting by letting the pigments mix on the paper and/or by charging various colors into the wet surface. The first watercolor sketch here (A) was painted with Cobalt Blue and Raw Sienna mixed in the palette. In the next example (B), Cobalt Blue was painted onto the paper, and Raw Sienna was immediately added so the pigments could blend on the paper. In the last example (C), Cobalt Blue and Raw Sienna were mixed on the paper and then Burnt Sienna and Rose Madder Genuine were charged in one at a time while the surface was still wet. It's important to give life to whatever color you use by making it "move." Avoid painting a solid color and value from side to side or up and down in any large area.

A B C

Brilliant Dark Values

Long-range pigments such as Permanent Alizarin Crimson or Winsor Blue (Green Shade) contain no black and are capable of brilliant dark value. The question: How can we mix a brilliant dark value of a color with a short value range? The answer: Combine it with a long-range transparent color from the same side of the color wheel. By combining related (or analogous) hues, you arrive at brilliant dark values. Renoir, Monet and other Impressionists who sought to convey the feeling of sunlight in their paintings often employed this technique to achieve brilliant dark values.

Mud

Mud happens! If you combine dark values of Burnt Sienna and French Ultramarine, the resulting color can be muddy. Whenever you mix color opposites in dark values, you run the risk of creating mud!

Burnt Sienna

French Ultramarine

Complementary mixes go flat in dark values.

Tip

It doesn't take long for colors in the center of your palette to run together and create some pretty interesting—or yucky—grays. Keep your palette and pigments clean, and you'll be sure your colors aren't contaminated or grayed.

Color Proportion

Color can be used in good taste or it can be abused. Even though all the hues in the color wheel are available for use, the experienced artist uses fewer hues but takes advantage of the color differences they can create by varying intensity and value. For instance, green can be varied to produce turquoise or grayed to become green-brown. Decorators use this same theory when planning a comfortable living space. Quiet background hues are used to set off sparkling accents of brilliant color. The same principle applies to paintings. Artists must be careful not to use several intense colors in same-sized areas.

On the left, all four swatches of color are of equal importance. The red becomes more dominant when the adjacent colors are subdued.

In this photograph, the number and variety of brilliant colors diminish the importance of the central figures.

Reducing the background area and graying the color cause the children in this painting to become the center of attention.

Limited Palette

For a painter, the word *palette* has two meanings: the tray on which pigments are mixed and, more importantly, the group of colors artists use in paintings. A limited palette (or a set palette) means the artist has used only a select number of pigments to complete her painting. Study the paintings you really enjoy—you may be surprised at the limited range of hues the artists used.

The best way to gain confidence and become familiar with your palette is by mixing color. Use a scrap of watercolor paper and vary the amount of water and pigments with each mixture. Start with one pigment and add others one at a time, letting the colors blend on the paper. Be sure to identify the combinations you like best so you can repeat them. By combining complementary pigments in light values, you can create a variety of beautiful grays.

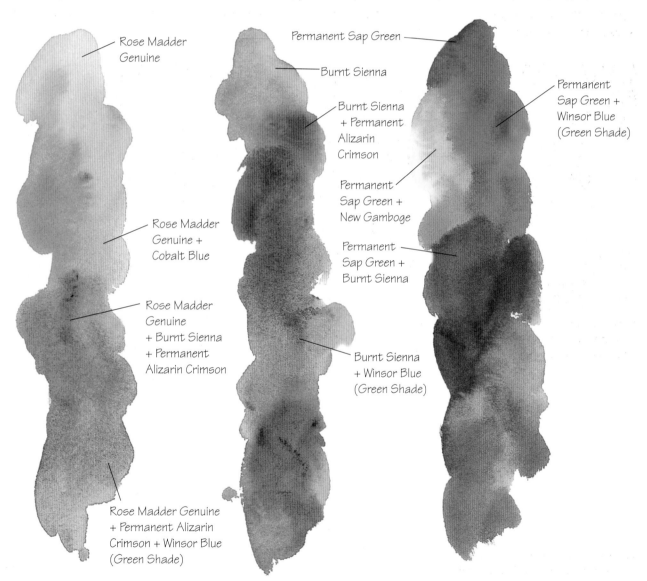

Rose Madder Genuine

Rose Madder Genuine + Cobalt Blue

Rose Madder Genuine + Burnt Sienna + Permanent Alizarin Crimson

Rose Madder Genuine + Permanent Alizarin Crimson + Winsor Blue (Green Shade)

Permanent Sap Green

Burnt Sienna

Burnt Sienna + Permanent Alizarin Crimson

Permanent Sap Green + New Gamboge

Permanent Sap Green + Burnt Sienna

Burnt Sienna + Winsor Blue (Green Shade)

Permanent Sap Green + Winsor Blue (Green Shade)

Become Familiar with Your Palette
The only way to become familiar with your palette is by mixing colors. Work on a scrap of good watercolor paper then be sure to note the combinations you like best.

Seeing Color

We know a pond mirrors the sky, but so does every other object exposed to the sky. Let's try an experiment so you can see this for yourself. Try this in morning or late-afternoon light (the brilliant midday sun makes subtle shadows less obvious).

Place a white box outdoors on a piece of solid-colored fabric or paper. Arrange it so one side faces the sunlight and the cast shadow falls across the colored surface. Notice how the top of the box reflects the sky and is bluer than the vertical side facing the sun. The vertical side facing the sun appears warmer in color temperature (more toward yellow). The side turned from the sun also reflects the sky and is cool in color temperature.

Now look at the shadow side. This side is not only 40 percent darker than the sunlit side, it also receives reflected light from the colored surface underneath or from adjacent objects that are in direct sunlight.

The shadow cast by the box is the same hue as what it's cast upon and is somewhat more than 40 percent darker than the sunlit surrounding area. You won't see reflected light in a cast shadow.

At the bottom of the box, you'll see a small, dark line or crevice. These "underneath" darks are warm because they aren't influenced by the sky.

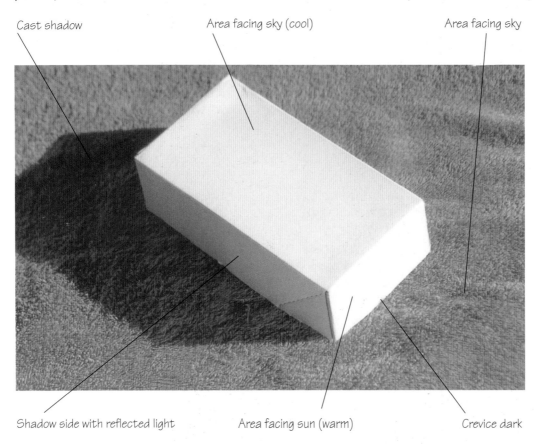

Cast shadow

Area facing sky (cool)

Area facing sky

Shadow side with reflected light

Area facing sun (warm)

Crevice dark

Tip
On a sunny day, subtle differences in color and color temperature appear everywhere in nature. An artist can make a petal appear to bend and a table appear to lie flat by making use of these subtle color temperature differences.

Translucent Light

An additional aspect of color and light is translucent light. This is especially noticeable in flower petals. Light penetrates the petals of a flower or a leaf and affects the color and value. In general, the light penetrating a petal warms the color temperature. The value is also affected. The key is careful observation.

Study the light on the peony in the photo on this page. Notice that where light penetrates only one petal, its value is lighter and somewhat warmer than where several petals are involved.

Tip

Since objects in sunlight often have reflected light on their shadow sides, artists are free to add reflected light to objects in paintings whether it's there in the actual subject or not.

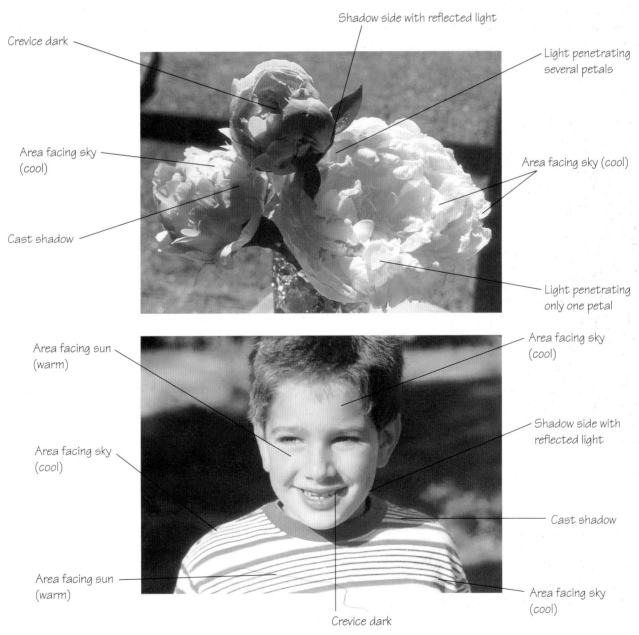

Shadow side with reflected light

Crevice dark

Light penetrating several petals

Area facing sky (cool)

Area facing sky (cool)

Cast shadow

Light penetrating only one petal

Area facing sun (warm)

Area facing sky (cool)

Area facing sky (cool)

Shadow side with reflected light

Area facing sun (warm)

Cast shadow

Crevice dark

Area facing sky (cool)

Step-by-Step Demonstration: Intense and Grayed Colors

In this project you'll learn how pure, intense pigment can be modified with the addition of other colors.

You will also learn the three dimensions of color:
1. Hue: the name of the color (blue, green, yellow, etc.)
2. Value: the lightness or darkness of a color
3. Intensity: the strength or purity of a color

Understanding and recognizing these three dimensions of color and learning the language of art helps to provide a foundation that will enable you to quickly and effectively create the color effects you want.

Brushes
no. 8 or 10 round (or your
 favorite brush)

Palette
New Gamboge
Rose Madder Genuine
Phthalo or Winsor Green
 (Blue Shade)
Cobalt Blue

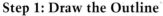

Step 1: Draw the Outline
Draw the outline of the jug onto a piece of water-color paper.

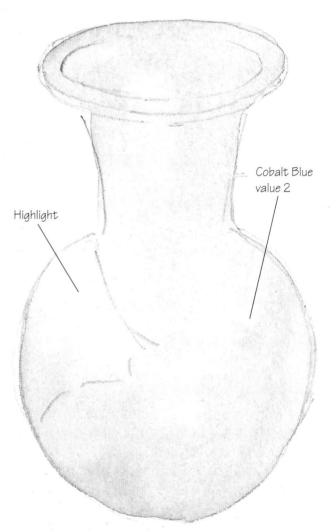

Highlight

Cobalt Blue
value 2

Step 2: First Wash and Highlight
Wet the entire surface of the jug with clear water and then add Cobalt Blue. Rinse your brush and squeeze out the water. Now use the brush to lift out a highlight on the left side of the jug. Allow the paint to dry before you continue.

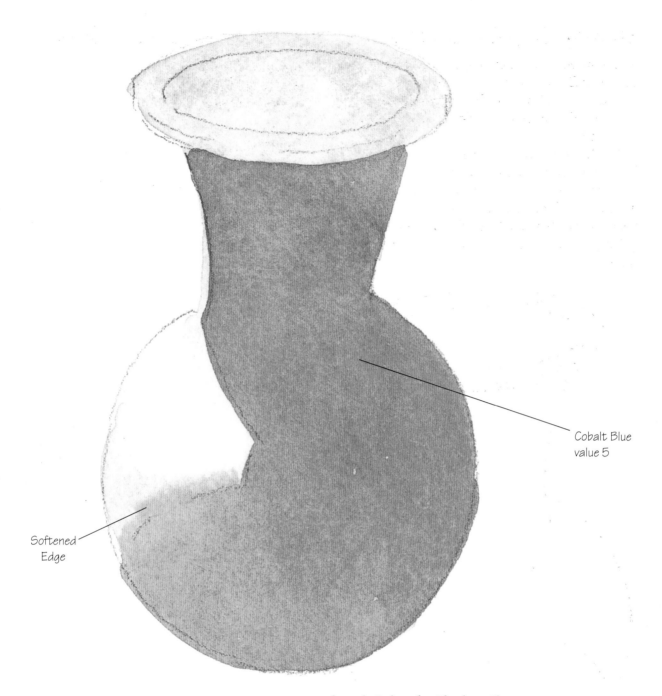

Cobalt Blue
value 5

Softened
Edge

Read These Instructions Before You Continue
Steps 3 and 4 must be done in rapid succession while the paper is still wet, so have all your paints ready before you begin. The basic color is Cobalt Blue, but have Winsor Green (Blue Shade) or Phthalo Green, New Gamboge and Rose Madder Genuine moistened and ready for use. Alter the intensity of Cobalt Blue by *charging in* the other colors. *Charging in* a color means to add colors into specific areas while the paper is still wet.

Step 3: Paint the Shadow Shape
Paint the shadow shape on the body of the jug with pure Cobalt Blue. This color can be at its maximum intensity. Work quickly using plenty of water. Immediately soften the edge along the rounded surface of the jug. Do this by using a slightly damp brush and running it along the edge you want to soften. It's best to work from the dry side.

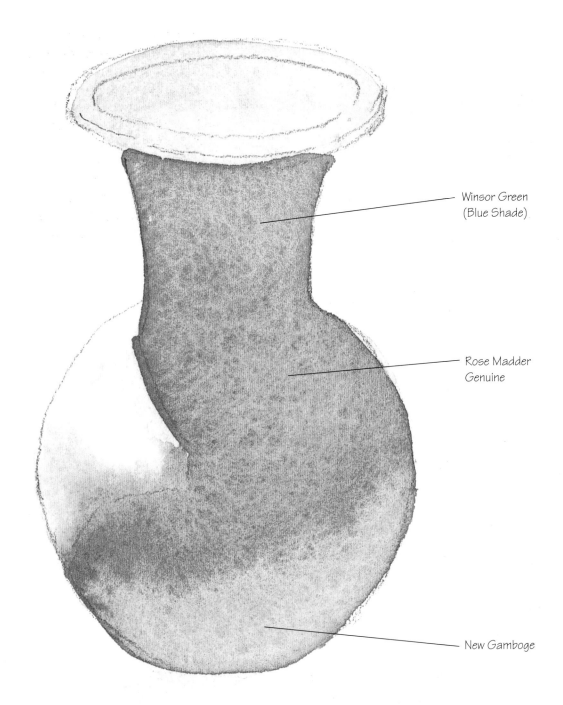

Winsor Green
(Blue Shade)

Rose Madder
Genuine

New Gamboge

Step 4: Add More Color

While the paint is still wet, dip a clean brush into
Winsor Green (Blue Shade) and add this color into
the neck of the jug. Clean your brush again and add
New Gamboge across the bottom. Then add a clean
stroke of Rose Madder Genuine just where the jug
bulges out from the neck. Let this dry before you
continue.

Tip

If the blue color has begun
to dry, stop and wait until
the surface is entirely dry
before you add more color.
Then re-wet the area with
clear water and add the col-
ors one at a time.

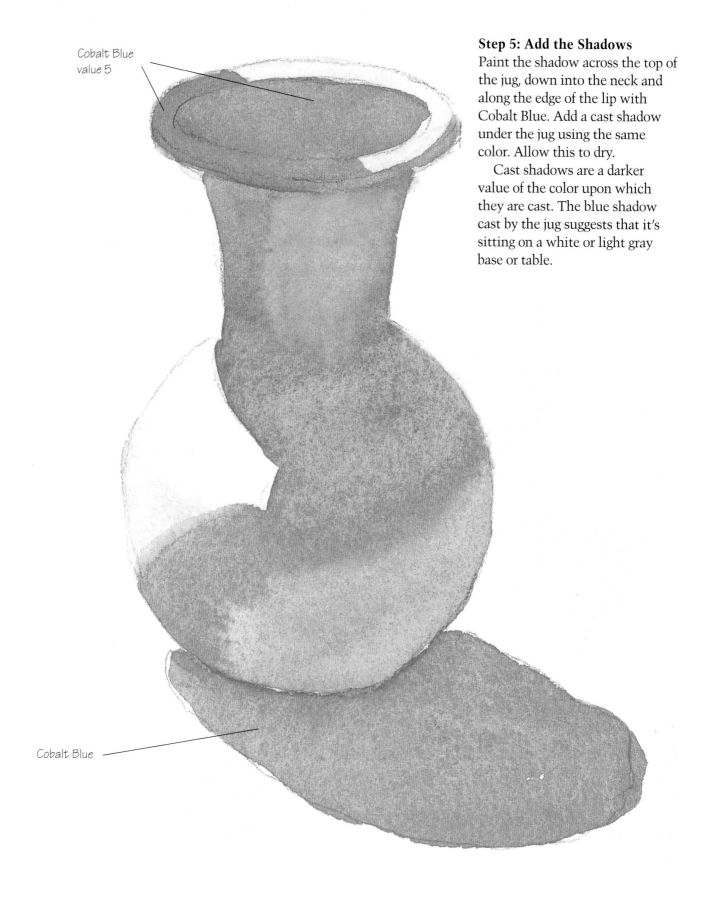

Cobalt Blue
value 5

Cobalt Blue

Step 5: Add the Shadows

Paint the shadow across the top of the jug, down into the neck and along the edge of the lip with Cobalt Blue. Add a cast shadow under the jug using the same color. Allow this to dry.

Cast shadows are a darker value of the color upon which they are cast. The blue shadow cast by the jug suggests that it's sitting on a white or light gray base or table.

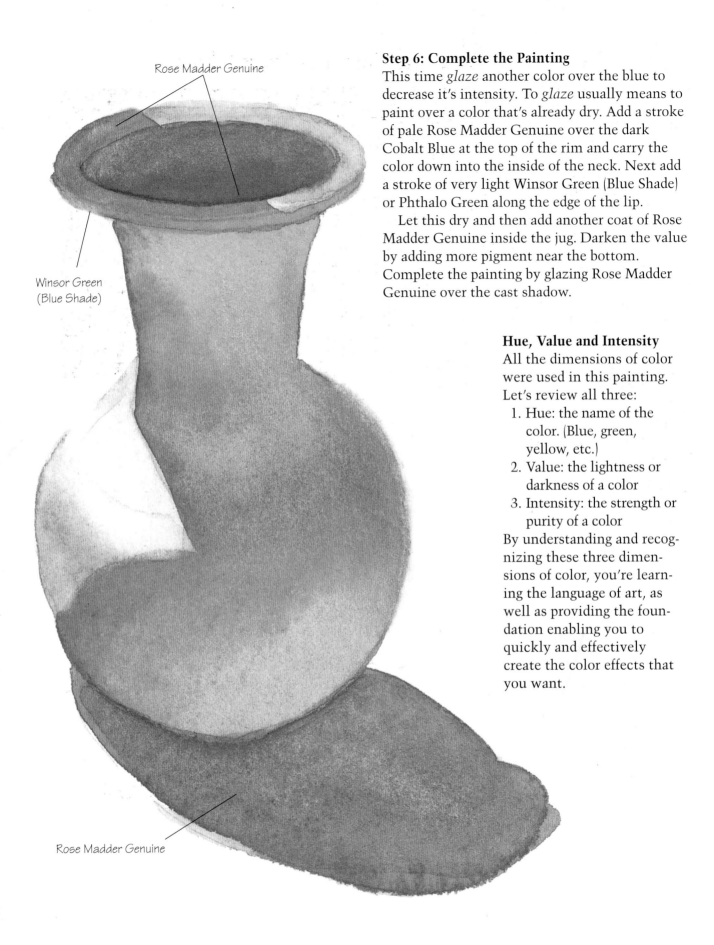

Rose Madder Genuine

Winsor Green
(Blue Shade)

Rose Madder Genuine

Step 6: Complete the Painting

This time *glaze* another color over the blue to decrease it's intensity. To *glaze* usually means to paint over a color that's already dry. Add a stroke of pale Rose Madder Genuine over the dark Cobalt Blue at the top of the rim and carry the color down into the inside of the neck. Next add a stroke of very light Winsor Green (Blue Shade) or Phthalo Green along the edge of the lip.

Let this dry and then add another coat of Rose Madder Genuine inside the jug. Darken the value by adding more pigment near the bottom. Complete the painting by glazing Rose Madder Genuine over the cast shadow.

Hue, Value and Intensity

All the dimensions of color were used in this painting. Let's review all three:

1. Hue: the name of the color. (Blue, green, yellow, etc.)
2. Value: the lightness or darkness of a color
3. Intensity: the strength or purity of a color

By understanding and recognizing these three dimensions of color, you're learning the language of art, as well as providing the foundation enabling you to quickly and effectively create the color effects that you want.

Step-by-Step Demonstration: Painting Dark Objects

Painting very dark objects can present a problem. Unless care is taken, dark colors often go flat. To avoid this, typically artists raise the value and brighten the intensity of the sunlit side of the object.

The subject here is a dark red rose; there's no other dark object that offers so interesting a challenge. The petals of the rose here are red on one side and white on the other. It has been sketched at a slightly different angle so we can compare the value differences of the white and red surfaces in shadow.

Reference photo

Brushes

no. 8 or 10 round (or your favorite brush)

Palette

Rose Madder Genuine
Cadmium Orange
Cobalt Blue
Burnt Sienna
Permanent Alizarin Crimson
French Ultramarine
Burnt Umber

Sketch of rose

Step 1: First Wash
Paint all but the white areas of the rose with a wash of Rose Madder Genuine. While wet, dash in Cadmium Orange in the direction of the light. Let this dry.

Step 2: Paint the Shadows
Paint the white parts of the petals that are in shadow with a mixture of Cobalt Blue and Burnt Sienna, value 4+. Next paint the shadows on the red petals with a mixture of Burnt Sienna and Permanent Alizarin Crimson. Go slowly and study the location of each shape as you paint.

Step 3: Darken the Center Petals

Use darker values of the Permanent Alizarin Crimson and Burnt Sienna mixture to darken the petals near the center of the bloom.

Step 4: Intensify the Values

There are crevice dark wedges (Burnt Umber and Permanent Alizarin Crimson) near the base of the petals and in places where they overlap. A rosy glow penetrates the petals on the left and reddens the cast shadow across the white inner bud.

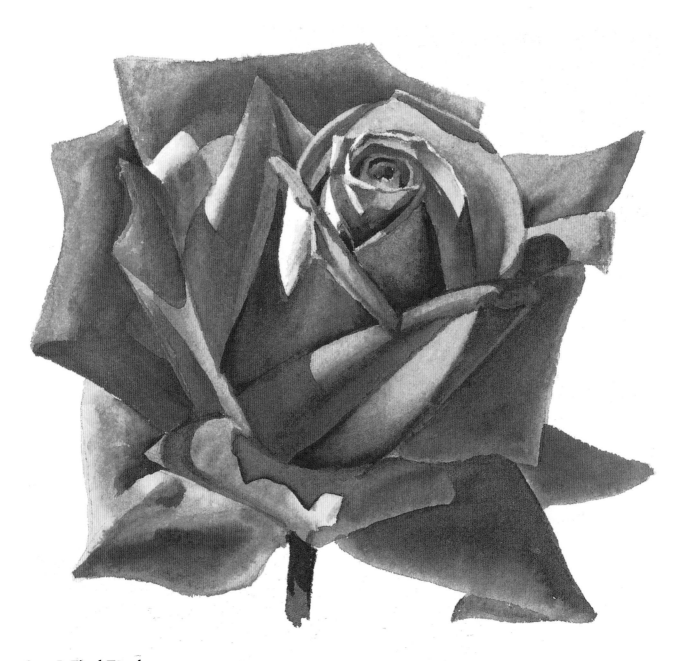

Step 5: Final Touches
Mix a dark red-violet using Permanent Alizarin
Crimson and French Ultramarine. With a small
brush use the mixture to complete the detail at
the rose's center.

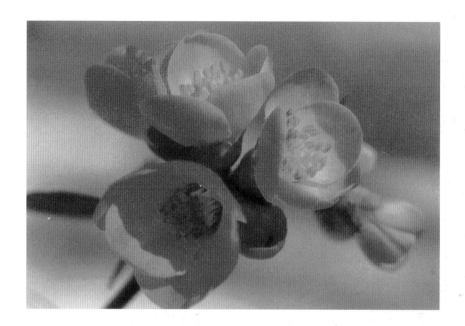

Now it's your turn. You can use the same colors used for painting the rose, to paint the red quince pictured here.

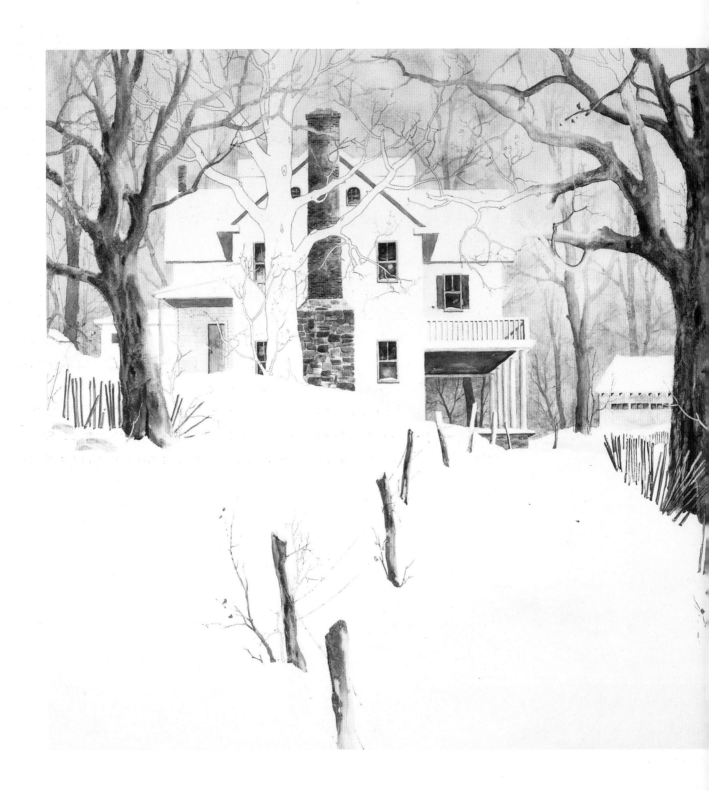

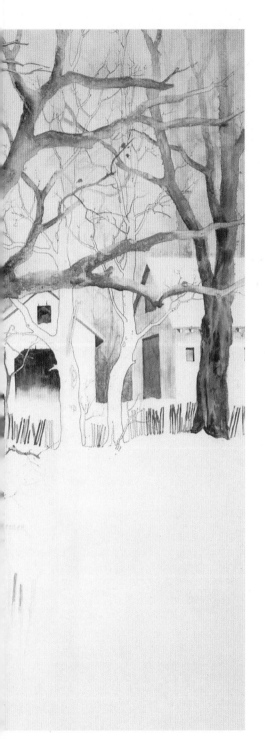

PERSPECTIVE SECRETS

When people hear *perspective* they go hide in a closet! They think *perspective* means drawing a zillion construction lines and using geometry, trigonometry and advanced physics. Learning perspective is no more complicated than learning to mix colors. It's certainly less complicated than learning to draw.

Don't be intimidated. Once you learn how and why perspective makes your paintings more interesting and believable, you will have a new perspective on perspective!

The White House
Phil Metzger
40" × 60" (102cm × 152cm)

Perspective Defined

Here's how one dictionary defines perspective: the science of painting and drawing so that objects represented have apparent depth and distance. To put it another way, perspective is what makes a two-dimensional picture seem three-dimensional. Use the following techniques to create the illusion of perspective, or to fool the eye:

- size and space variations
- overlap, detail and edges
- shadows
- one-point linear perspective
- two-point linear perspective
- curves in perspective
- aerial perspective

Size and Space Variations

If you have a row of same-sized objects or equally spaced objects, such as fence posts, you can create a feeling of distance if you make them progressively smaller and closer together as they march off into the distance.

All artwork on pages 98 through 127 was created by Phil Metzger.

Here the posts are the same height and spaced uniformly, so this picture looks flat . . .

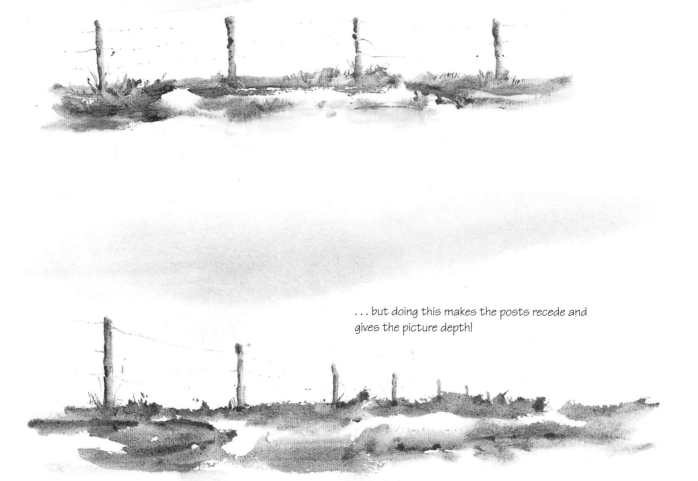

. . . but doing this makes the posts recede and gives the picture depth!

Overlap, Detail and Edges

You can make objects seem to advance or recede by placing closer ones over distant ones and by giving near objects more detail and sharper edges.

Shadows

By introducing deep shadows you can suggest depth. For example, in the sketch of the shed, just making the doorway dark helps establish depth by making you feel you're looking inside the shed. By modeling an object—that is, shading some of its surfaces—you can make even a small object seem three-dimensional. Shading on the side of the tree away from the sun makes the tree feel rounded, as though it actually has thickness.

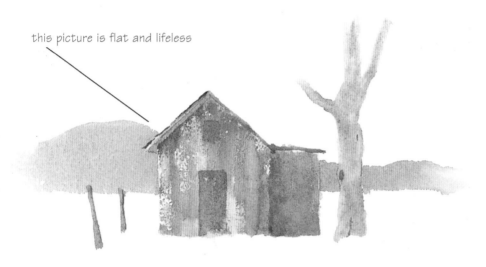

this picture is flat and lifeless

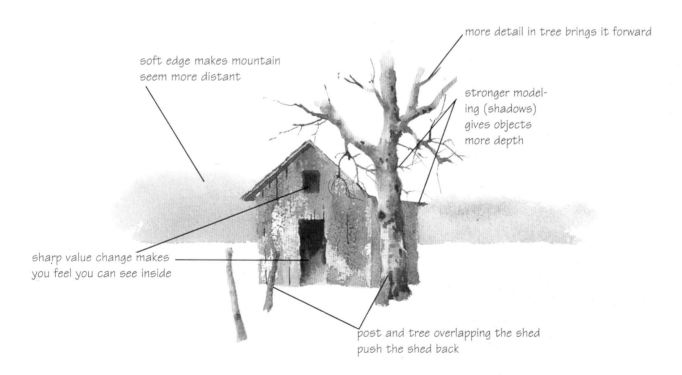

soft edge makes mountain seem more distant

more detail in tree brings it forward

stronger modeling (shadows) gives objects more depth

sharp value change makes you feel you can see inside

post and tree overlapping the shed push the shed back

One-Point Linear Perspective

Parallel lines, such as the sides of the straight road in this picture, seem to meet at a single point in the distance on the horizon. This is an example of one-point linear perspective.

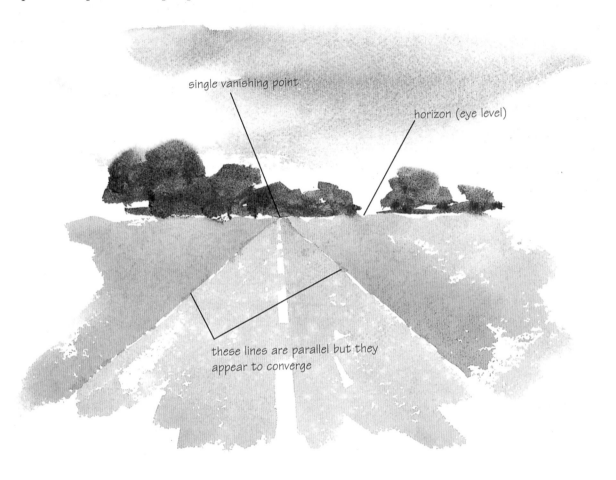

single vanishing point

horizon (eye level)

these lines are parallel but they appear to converge

Two-Point Linear Perspective

When a rectangular object, such as the box, is turned so you see two of its sides, its parallel edges (if you imagine extending them far enough) meet at one of two vanishing points on the horizon. This is an example of two-point linear perspective
More information on one and two-point linear perspective begins on page 114.

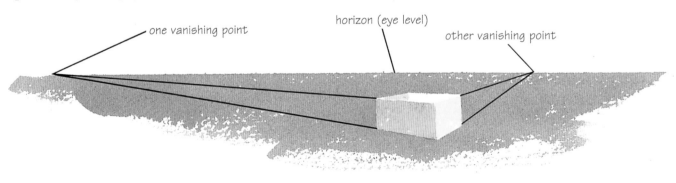

one vanishing point

horizon (eye level)

other vanishing point

Everyday Perspective

Once you understand perspective, you should use it to make all your paintings more believable. Here's a row of battered beer cans which are all the same size. Because the one at the rear is shown smaller than the one in the front, we know the one at the rear is the farthest away.

It's not only the diminishing sizes of objects that make them seem distant, the spaces between them behave in the same way. Power poles along a country road are generally spaced evenly, but if you look at them at an angle, the poles appear to shrink in height and the spaces between them appear to get smaller.

Start noticing how perspective affects your everyday perception. It's fascinating, and fun to reproduce.

Boring symmetry, no depth.

Now we have depth.

Curves in Perspective

Circular shapes only appear circular when you look at them straight on. If you tilt them at any angle they still look curved, but not circular—they look like ellipses. Hold an empty dish or cup in front of you and see how its circular outline changes to a flatter and flatter ellipse as you gradually tilt the object.

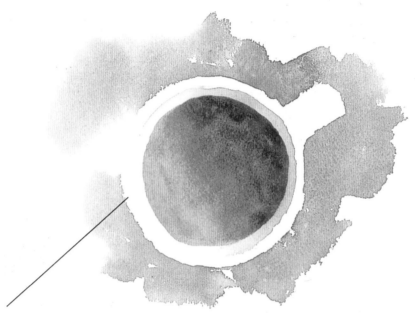

if you look at this mug from above, it's circular . . .

. . . but seen at an angle, it's an ellipse!

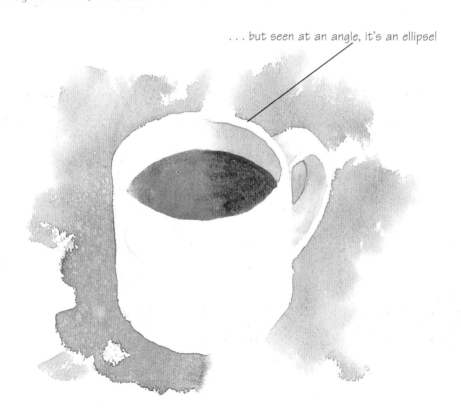

Cylinders in Perspective

Suppose you're drawing a cylindrical silo or pipe or tunnel in perspective. If the curved ends give you trouble, start by sketching a rectangular shape and then draw the curves inside it (as shown at right).

How Eye Level Affects Curves

What's wrong with the vase on the left (below)? Something seems out of whack. You see the bottom of the vase as a straight line, but the curve at the top suggests you're looking down at the vase. The problem: This picture has two eye levels. That's illegal unless your name is Picasso. To draw or paint a realistic picture, choose an eye level (only one) and stick with it.

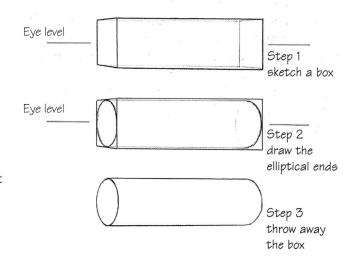

Eye level — Step 1 sketch a box

Eye level — Step 2 draw the elliptical ends

Step 3 throw away the box

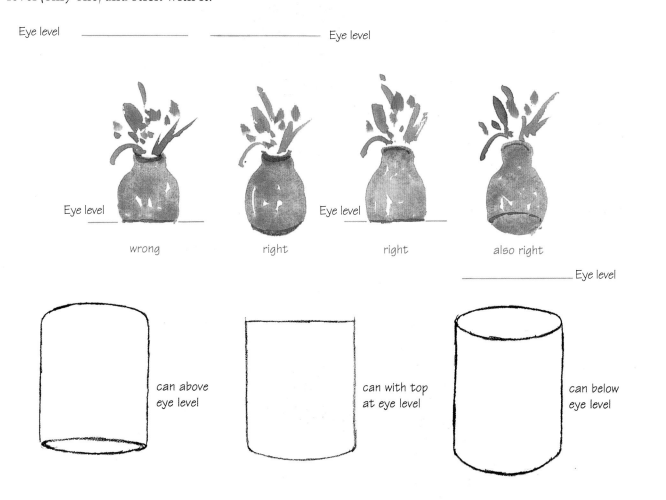

Eye level ——————————————————— Eye level

Eye level ———— wrong right Eye level ———— right also right

——————————— Eye level

can above eye level

can with top at eye level

can below eye level

Compare Curves

Get in the habit of comparing curves. Here are ordinary cans positioned above, at and below eye level. Study the way the curved ends vary according to their distance from the eye level.

Aerial Perspective

Aerial perspective is what causes distant objects to look paler and cooler than nearby objects. It's what makes a faraway mountain look blue when you know darn well it's no such color.

Using Color to Create Depth
Distant objects tend to have cooler colors than those same objects appear to have up close.

Landscape artists make use of this phenomenon by placing warmer colors in the foreground of a painting and cooler ones in the background. You can see from the hills illustration how effective this can be. Simply build your paintings to conform to the way you see things. The general rule: Warm colors advance; cool colors recede.

Without Aerial Perspective
In this scene the distant hills are painted in what might be their actual colors. There is little sense of distance except for some value change and the use of more detail in the closer hills.

The Difference With Aerial Perspective
Look at the difference a little aerial perspective can make. Those distant hills still look green to someone standing on them, but they don't to an observer far away.

Making Warm Colors Recede

Obviously, not every warm-colored object will appear in the foreground of your painting. You may well want to place a red barn, for example, in the distance. How do you put such an object in the painting without having it seem to jump forward because of its warm color? Simply mute the color enough to make it feel right. If your red barn is in the foreground, make it as red as you wish; if it's in the middle ground, dull the red a bit; and if it's to be far away, dull the red even more. Because of aerial perspective, it's entirely possible for a bright red barn to appear grayish red if it's far enough away and the air is hazy.

Dulling For Distance
To make an object such as this red barn appear more distant in your painting, dull its red color. The farther back you want it to be, the duller you should make the red. You can dull a color either by adding black or gray to it or, as here, by adding some of the color's complement—in this case, green.

Woods Perspective

Woodland scenes are a popular motif in watercolor. You can use a number of techniques, including aerial perspective, to suggest depth in the woods. Along with aerial perspective, use softer edges for the distant trees and more detail in the foreground trees.

To introduce aerial perspective into a landscape scene, think in terms of three stages: distance, middle ground and foreground. Stage designers think this way when making stage props to simulate distance: At the rear of the stage is a light, fuzzy prop with little detail; halfway toward the front of the stage are props with more detail; and in the front are the strongest, most detailed props.

Steps for Building Your Picture
It's helpful to build your picture in three steps. The first step (the distance) is light in value and cool in color. The second (the middle ground) is darker and warmer, and the third (the foreground) is still darker and warmer.

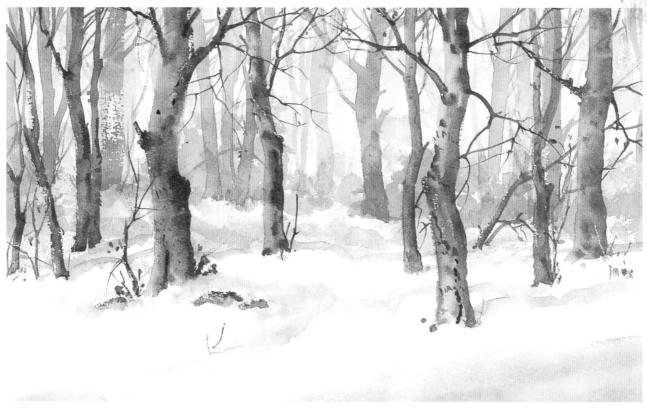

Perspective in Woodland Scenes
The key to building perspective in your woodland scenes is to slowly introduce depth and details by gradually building up the layers of colors. The distant trees were painted without much detail, keeping the color cool and the value light. The middle ground trees were painted darker and warmer and show a little more detail (you can paint right over the light background trees). The nearer, more detailed trees were then painted, along with their cast shadows. Partially covering (overlapping) some of the trees that have already been painted also helps to create perspective.

City Perspective

You don't have to be in the mountains to notice aerial perspective. City people know hazy air or fog can dramatically change how their city looks. Sometimes haze is so dense because of the pollutants from automobiles and factories that buildings only a short distance away are blurry, if not invisible. These effects may be magnified at night, when vision is affected by failing light as well as haze.

Using Layers of Colors

This city scene is built with layers of colors. The background was painted with a light gray all over the paper—darker at the top. Next, the distant buildings were painted with a warmer value of paint and without much detail. The look of fog was created by wetting the bottom of the paper and painting the buildings down into the wet area so they blurred and faded.

After the paper dried, the middle ground buildings were painted bluish gray, also without much detail. Finally, the buildings in the foreground were painted warmer, and detail was added to them to complete the illusion of depth. Again, these buildings were faded into the wet paper to make them appear to be in ground fog.

Using Value to Create Depth Over Short Distances

Value means lightness or darkness. A light area is said to have a high value, and a dark area has a low value. The term can be applied to either a colored or a black or gray area. The lowest value is black and the highest, white. A midvalue is somewhere between black and white

Soft, gentle value changes are used for modeling (or shading). A head gets form and thickness from the gradual darkening of the shadow side. A tree looks rounded by the lightening of one side and the gradual darkening of the other. Although modeling can be used on any curved object, it's often used for drawing or painting smaller objects, such as bowls, poles, apples, fingers and heads. Modeling can even give an illusion of depth to objects that are only a few inches deep.

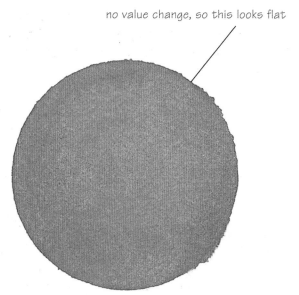

no value change, so this looks flat

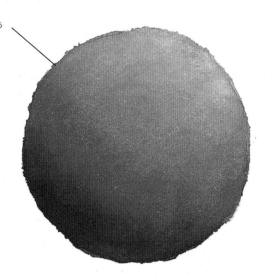

value change introduces curvature and depth

pretty flat!

a little more edible

110

Measuring Things

Once you get a feel for linear perspective, it's time to put the ideas to work in a practical way with a few drawing techniques that will help you get distances, angles and shapes correct.

Comparing

There are usually two kinds of measurements you make when you do a drawing: distances and angles. Distance may mean the space between a pair of buildings or between an apple and a bowl. Distance may be the length, width, height or diameter of an object. All of these distances in your subjects may be measured accurately enough by the thumb-and-pencil method: Close one eye and hold at arm's length a straightedge, such as a pencil or a ruler, and use your thumb to mark off a distance measured from the top of the straightedge. Then compare that distance to another marked off in the same way. You may find that distance A is about three times distance B (your thumb is three times farther down the pencil for A than for B). On your drawing mark off similar distances—if you decide that B is one inch (25mm) on your paper, then A is three inches (76mm). All you're doing is determining the relative sizes of things.

Once you've sketched lines that mark off distances or sizes, you need to check on angles. In linear perspective your drawing will be convincing only if you get the angles right. An angle is the measure of the direction of one line compared with the direction of another: the slope of a roof compared with the vertical side of the building, the slope of the top of a doorway compared with the side of the doorway, the slope of a table edge compared with the vertical edge of a wine bottle.

Learn to "see" the hidden edges.

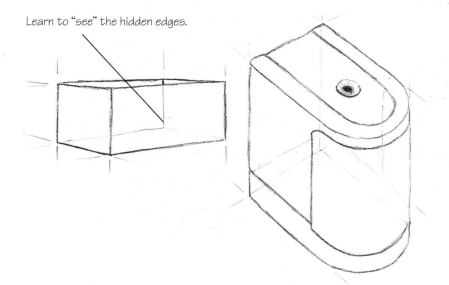

Drawing Through

A great way to draw a shape convincingly is to "draw through" the object—that is, draw the lines you can't see as well as those you can. It's like imagining the object to be transparent so you can see all its edges. Drawing through is a great help in getting linear perspective right, whether you're drawing a simple box or a more complex subject.

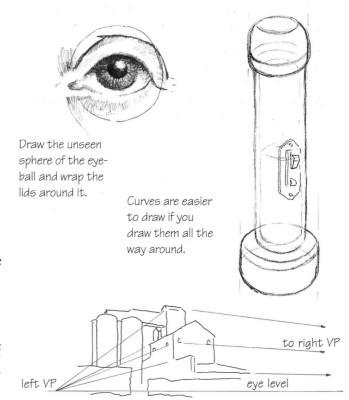

Draw the unseen sphere of the eyeball and wrap the lids around it.

Curves are easier to draw if you draw them all the way around.

to right VP

left VP

eye level

Sketch of *The Old Mill* showing accurately measured angles and vanishing points.

See the Other Side
Drawing through helps you visualize what's on the other side of the mountain! Use faint lines when drawing through so you can erase them or cover them with paint easily. Drawing through is particularly helpful for curved lines, such as ellipses (circles in perspective).

Boxing

No matter what curved object you draw, it may help to stick it in a box. Boxing an object helps you visualize it better. Sometimes you start with a box and draw the object inside it; other times you might draw the object freehand first and only sketch a box around it if the drawing needs fixing.

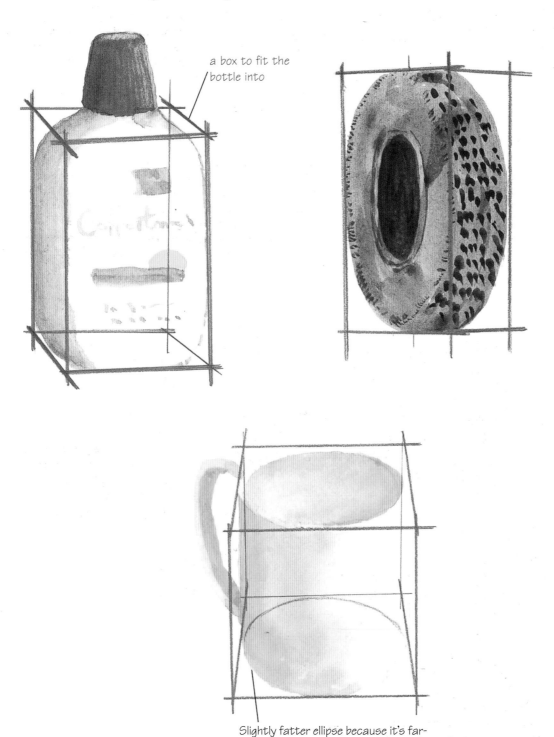

a box to fit the bottle into

Slightly fatter ellipse because it's farther below eye level than the top ellipse.

Foreshortening

Foreshortening is a way of creating an illusion of depth by shortening receding lines. You probably use foreshortening all the time. If you draw the side of a building shorter than you know it to be in proportion to the rest of the building—the side is receding from you—you're using foreshortening. More commonly the term is used about drawing such objects as tree branches or the human figure.

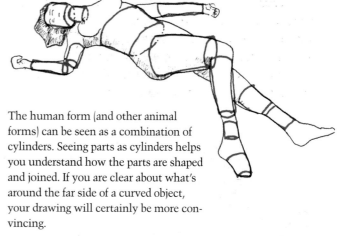

The human form (and other animal forms) can be seen as a combination of cylinders. Seeing parts as cylinders helps you understand how the parts are shaped and joined. If you are clear about what's around the far side of a curved object, your drawing will certainly be more convincing.

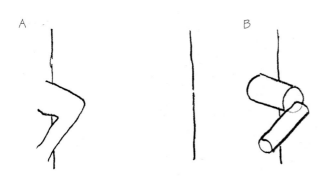

When you draw branches advancing or receding, it's helpful to treat the branches (in fact, the entire tree) as a bunch of cylinders. It may be difficult for you to "see" the branch coming toward you (A) but if you draw the branch as cylinders placed end to end (B) the picture becomes clearer .

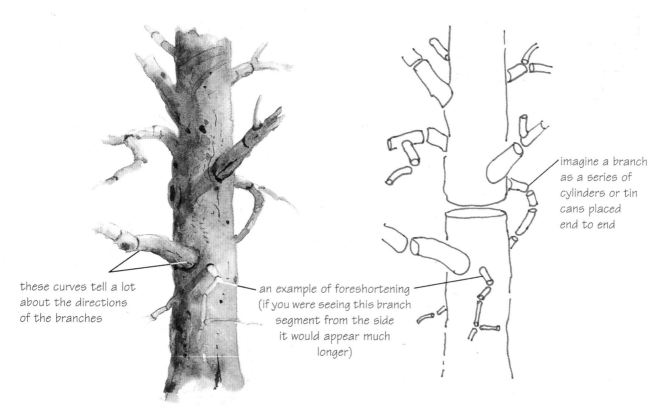

these curves tell a lot about the directions of the branches

an example of foreshortening (if you were seeing this branch segment from the side it would appear much longer)

imagine a branch as a series of cylinders or tin cans placed end to end

Try seeing a tree as a combination of cylinders. This will help make branches go where you want them to. Be especially careful to show the curved lines where a branch meets the trunk. Getting these curves right helps suggest direction.

More on One-Point Linear Perspective

Earlier, you read about something called the vanishing point, the place where an object's parallel lines would seem to meet if they were extended. Some pictures have only one vanishing point. All the receding parallel lines in such pictures meet at this single point. A well-known example is da Vinci's *Last Supper*.

Pictures done in one-point perspective tend to be symmetrical and formal. If that's what you're after, this type of arrangement may suit you well. Most pictures, especially modern ones, are done in either two-point perspective or a combination of one-point and two-point perspective. Such pictures tend to be looser and less static than those done in one-point perspective.

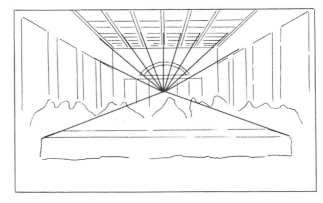

Single Vanishing Point
The single vanishing point in this sketch of da Vinci's *Last Supper* is near Christ's head. All receding horizontal lines in the scene converge at that point. The lines above the eye level slant down to reach the vanishing point, while the lines below the eye level slant up to the vanishing point.

Above Eye level
The face of this box is parallel to the picture's surface. The receding parallel edges come together (vanish) in the distance at a point that lies at eye level. Since this box is above eye level, all its receding lines slant down toward the vanishing point.

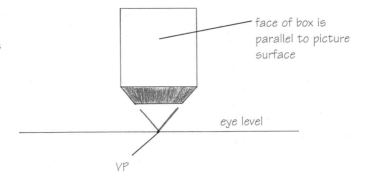

Eye Level
This box straddles the eye level. The front and back have been left off so you can look through and see where the vanishing point is. Notice that receding lines above the eye level slant down and those below the eye level slant up.

Below Eye Level
The face of this box is parallel to the picture's surface. Since the box is below eye level, its receding lines slant up toward the vanishing point.

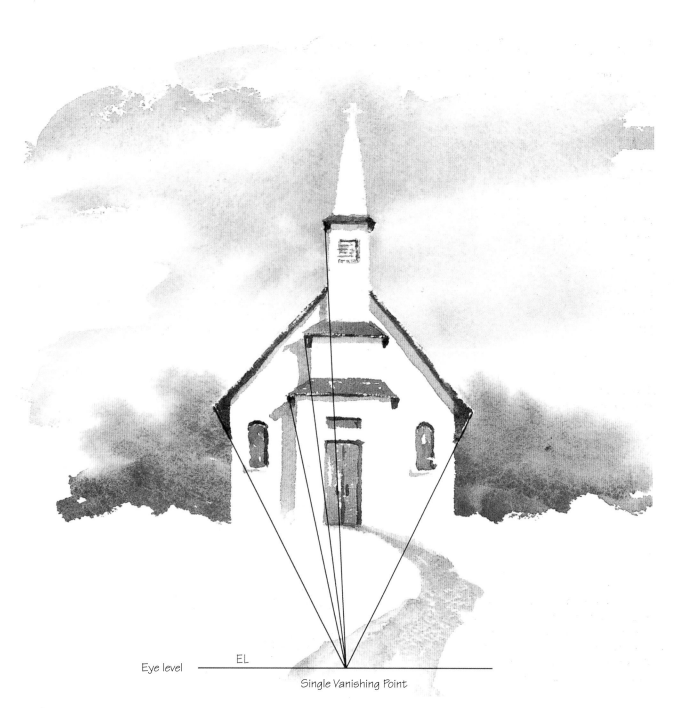

Eye level ———— EL

Single Vanishing Point

Looking Up

Here the eye level is low. This is how a building might look to someone standing downhill from the church.

Up and Down

Receding lines above the eye level slant down to a vanishing point; lines below the eye level slant up to a vanishing point.

More on Two-Point Linear Perspective

In two-point perspective there are two vanishing points. Let's say you're drawing a box and none of its sides are parallel to the picture's surface. You see parts of two sides and perhaps the top or bottom as well. The top and bottom edges of one of the sides recede toward one vanishing point and the top and bottom edges of the adjacent side recede toward the second vanishing point. Both vanishing points lie at eye level.

Rotate that same box to a couple of different positions and see what happens. You'll notice that the vanishing points move around a lot, but both vanishing points always remain at eye level.

Why Are Vanishing Points Important?

Vanishing points help you avoid awkward drawings. If you make sure all receding lines converge at the proper vanishing point, your boxes and buildings should look at least plausible. Look at the simplified house on the opposite page; some of the receding horizontal lines don't hit the vanishing point.

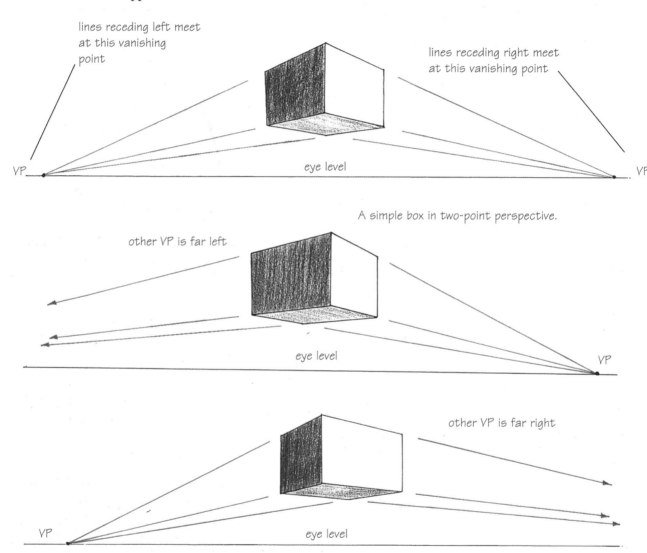

lines receding left meet at this vanishing point

lines receding right meet at this vanishing point

VP eye level VP

A simple box in two-point perspective.

other VP is far left

eye level VP

other VP is far right

VP eye level

The vanishing points change every time you change the position of the box. In many cases a vanishing point may fall far to the right or left and off your drawing. You can tape a piece of scrap paper to the drawing to allow room for extending the eye level and locating the vanishing point.

Where to Put the Vanishing Points

Unless you're doing some complicated architectural rendering, you don't necessarily start off by placing a vanishing point anywhere. What you do is sketch or paint an object as you see it and enjoy yourself. You only resort to vanishing points and construction lines to check your drawing, especially if something looks cockeyed but you're not sure what. Let's fix a building that seems not quite right.

Clearly, there's something wrong with this building. This is a simple sketch, and it may be easy to fix without fooling with vanishing points. Often, however, goofs are more subtle and you may need to fall back on your knowledge of vanishing points and the eye level to correct them.

Sketch in the eye level where you want it.

Look at the left side of the building and see which receding line looks most natural. Let's say you're comfortable with line A. Put a dot where line A crosses the eye level. That's your left-hand vanishing point, VPL.

Now fix line B and line C. Make them behave by aiming them at the vanishing point. Looks better already, doesn't it?

Do the same for the right side's lines. In this case you'll need to tape extra paper alongside the drawing so you can extend the eye level to the right and make room for VPR. Now our little cockeyed house looks more normal. The slanting roof lines are not quite right, but we'll get to that later when we discuss three-point perspective.

117

Moving the Vanishing Points

You may place the vanishing points anywhere you wish along the eye level line. If you place them far to the right and far to the left, the object you're constructing will look flat; if you squeeze the vanishing points too close together you'll get a distorted view of the object. Try different placements for the vanishing points until you're satisfied with the result. Here are three versions of a building, each with a different set of vanishing points. You can see what a difference their placement makes.

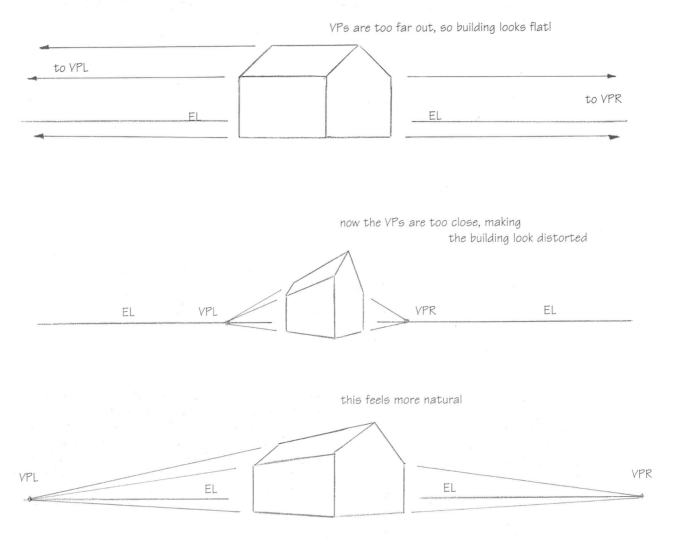

VPs are too far out, so building looks flat!

to VPL

to VPR

EL EL

now the VPs are too close, making
the building look distorted

EL VPL VPR EL

this feels more natural

VPL VPR

EL EL

How Do You Treat Multiple Objects?

Suppose you're painting a scene that has several buildings in it. What do you do about eye level and vanishing points?

First, remember there is only one eye level in a scene—the entire picture is painted from the viewpoint of one observer. Adding more objects, such as buildings to the scene, does not affect eye level. But each object has its own vanishing points. Occasionally some of them may coincide, but usually each object's vanishing point will be separate and distinct from all the others. What all the vanishing points in one-point and two-point perspective have in common is that they all lie on the same eye level.

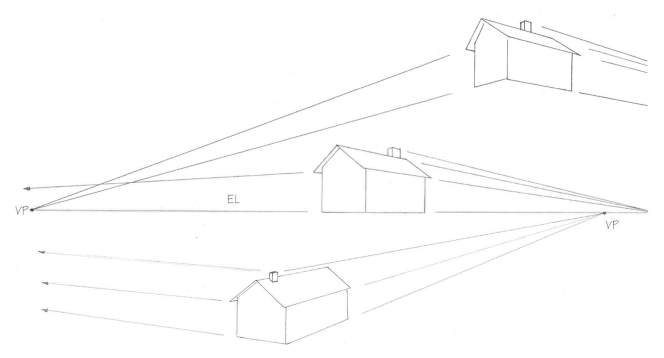

Two-Point Perspective in a Nutshell
- Decide where the eye level is to be.
- Draw your rectangular object freehand.
- Test the correctness of your lines by extending all horizontal receding lines until they cross the eye level line.
- All lines receding toward the left should meet at one vanishing point on the eye level. Adjust any lines that don't meet there.
- All lines receding toward the right should meet at a second vanishing point on the eye level. Adjust any lines that don't meet there.
- Receding lines above eye level slant downward; those below eye level slant upward.

In this picture there is a single eye level but three different houses—one at eye level, one on a hill above eye level and one in valley below eye level. Each building has its own pair of vanishing points. You can stick other buildings in the picture anywhere you wish, as long as their vanishing points fall somewhere along the eye level. Often a vanishing point will fall outside the picture's boundaries, and you can only place the vanishing point by extending the eye level line far to the left or right.

Finding the Perspective Center

When you show a rectangle in perspective, its center is no longer halfway between its sides. The center shifts to a new location we call the *perspective center*. To locate it, draw the rectangle's diagonals; where they cross is the perspective center.

Why do we care where the perspective center is? Suppose the rectangle in the last illustration is the side of a house and you want to place a door in the middle of that side. You could do it by placing the door halfway between the two vertical edges, but you'd be wrong! There should be more space between the door and the near edge than between the door and the far edge.

Notice that the door in perspective is not evenly divided, with one-half to the right of perspective center and one-half to the left. More of the door shows on the near side than on the far side. That's because the door, as well as the side of the house, is in perspective.

Getting the Angles Right

Here's a way to practice getting angles right. Mount a sheet of glass (or Plexiglas) between you and a scene and draw the scene directly on the glass, using a marker. You'll easily reproduce the scene with no chance of getting angles wrong. You simply copy what you see through the glass. You can use one of your house windows or your car window if there's an appropriate scene outside, provided you use a marker that can be easily erased. Another option is to tape a sheet of transparent paper or Mylar or similar material to the glass and draw on that surface instead of on the glass. When you're finished, you'll have an accurate drawing you can trace onto your watercolor paper.

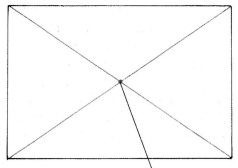

True center is where the diagonals cross.

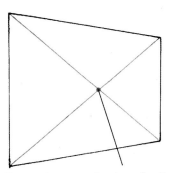

Perspective center is where the diagonals cross.

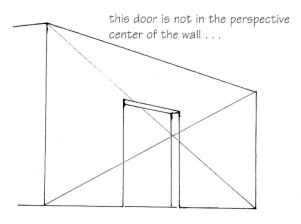

this door is not in the perspective center of the wall . . .

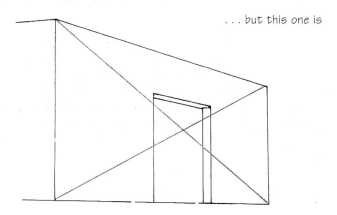

. . . but this one is

Doors, Windows and Other Details

They say the devil is in the details. The shape and placement of small items such as windows and doors can affect how reasonable your drawing or painting looks. Sometimes an otherwise sound drawing is unconvincing because details are not right. Remember that many kinds of details are simply one rectangle (such as a window) placed within another rectangle (such as a wall). Recall also the ear-

lier lessons: Just as receding fence posts seem to diminish in size and spacing, so do windows and doors (and bricks and shingles). Later you'll build an entire house from scratch, but first look at doors, windows and chimneys. (For more detailed examples, see Phil Metzger's *Perspective Without Pain* [North Light Books].)

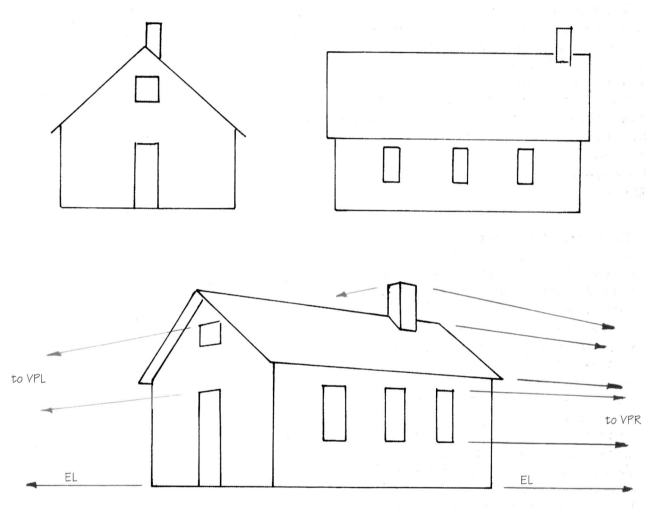

It's All in the Details

Looking at this house head-on, the door, the window, the chimney and the side of the house are all flat rectangles. In two-point perspective all these rectangles obey the rules of linear perspective. One set of perspective lines aims toward the right-hand vanishing point; the other, toward the left-hand vanishing point. Notice that the steepest slants belong to the lines that are the farthest above or below the eye level—in this case, the chimney-top edges.

The red lines meet at a vanishing point off the page to the right; the green lines meet at a left vanishing point. The windows get progressively smaller as they recede, and so do the spaces between them. The little window in the gable end of the building might at first appear to be placed too far to the right, but that's only because the overhanging roof hides part of the wall from view. If you draw through and "see" the underlying edge of the wall, you'll see that the window is placed properly in the perspective center of the wall.

Exercise
Finding the Perspective Center

How do you get the door just right? As a practical matter, simply eyeball things and draw the door a little wider on the near side of center than on the far side. That's the way you'd almost always proceed. But suppose you need to get things more precise, or suppose your freehand effort doesn't look quiet right and you want to check it out. Here's how to get the door perfect (well, almost).

Paper
drawing paper or scrap
 paper

Miscellaneous
pencil
ruler (optional)

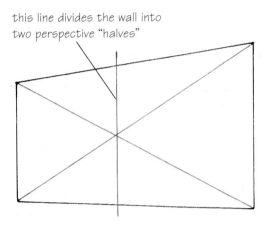

this line divides the wall into two perspective "halves"

Step 1: Draw the Side of the Building
Start by drawing the side of the building in perspective.

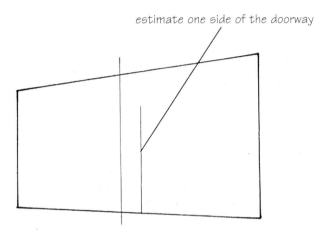

estimate one side of the doorway

Step 2: Sketch In the Doorway Edge
Freehand, sketch in approximately where you think one edge (side) of the doorway should be.

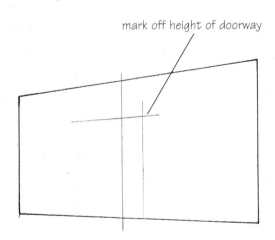

mark off height of doorway

Step 3: Sketch In the Height
Sketch a line showing the doorway's height.

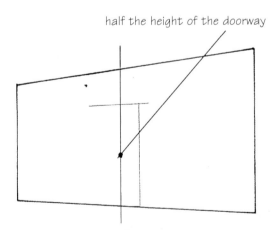

half the height of the doorway

Step 4: The Perspective Center
Along the vertical line that represents the perspective middle of the building's side, put a dot halfway between the doorway's bottom and its top. Either measure with a ruler or just wing it. For practical purposes, this is the perspective center of the doorway.

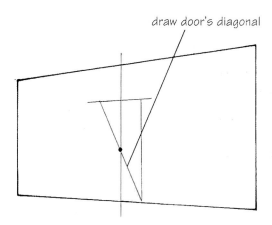

draw door's diagonal

perfect! with practice you can do this by eyeballing

Step 5: Draw a Diagonal Line
Draw a diagonal line from the lower-right corner of the doorway up through the perspective center.

Step 6: Draw the Other Side
Draw the other side of the doorway. Now you have a doorway in proper perspective within a wall that's also in perspective.

Notice the Details
Here's a proper doorway, including a door and a window in the door, all in perspective. Notice that part of the right side of the door is hidden behind the door frame and so is the doorknob. Notice also that the space to the right of the window seems smaller than the space to the left—this is because part of the right-hand space is hidden behind the door frame.

Whoa!
Getting worried about all these construction lines? Don't be. This construction is just to show the principles underlying linear perspective. Once you understand the principles, you'll use them automatically and rarely need to do fussy perspective drawing.

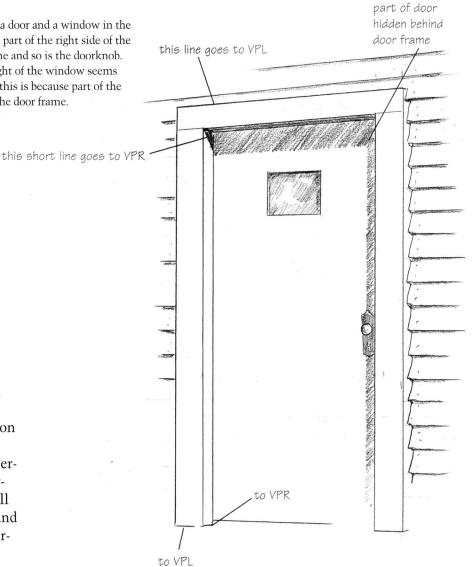

part of door hidden behind door frame

this line goes to VPL

this short line goes to VPR

to VPR

to VPL

Paths, Roads and Streets

Steep and Flat Roads

Suppose you have a road or street or path receding from the foreground toward a house in the distance. If the land leading to the house is relatively flat, you can suggest that by making the road wide in the fore-ground and narrow in the distance. If, on the other hand, you want to show the road leading up a hill toward the house, keep the sides of the road more nearly parallel.

In either case, you have to try various widths to find what feels right. If, for example, you widen the road too much in the foreground it may not look convincing—it may feel like a four-lane highway. But if you make the sides of the road too nearly par-allel the result will be equally unconvincing—the road may look vertical!

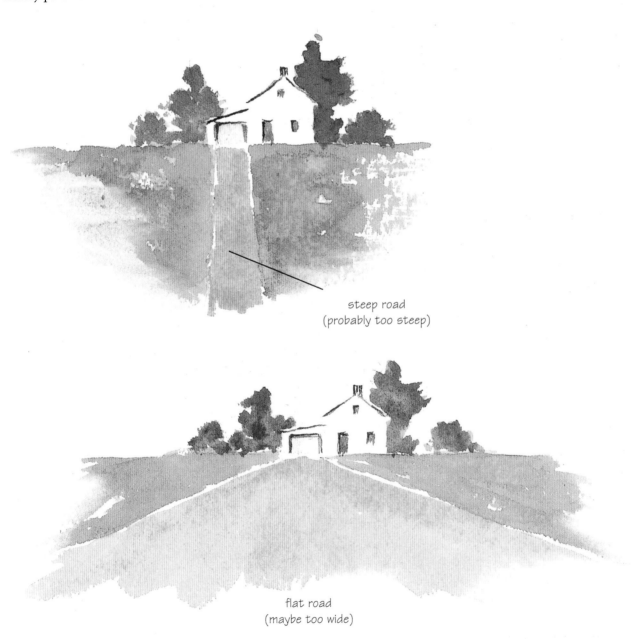

steep road
(probably too steep)

flat road
(maybe too wide)

Zigzagging Road

In many landscapes a road or path helps lead the viewer's eye toward the center of interest. A straight road may do this in too obvious a manner (you might as well put a sign in the painting saying "this way to center of interest"). Often a more suitable solution is to use a zigzagging road or path that leads to the center of interest in a more entertaining and less obvious manner.

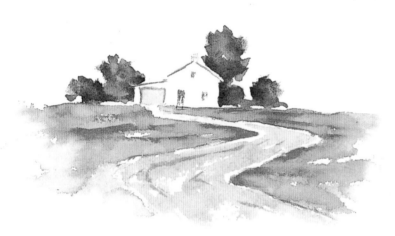

A zigzagging road is more interesting than a straight one.

Country Road, Hilly Terrain

Here's a way to suggest distance over rolling or hilly terrain. The road is like a roller coaster with a number of dips. Instead of smoothly narrowing as it goes into the distance, the road seems to narrow abruptly because the connecting parts of the road are down in a dip and lost to the viewer's sight.

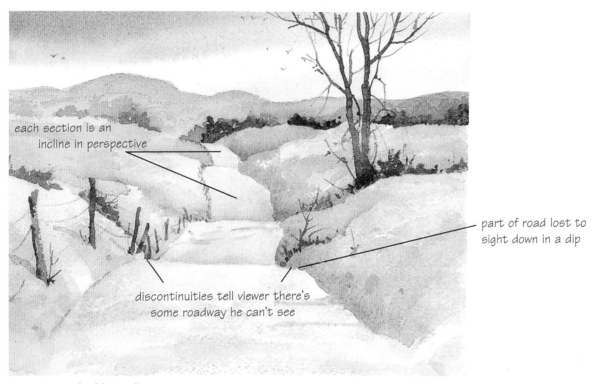

each section is an incline in perspective

part of road lost to sight down in a dip

discontinuities tell viewer there's some roadway he can't see

A country road is like a roller coaster.

Fields and Streams

Plowed Fields

Sometimes plowed, furrowed fields fit well in a farm scene. You can arrange the furrows so they help lead the eye into the distance, but be careful not to make the arrangement too rigid and obvious. The same is true of all the perspective techniques—try to use them so they quietly lead the eye into the distance.

Streams

Like a road or path, the wanderings of a stream can help give a feeling of distance and at the same time tell the viewer something about the contours of the land. The way you treat the surface of the stream affects the mood of the picture; a turbulent surface gives you an active picture, and a smoother surface gives you a quieter picture.

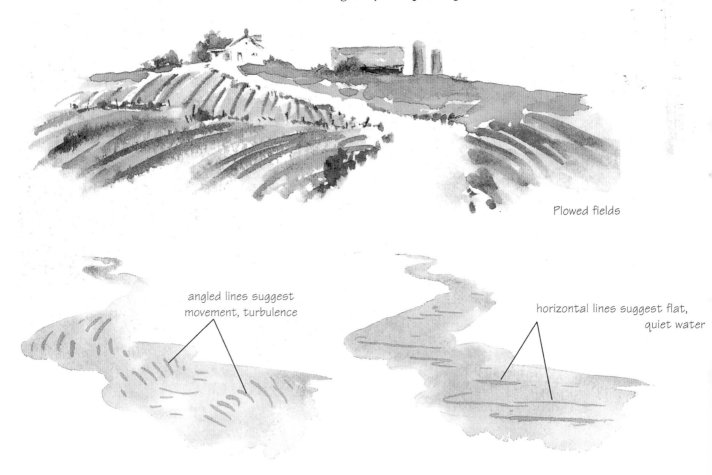

Plowed fields

angled lines suggest movement, turbulence

horizontal lines suggest flat, quiet water

A Second Look

Most of the techniques discussed in this chapter are used in *Cardinal*.

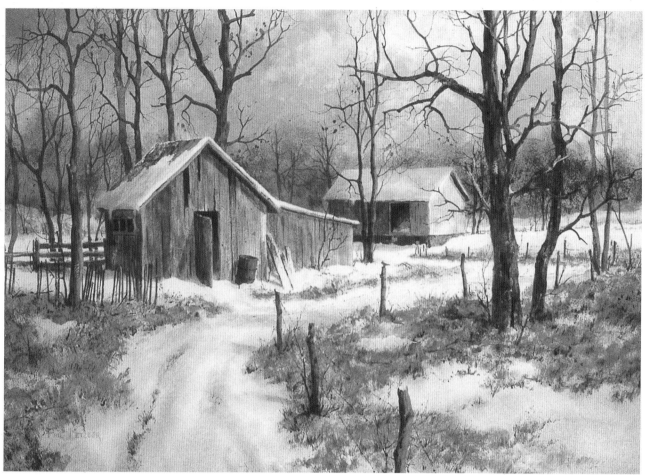

Cardinal
Phil Metzger
18" × 24" (46cm × 61cm)
Collection of Mr. And Mrs. Richard Sherrick,
Rockville, Maryland

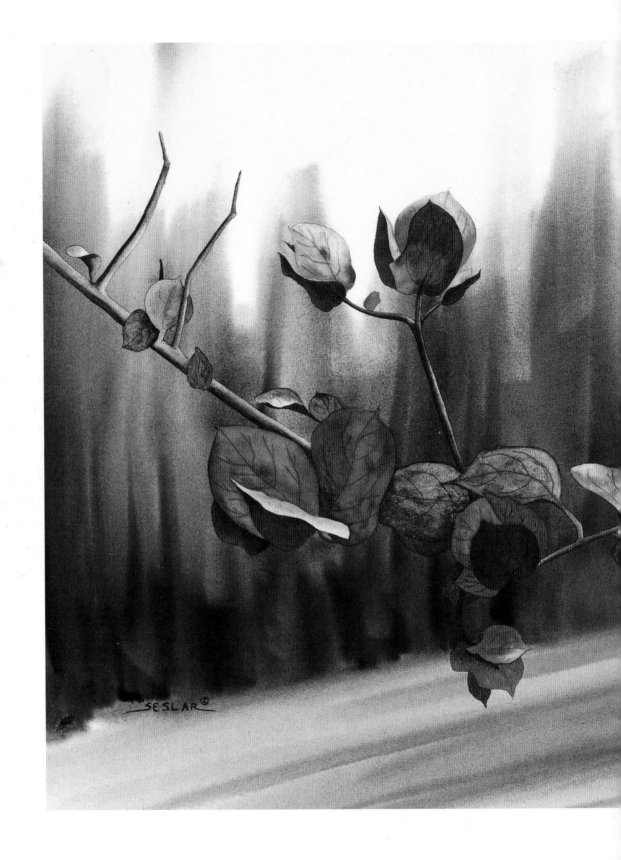

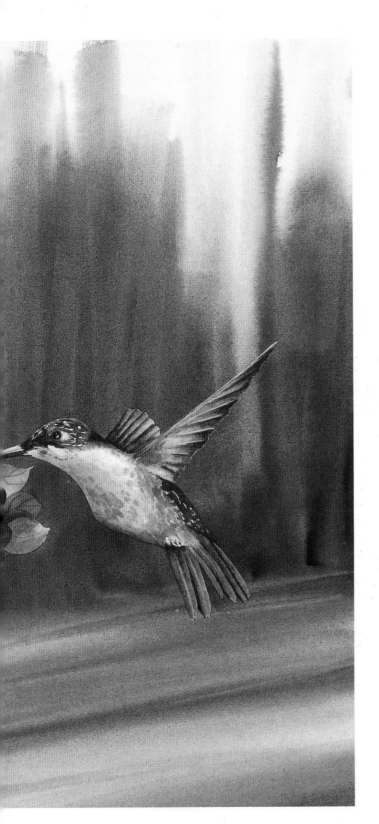

PAINTING FROM PHOTOGRAPHS

Where to begin? At the beginning, of course. In this chapter, you'll learn all you need to know about painting from photographs, including what your choices are when it comes to cameras, lenses and film, and even some simple photographic "tricks of the trade" to help you take better reference photographs.

There is also a recap of basic brushstrokes and techniques that are useful when painting from reference photographs. All of this information will make the process of creating paintings from your favorite snapshots easier and more enjoyable.

Bougainvillaea
Pat Seslar
12" × 16" (30cm × 41cm)

Cameras and Film

Any camera will suffice for collecting snapshots and reference photographs, so don't hesitate because you aren't sure your camera or photographs are good enough. Snapshots are only a starting point—it's what you do with your paints and brushes that matters. If you already own a camera, great! You probably have a stack of promising reference material to get you started. On the other hand, if you don't own a camera yet, take heart—you don't need to spend a fortune or become a photomaniac to get the reference material you need. Here are a few pointers that should help you make a good selection.

Single-Use Cameras
Single-use cameras are readily available and cost only slightly more than film and developing alone. Standard and panorama print formats are available, and for a little more you can get an underwater camera. Because the components are inexpensive, the focus won't be as sharp as in more expensive cameras, but the prints are still adequate for your painting reference.

Point-and-Shoot Cameras
"Point-and-shoot" cameras range in price from slightly more than single-use cameras to as much as a good 35mm model. Quality point-and-shoot cameras have better lenses and produce sharper images than single-use cameras. Equally important, both print and slide films are available, as are faster (more light-sensitive) films for low-light situations. Many point-and-shoot cameras offer features such as telephoto lenses; autofocus; and automatic film loading, winding and rewinding.

Advanced Photo System Cameras
Advanced photo system (APS) cameras are hybrids of point-and-shoot and 35mm cameras. Prices are similar to those of point-and-shoot cameras, and many "auto" features are available. APS cameras allow users to select one of three print formats (see next page) and to see the image in the viewfinder in the chosen format. APS processing is expensive, and no slide films are currently offered.

35mm Single-Lens Reflex Cameras
35mm single-lens reflex (SLR) cameras offer a full range of automated features and two additional advantages: (1) Viewing is through the lens, so "what you see is what you get"; and (2) lenses can be interchanged between standard, wide-angle and telephoto lenses. An autofocus lens that zooms from wide angle to telephoto, such as a 28-105mm, is an excellent all-in-one lens, allowing maximum flexibility when composing reference photographs. Either print or slide film in various speeds (degrees of light sensitivity) can be used in 35mm SLR cameras.

Digital Cameras
Digital cameras (not pictured) are the newest arrival on the scene. These cameras offer a great shortcut if you have a home computer. Images are stored as digital data that can be downloaded directly into the computer. With appropriate software, the images can be manipulated in many ways before being printed out on a full-color ink-jet printer in photo-quality resolution.

Artwork in this chapter was created by Pat Seslar or Lin Seslar.

Single-use camera

"Point-and-shoot" camera

Advanced photo system (APS) camera

35mm single-lens reflex (SLR) camera

Prints

Standard and Panoramic

APS cameras offer three photographic print formats—panoramic, medium and standard—which are great aids in visualizing compositional possibilities. The panoramic format is also available in single-use cameras.

35mm Slides

35mm slides aren't as easy to view as prints, but they offer superior color. A light table and photo-grapher's loupe make it easy to view many slides at once.

When you're using a single slide for reference while painting, a battery-operated handheld viewer works well and provides a visual sensation that is almost like being at the original scene. Surprisingly, viewers that must be held to the eye like a telescope work better for this purpose than either the 2" × 2" (5cm × 5cm) handheld viewers or larger rear-projection viewers.

Prints: standard and panoramic

Slide viewer

35mm slides

Compiling a Photographic Sketchbook

If your time for sketching on location is limited, use a camera to create a quick sketchbook. Take photographs of interesting textures, unusual details or general scenic shots to help you capture the flavor of an area. Later, combine images from different photographs into one painting. You can improve the quality and usefulness of your photographic sketchbook by using your camera's viewfinder to "crop" the subject into a good basic composition before taking a shot. Polarizing filters and zoom lenses create even more possibilities for cropping and trying different angles.

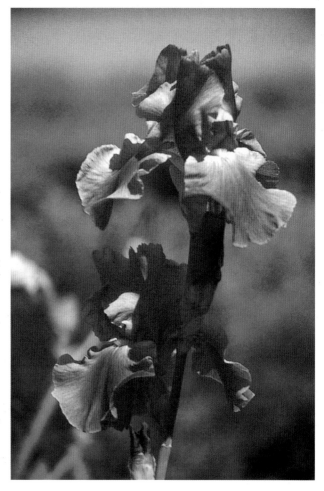

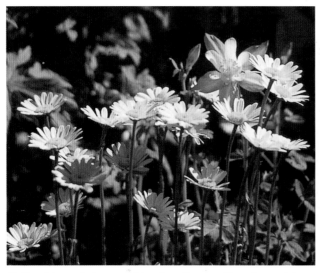

Collect bits and pieces such as these flowers. One piece might become a painting itself or a detail in a larger painting.

Overall shots provide the "big picture."

Smaller details
add authenticity
and completeness.

133

Visualize With a Viewfinder

If you have access to a reflex camera (a camera with a through-the-lens viewfinder), use the restricted field of vision to help isolate interesting subjects or to experiment with different compositions. Try horizontal versus vertical formats. Move closer or farther back. You'll soon develop an eye for spotting promising compositions.

This view (upper right) of a street near the sponge docks in Tarpon Springs, Florida, is interesting. But notice how much more dramatic and focused it becomes when you move closer and frame it vertically (above), then move still closer and return to a tight horizontal composition (lower right).

Zoom In on the Action

A zoom telephoto lens (for example, 70-200 mm) expands compositional possibilities even further, not to mention that it saves a lot of walking. A telephoto lens is particularly helpful in deciding whether a subject would be better rendered close-up, as an overall scene or anywhere in between.

A distant view, such as of this old church undergoing renovation, holds promise but is often too general to have a good focal point. With a zoom telephoto lens, it's easy to experiment with closer views.

This view, taken with a zoom telephoto lens and from a slightly different angle, seems more interesting than the first overall view.

In the end the artist decided to zoom closer still and focus on what had attracted her to the church in the first place, which was the steeple's curving supports and the beautiful contrast of the steeple against the sky.

Bucks County Steeple
Lin Seslar
12" × 16" (30cm × 41 cm)

Play With Perspective

Photographers often use a wide-angle lens (for example, 28mm) to compress a vast panorama into a single frame of film. This is the opposite of what artists need. For panoramas, they're better off using a panoramic camera or taping two or more overlapping shots together to retain more natural proportion. Still, a wide-angle lens is often useful when you want to create an interesting treatment of otherwise ordinary subjects, such as a barn or the looming bow of a ship.

Perk It Up With Polarization

Many colored and special effects filters are available for cameras, but for artists, a simple polarizing filter is the most useful. It reduces glare, causing colors to appear richer and warmer. With a polarizing filter, your photographs will retain more of the vitality that attracted you to the scene and make it easier for you to re-create that same sense of excitement in your paintings.

A polarizing filter helps retain the vivid colors you actually see. By reducing glare, the filter increases the intensity and warmth of colors. Skies appear bluer, clouds crisper and trees greener.

The artist was attracted to the prowlike roof extension of this old northern Indiana barn almost completely overgrown with trees. To accentuate that feature, she moved closer and shot a reference photograph with a 28mm wide-angle lens.

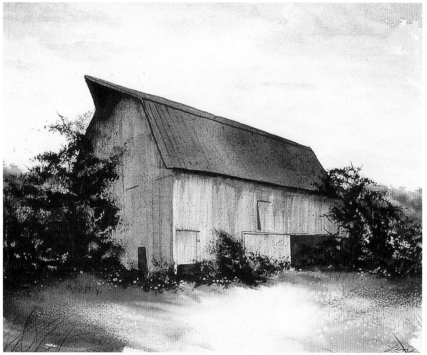

Using the wide-angle photograph as a jumping-off point, the artist eliminated most of the trees, added details to the barn, and changed the color scheme to suggest twilight rather than an overcast afternoon.

Twilight
Lin Seslar
13" × 16"
(33cm × 41cm)

Slide Projectors

Slide projectors are perhaps the best and most versatile means of enlarging images from 35mm slides. Nearly any slide projector can project a crisp image in a darkened room at distances of up to fifteen or twenty feet (about five to six meters). With both slide and opaque projectors, it's easy to trace a portion of your subject then move the projector to rearrange or resize other elements for a better composition. With either opaque projector type, you may need a special lens or adapter for reducing the size of the projected image.

Photographs such as this offer promising reference but lack color and interest.

This lovely window box with its colorful blossoms can add needed color to our window subject. To merge the two subjects, first project and draw the window, then project the window box over it. You may need to move the projector closer or farther away to match the size and scale of the window box to the window you've already drawn.

Here's the result!

Cropping for Impact

As mentioned earlier, a photographic reference almost always contains more visual information than you need. The solution is to crop the image to provide better balance and focus. There's nothing mysterious or difficult about cropping. Just grab a few scrap pieces of mat board and lay them over unwanted portions of the photograph to determine the most pleasing composition. Slides should be approached in the same way (though on a smaller scale). Lay the slide on a light table, then use the cardboard edges of other slides to crop out unwanted portions of the image.

Scraps of mat board (white) make it simple to crop excess material from photographic prints.

To mask unwanted areas so a cropped slide can be projected, apply silver slide masking tape.

This painting, created from the cropped photo, was modified further by eliminating the blossom and stem on the left and adding a butterfly from another reference photograph.

Day Lilies
Pat Seslar
14" × 10" (36cm × 25cm)

Help From Your Computer

With digital imaging rapidly replacing traditional film in many applications, computers are beginning to rank high on the list of artists' equipment, right alongside paints and brushes. Today you can take your film to a local store and order regular photographic prints or have your images returned on a floppy disk or CD. If you have stacks of prints from years past, reasonably priced flatbed and slide scanners offer another easy way to get images into a computer for further manipulation.

Several companies offer inexpensive photo-editing software that makes it a snap to crop your reference image in various ways. With this software, it's also easy to change colors, erase unwanted objects or add objects plucked from other scanned images. When you are satisfied with the result, an inexpensive color ink-jet printer quickly produces a print that is close to photographic quality.

With inexpensive photo-editing software, photographs can be cropped in different ways to see which composition looks best.

Make Changes
Photo-editing software was used to "paint" a blue sky between the two buildings. The dark post on the right was painted out and replaced with a portion of the white shirt on the clothesline and portions of the cordwood, grasses and flowers below. The final result was printed on a color ink-jet printer.

Helpful Strokes and Techniques for Painting From Photos

Now that you know how to capture a subject with your camera, how do you begin to transfer your idea to watercolor paper? When you look at your photo you need to know what technique and/or stroke will allow you to achieve that look. Following are several strokes and techniques that will help you create wonderful paintings.

Flat Wash

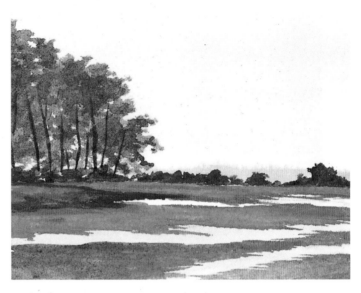

To create this soft, even tone, or flat wash, premixed color was applied to clean wet paper using a 1-inch (25mm) flat brush and steady horizontal strokes. Excess color puddles were blotted from around the edges of the masking tape to prevent backruns. For deeper colors, a large quantity of the desired color was pre-mixed (the paper was not pre-wet). Before they were applied, color mixtures were tested on scraps of watercolor paper to preview the strength and color of the wash .

Graded Wash

When you want color to change from dark to light use a graded wash. The desired color was premixed and applied using the techniques described for a flat wash, clean water was added with each horizontal stroke. To speed up or retard the movement of color, the paper was tilted. A perfectly graded wash takes practice, unless you must have an absolutely even tone, a variegated wash is usually the better option.

Variegated Wash

Variegated washes are useful for skies such as shown here, and also for amorphous backgrounds (see *Pumpkin Wagon* below).

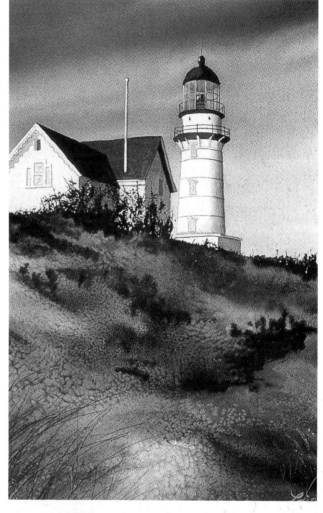

Variegated washes are the easiest washes to create. Simply pre-wet the paper evenly, then mix and apply the desired color or colors. For strong contrasts, use as little water as possible in the premixed color and leave areas of the paper wet but unpainted.

Cape Elizabeth Light
Lin Seslar
20" × 16" (51cm × 41cm)

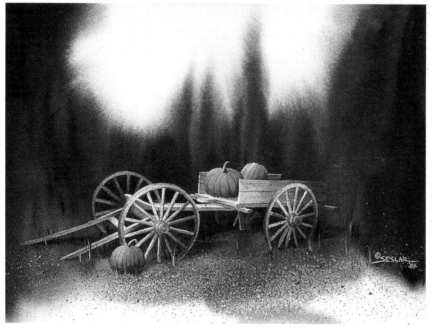

Control the flow of variegated washes by tilting the paper, if necessary. Control the spread of color by varying the wetness of the paper. On really wet paper, colors bleed into each other and lose much of their intensity. On damp paper, colors feather slightly along the edges and remain close to where you placed them. Beware of backruns if the paper gets too dry.

Pumpkin Wagon
Pat Seslar
12" × 16" (30cm × 41cm)

Drybrushing

Photographs such as this provide good subjects for drybrushing but should be simplified for focus and impact.

With a little more space around the subject, this photograph could be painted as is and would make an excellent subject for practicing dry-brush techniques.

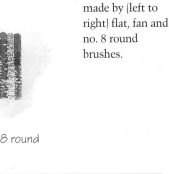

Dry-brush strokes made by (left to right) flat, fan and no. 8 round brushes.

Flat Fan No. 8 round

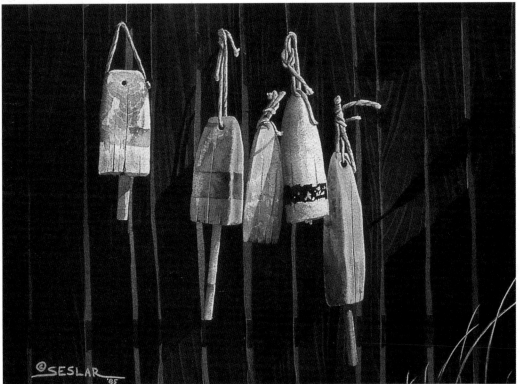

Where the Buoys Are
Pat Seslar
10" × 14"
(25cm × 36cm)

This composition makes extensive use of drybrushing and is a compromise between the two reference photographs. To create a dry-brush stroke, pick up the desired color with your brush, then lightly blot most of the moisture out with a paper towel. A flat, fan or round brush is ideal. Keep the brush nearly parallel with the paper and drag it lightly across the surface. Practice the stroke on scrap paper first! Too much moisture in the brush leaves a more solid trail; too little leaves barely any color. Drybrushing is a tricky but useful technique that works best on cold-pressed or rough paper.

Grasses

No. 1 liner

No. 1 liner with gouache

No. 4 round

Painting knife (broadside)

Painting knife (edge)

Grasses (left to right):

- No. 1 liner: Use bottom-to-top sweeping strokes.
- No. 1 liner (with gouache over darker color): Use a liner loaded with gouache White, Cadmium Yellow Pale and Sap Green to create light grasses against a darker background.
- No. 4 round: A small round brush leaves a fuller stroke.
- Painting knife (broadside): Dragging a painting knife through damp color leaves a lighter trail.
- Painting knife (edge): Pressing the edge of a painting knife into a wet wash leaves a crisp, fine grasslike line.

A good starting point.

Grasses add a natural feeling to many different subjects. They are easily rendered with a liner or small round brush or with the blade or edge of a painting knife.

Spattering

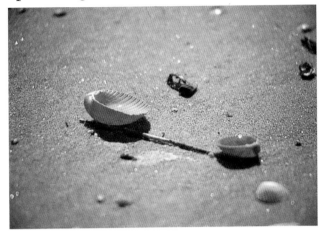

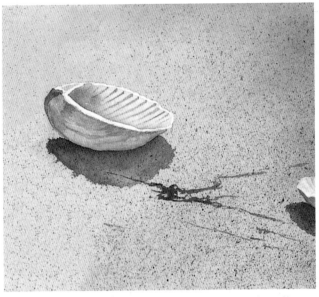

Spatter texture works well to re-create the feel of sand, gravel and even plain old dirt.

Spatter texture can be created by flicking the hairs of a stiff bristle brush, toothbrush or fan brush with your thumb or forefinger. Experiment on scrap paper to see where the spatters land and how wet the color needs to be to produce the desired texture. Spatter with several different colors for added interest.

Spatters (left to right) bristle brush, toothbrush, fan brush.

Lifting Color With Paper Towels

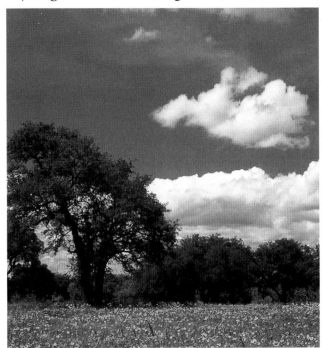

Scenes with cumulus clouds are ideal for lifting color with paper towels.

To create cumulus clouds, lay in a wash (flat, graded or variegated), then immediately press a wad of paper towels onto the paper to lift away color. In small areas, some color will remain, suggesting shadowed areas of clouds. On larger paintings, use clean water to pre-wet areas where you want clouds, then wash color around them to define the rough shapes. Quickly blot around the edges of the cloud shapes with paper towels to soften and feather the edges. Try this a few times on scrap paper before attempting it on your masterpiece!

Masking Fluid

If you hate painting around things, then masking fluid is for you. Rub your brush with bar soap to keep the masking fluid from adhering to the hairs. Rinse and resoap your brush when little balls of rubber begin to form on the hairs.

To ensure that the paper remains white, apply a second coat of masking fluid after allowing the first to dry. Using two coats also makes it easier to peel off the dried masking after the background has been painted. Use masking tape to pick up the edge of the dried masking fluid, then peel and paint!

Protecting the flowers and butterflies with masking fluid makes it simple to render complex and interesting backgrounds.

Bar Harbor Wildflowers
Pat Seslar
12" × 16" (30cm × 41cm)

Salt Texture

Scenes such as this are good candidates for salt textures.

You can render falling snow in the sky area using salt texture. Apply a wash of color, then sprinkle salt onto the paper just as the wet sheen disappears. The first textures will appear in a few minutes.

Not all colors react to salt in the same way, so use scraps of watercolor paper to see what texture results from different colors and degrees of wetness. Wetter paper will create a subtle texture, while drier paper will produce very little texture.

Step-by-Step Demonstration: A Grand Summer Landscape

Vacations provide a wealth of opportunities to stock your photo-sketchbook with interesting summer landscape scenes. Naturally, the references you collect reflect your artistic inclinations. Some artists are drawn to the strong perspective of Midwestern plowed fields or the warm tan of cornstalks just before harvest. Others think the wide expanses of the West are the ultimate landscape. No matter what appeals to you, the following tips and demonstration will help you collect better reference photos and create stronger paintings.

This photograph was taken without using a polarizing filter on the camera lens. Notice how washed out the sky looks.

Paper
Arches 300-lb. (640gsm) cold-pressed watercolor paper

Brushes
1-inch (25mm) flat
½-inch (12mm) flat
no. 8 round
fan
no. 4 round

Palette
Cerulean Blue
New Gamboge
Alizarin Crimson
Cobalt Violet
Cadmium Orange
Cadmium Yellow Pale
French Ultramarine
Burnt Sienna
Sap Green
Sepia

Compare the sky in the previous photo to the sky in this one, taken using a polarizing filter. Better, right? A good compromise would be to use this one for everything but the water. For that, refer to the first photograph because the sky reflections on the water add color and visual variety that are lost when a polarizing filter is used.

This is an example of a marginal reference photograph. The large boulder on the right is a bust, so to speak. You might be able to save the shot by ignoring the boulder and inventing a little of the canyon in its place from another shot. Or you can relegate it to the "boneyard" for parts.

This is a nice shot that could be painted as is. Of course, you would inevitably make hundreds of minor changes in color and emphasis even if you attempted to paint it absolutely literally. In this case, the artist decided to use it as a basic framework for her composition, but she opted to change the time of day as a means of introducing more interesting colors.

The artist selected this photograph from her files to serve as a general guide to the richer colors she had in mind. The challenge, of course, was to refer to the daylight scene for values and forms while using this one to stimulate color ideas.

Step 1: Sky and Clouds

Sketch the key elements from the reference photograph.

Pre-wet the sky with clean water. Use your 1-inch (25mm) flat to apply a pale variegated wash, beginning with mixtures of Cerulean Blue and New Gamboge at the top and transitioning into Alizarin Crimson and New Gamboge at the horizon line. When the wash is dry, return with your ½-inch (12mm) flat to indicate the shadow portion of the clouds with mixtures of Cerulean Blue and Cobalt Violet. Next, working over and slightly above the cloud shadows, add the illuminated color of the clouds with mixtures of Alizarin Crimson and New Gamboge.

Step 2: Sunlit Rocks and Canyon Purples

With your no. 8 round, paint the brightly illuminated rocks just below the horizon line with Cadmium Orange. Add clean water along the bottom edge of this wash to allow the color to soften down into the deeper canyon areas. When the wash is dry, render the blue-purple shadowed rock faces deeper in the canyon with mixtures of Cerulean Blue and Cobalt Violet. Several applications of color will be required to suggest the lighter and darker rock faces within the canyon.

Step 3: Rocks and Foreground Wash

Still working from distance to foreground, paint the middle-ground rocks just behind the lone tree. Begin with mixtures of Alizarin Crimson and New Gamboge, then follow with shadow tone mixtures of Cerulean Blue and Cobalt Violet. Next, pre-wet the foreground with clean water. Apply a wash of Cadmium Yellow Pale and Cadmium Orange, working from right to left and gradually adding Alizarin Crimson to the mixture. When the wash is dry, cover the sky and canyon areas with scrap mat board. Use your fan brush to spatter the foreground with the color mixtures used to paint the middle ground.

Step 4: Tree and Foliage

Working with your no. 4 round and mixtures of French Ultramarine, Burnt Sienna, Alizarin Crimson and New Gamboge, begin establishing the color and value of the weathered tree trunk and limbs. Several applications of color are necessary to create the darkest values. For the foliage, first apply a dilute mixture of Sap Green, Sepia and New Gamboge. As this wash dries, apply a darker mixture of Sap Green, Sepia and French Ultramarine for the main body of the foliage. A still darker mixture of the same colors establishes the deepest shadow tones in the foliage.

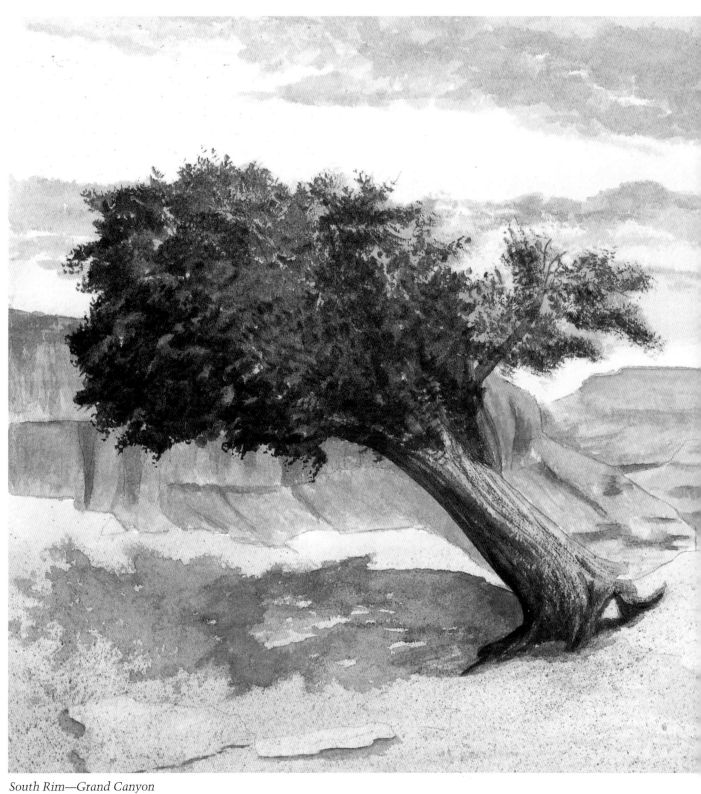

South Rim—Grand Canyon
Lin Seslar
10″ × 15″ (25cm × 38cm)

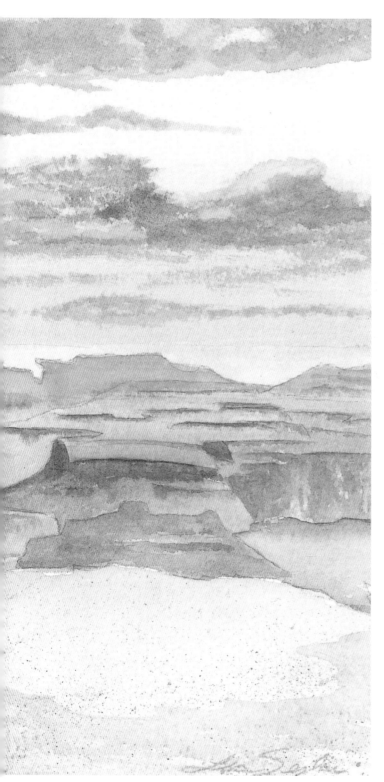

Step 5: Cast Shadow and Final Touches

Add the cast shadow of the lone tree using mixtures of French Ultramarine, Alizarin Crimson and Cobalt Violet. Notice that the artist left "holes" in the shadow for interest and the shadow extended to the left to indicate the sun's lower position at sunset. When the cast shadow is complete, deepen some of the values on the shadow side of the tree trunk and roots to keep everything in balance. To complete the painting, use clean water to wet the tops of the two irregular rock slabs in the lower left, then lighten the color by lifting pigment with a dry paper towel. To bring the rock slabs out, add a shadow tone around their lower edges with mixtures of Cadmium Yellow Pale, Cadmium Orange and Burnt Sienna.

Step-by-Step Demonstration: Simplifying Reflections

Silver, brass and chrome are perfect candidates for painting from photographic references, because reflections of nearby objects are complex and often distorted. If your drawing skills are still developing, it's sometimes hard to draw these unusual shapes freehand. Tracing the outlines of each reflected shape allows you to concentrate on values and colors and how they change within each shape.

The easiest way to paint silver or other reflective surfaces is to stop thinking of them as silver or anything else. If you simply paint the color and value changes you see within each shape without thinking what they are, at some point a kind of magic happens. Suddenly, almost without effort, a realistic reflective surface emerges. This demonstration has many in-progress steps so you can see how the reflective surface of the silver creamer begins—looking quite unpromising—and then suddenly pops out looking incredibly lifelike.

Paper
Arches 300-lb. (640 gsm) cold-pressed watercolor paper

Brushes
1-inch (25mm) flat
no. 4 round

Palette
New Gamboge
Alizarin Crimson
Winsor Green
Burnt Sienna
French Ultramarine
Charcoal Gray
Sepia
Cadmium Orange
Raw Sienna
Burnt Umber
Cadmium Red Medium
Sap Green
Cadmium Yellow Pale
Gouache (Permanent White)

Miscellaneous
drafting curve template
slide projector
5H pencil
tracing paper
1-inch (25mm) masking tape
bar soap
masking fluid (gray)

When you combine reflective surfaces, like silver, with interesting colors and shapes, you have a great start for a painting project. For complex subjects such as this, photographic references (slides or prints) greatly simplify the process of drawing shapes accurately.

Differently shaped pieces create different reflections. Try placing several silver pieces in the same setting one after the other to see which reflections are most interesting. Notice how beautifully the rich darks in the spout of this sauceboat contrast against the light shapes of the grapes. Notice also how the base of the sauceboat is reflected in the bottom of the sauceboat itself. When this happens, I usually exercise artistic license and ignore the reflected image of the base. The result is an image that, although not completely literal, is less confusing and "reads" more easily.

In this photograph, the backdrop is a piece of cardboard and the shelf is a small wooden table. The two photofloods are reflected in the creamer—of course, you'd tone them down considerably. Notice how the straight edge of the shelf appears curved in the reflection. Notice also that it's the shadow side of the orange wedge reflected in the creamer—as a result, the reflected orange wedge is dark except across the top, where light spills over from the front.

This interesting combination of shapes, textures and colors could make a great painting. If you create a setup like this, a slide will give you the brightest and sharpest image to draw from. The reflections in this silver compote are subtle, so you'll need to pay close attention to value changes to create a credible illusion of the reflections.

This photograph was chosen because the reflections are fairly straightforward and the doily is reasonably simple to draw and paint. Keep in mind that the reflection illusion is convincing because the values are as light and as dark as they should be. If the illusion in your painting doesn't seem strong enough, try darkening your darkest values. Remember that the color of silver is largely that of the things around it—in this case, the shelf, doily, cherries, dark background (center of reflection) and light background (left and right sides of reflections).

Step 1: Draw

Project and draw this image onto your watercolor paper. Use a drafting curve template to clean up the many contours in the drawing. Another good idea is to lay tracing paper over your drawing, mark the vertical centerline, then trace one-half of the object. To make sure your drawing is symmetrical, flip the tracing over and realign the vertical centerline to see if it matches the profile of the opposite side. If not, use the tracing to mark the correct shape before proceeding.

Step 2: Mask

When trying to protect a large area of white paper, it's sometimes easier to mask around the outline in a strip about ⅜-inch (10mm) wide. This saves time, masking fluid, and wear and tear on the surface of the paper. Remember to apply two coats, and let it dry after each coat.

Step 3: First Washes

Pre-wet the entire background above the doily, carefully avoiding the silver cup. Then, use your flat to apply a variegated wash of New Gamboge and Alizarin Crimson. At the left and along the bottom of the wash, darken the color with a hint of Winsor Green. Below the shelf, establish the overall color with several washes of Burnt Sienna, French Ultramarine and Alizarin Crimson. Let dry.

Step 4: Shadow and Wood Grain

Paint the dark shadows below the shelf using your flat with dark mixtures of Charcoal Gray and Burnt Sienna. When the first wash dries, go over it again to darken the value further. Next, using the same color mixture and your round, paint the dark grain on the shelf face. Use your imagination here—there's no right or wrong. Paint the cast shadow of the silver cup (left) using the darker mixture from the background. Then paint the cast shadows of the doily on the front of the shelf using the dark mixture you used below the shelf. When everything is dry, remove the masking.

Step 5: Linen and Silver Washes

Pre-wet the entire doily area and lay in a pale wash of Sepia, Cadmium Orange and Raw Sienna, grading the wash from dark to light and top to bottom. Next, lay in the initial reflection colors on the silver creamer. For the spout, use the colors already used on the shelf face and the shadow below. For the light area just to the left of the spout, use the background color; for the comparable area on the left side, use the darker version of the same color. To paint the ends of the table that are reflected below the areas just painted, use the colors from the shelf. For the large dark area in the center of the creamer, use a mix of Burnt Umber, Charcoal Gray and French Ultramarine.

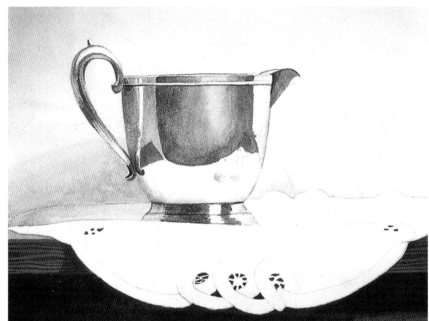

Step 6: Silver Details

With the same mixtures used for the doily, wash in its reflection at the creamer's base. With your round, subtly grade the wash from darker at left and bottom to lighter at the top. Carry the creamer's handle to a high degree of finish using your round and with mixtures of the basic silver color (Burnt Umber, Charcoal Gray and French Ultramarine). Begin with pale washes, avoiding the highlight areas, then follow with darker applications of color using dry-brush techniques. As you progress, make adjustments to strengthen the illusion of reflection. This means darkening the reflection of the background color on the cup's left side and the comparable color on the base. It also means darkening the darks in the base to bring out the highlight there. See if you can spot any other adjustments.

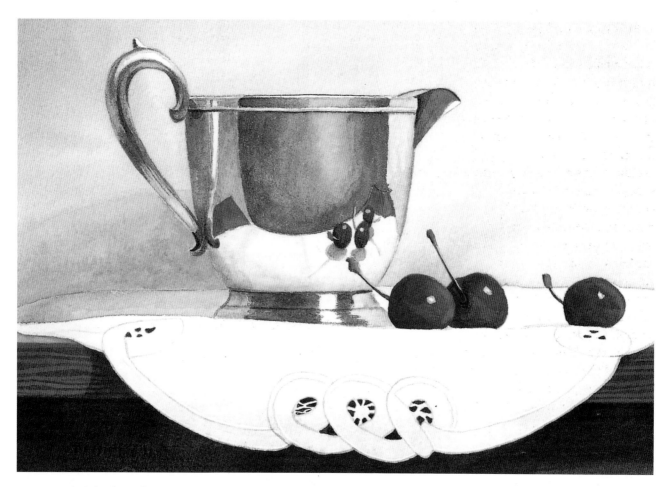

Step 7: Finish the Cherries

To complete the painting, apply dots of masking fluid to the highlights on the cherries and their reflections. Then, apply repeated washes of Alizarin Crimson and Cadmium Red Medium. For the darker values on the left side and bottom of the cherries, add Burnt Sienna and a hint of Charcoal Gray. After removing the masking from the cherry highlights, paint the stems with mixtures of Sap Green and Burnt Umber. Highlight their right edges using a mixture of Permanent White gouache and Cadmium Yellow Pale. Paint the upper ends of the stems with a wash of Cadmium Orange, then darken the shadow sides with Burnt Umber. Voilà—reflections!

Still Life With Reflected Cherries
Pat Seslar
7½" × 10" (19cm × 25cm)

BETTER FLORAL PAINTINGS

Artists have many reasons to paint flowers. First, flowers are living objects that move, live and grow, as people do. Painting a flower gives artists a wonderful opportunity to connect with the very heart of nature. Each flower is formed with great precision according to its innate blueprint, yet each bloom is totally unique—even when several blossoms sprout from the same branch.

Gain confidence in your ability to paint flowers. In this chapter you will learn basic floral painting concepts, the best palettes to use, different leaf shapes, and what backgrounds are best. You will also have the opportunity to work on several step-by-step demonstrations to put these concepts together.

All artwork this chapter was created by Sharon Hinckley.

Eymbidium
Sharon Hinckley
24" × 30" (61cm × 76cm)

161

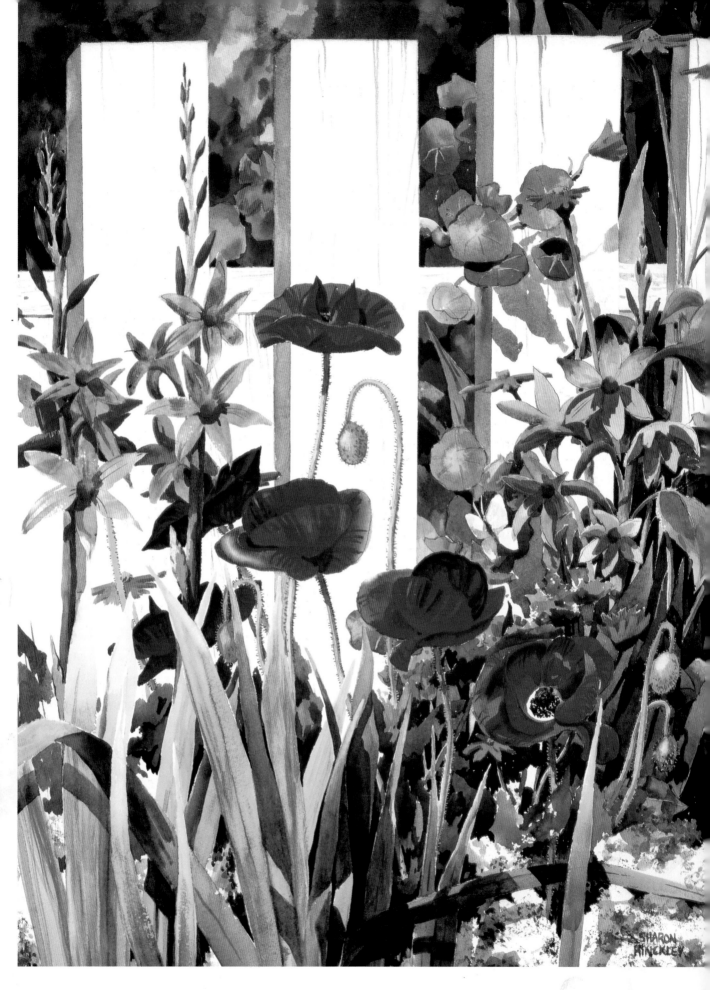

Easy Tips for Better Flower Paintings

When working out the composition of a flower painting, you have many things to consider.

Choice You may choose to limit your palette, your subject, your paints or even your painting time. The key is choice. If you used every color that you have on your palette, you probably wouldn't be thrilled with your final painting

Color One easy way to make a better painting is to pick a dominant color and explore it. For instance, white flowers on a white background. Where are the warms? Where are the cools? How much color can you add and still retain the feeling of whiteness?

Composition One popular guidelines for good composition is the four-quadrant grid. Simply draw two lines, either mentally or with a light pencil, to bisect your paper vertically and horizontally into four equal areas. The rule is to place a different shape in each quadrant.

Control Control the things you can: the quality of your materials, time devoted to your work and the care of yourself. Always restock your materials at the end of a painting session so you'll be ready for the next day's work.

Contrast The eye automatically finds the area of highest contrast in a painting, so keep that area interesting. Always put your lightest light, your darkest dark and your center of interest in one place. Place a light shape against a dark shape or vice versa.

Planning Think about your entire painting even while focusing on a specific area. Know the direction you're headed, but allow the picture to develop and evolve as it will—don't insist that the painting rigidly conform to a prearranged model.

Unity and Variety Include a variety of shapes, colors, sizes and textures in your paintings. Balance this variety with a sense of unity and harmonious design to excite, not shock, the viewer.

Joyful Flowers
Sharon Hinckley
25" × 19" (64cm × 48cm)

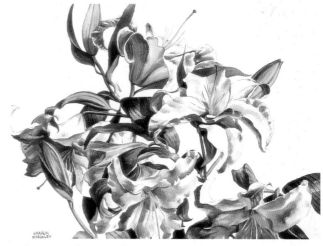

White on White
Sharon Hinckley
19" × 25" (48cm × 64cm)

The four-quadrant grid.

A study in contrast.

The Happy Accident It's not always a mistake to make a mistake. It's fun to use happy accidents for all they're worth! Did you put a spot of red where you wanted blue? Don't be in a big hurry to correct it. It just might help you out of a jam.

Light Source Always be aware of your light source. Where is it coming from (direction)? How bright is it (intensity)? What is its quality (mood)? Indoors, it's easy to set up a spotlight to give your subject strong, consistent illumination. Outdoors, there's about a two-hour window of time in both midmorning and midafternoon during which you can work with consistent light. There is only one sun, so make sure your outdoor paintings have only one light source. That may sound silly, but many paintings are ruined by conflicting shadows.

Load and Organize Your Palette Load your palette fully, making sure the paint wells are filled with moist pigment every time you begin to paint. You can't paint a vibrant picture with dried-up old paint. Squirt some water and a dab of fresh paint on top, and you're ready to go!

Organize your palette so it makes sense to you. Following the color wheel is usually best. Once you have a setup you like, don't change it. You'll never have to search for a color in midstroke.

Mixing Color Color theory is incredibly simple. Beginning painters should work with only three colors at any one time. More advanced students can go by the theory, "Smoosh everything together until it looks right!" Taking time to make color charts can be extremely helpful. When an artist is truly in the rhythm and flow of painting, there's no time to think, "What color is it?"

Matching-Brush Technique If you use two brushes of similar size and shape, one brush fully charged with color and the other (usually a broken or older brush) containing clear water, you can paint a hard edge in one area and quickly fade it out in another. This is also an excellent way to paint shadows and backgrounds.

Multiple-Brush Technique Try mixing color on your paper rather than on your palette. You can accomplish this by using several brushes, each loaded with a different color. Just remember which color is on which brush!

Shapes There are four basic shapes: circles, squares, triangles and free forms. Circles can be ellipses and oblongs. Many flowers and leaves are rounded, or radiate from a central point. Excluding some crystals, squares and rectangles only occur in man-made structures. Triangles appear in mountains, crystals, leaves, thorns and structures like the pyramids. A free form doesn't conform to any of the above shapes. Once you become familiar with shapes, you'll see them everywhere—enabling you to paint anything easily!

Happy Accidents
While painting Study in Pink and Green, the artist was not happy with the background. The painting was in the trunk of her car when she drove through a car wash. The trunk had not latched properly. The artist was stunned when she saw runs on her nearly completed painting, until she realized they could solve her background problem—an excellent example of a "happy" accident.

Study in Pink and Green
Sharon Hinckley
21" × 29" (53cm × 74cm)

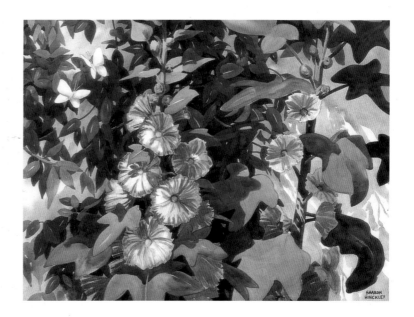

164

Overlapping Paintings are more interesting if shapes are overlapped. Lining up all the objects in a row makes them look like stiff wooden soldiers.

Subject Matter Any subject is suitable for a painting—even a weed! Thistles can even be a wonderful subject for a painting. In the beginning, limit yourself to three subjects or less. As you advance in your artwork, you will naturally develop the skills necessary for greater complexity.

Theme of Three To keep things simple when composing a painting, use the number three. You might limit yourself to three main colors—such as red, pink and green or blue, yellow and orange—or three main shapes—large, medium and small.

Rules About Rules There are no rules! Seriously, the rules are meant to be guidelines and suggestions to get you started in the right direction. If, in the course of your work, you come across something that's a total departure from the known and it seems to work, go for it!

Work From Life Many artists go on location, take a few snapshots, go home, and rearrange them to make a painting more interesting than nature. How can you make something more interesting than nature? Nothing is better than feeling the energy of and the connection with the earth. This can only be achieved by working outside. Give it a try.

Stiff, uninteresting wooden soldiers.

Eye-catchingly overlapped.

These blossoms illustrate the theme of three.

Paint outdoors often. Nature always has something interesting waiting.

Mixing Greens

Some artists keep green pigment on their palettes. If you mix greens rather than using tube colors, you have a better chance of achieving the variety of greens in nature in your paintings. The only exception is Emerald Green—it's a luscious, albeit opaque, color.

Many beautiful combinations create some of these greens.

Lemon Yellow and Cerulean Blue make a fresh spring green.

New Gamboge and Cerulean Blue make a slightly warmer summer green.

New Gamboge and Cobalt Turquoise combine into almost a jade green.

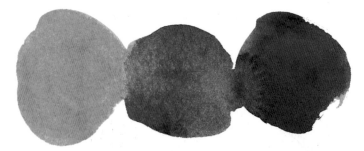

New Gamboge and Antwerp Blue create a warm, earthy green.

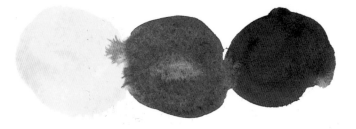

Lemon Yellow and French Ultramarine blend into a rich, cool green.

New Gamboge and Emerald Green also make a fresh spring green, though the result is more opaque than the green created with Lemon Yellow and Cerulean Blue.

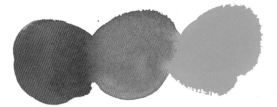

Opera and Emerald Green make a wonderful blue-gray green, perfect for eucalyptus leaves.

Raw Sienna and Cobalt Turquoise create a green that is almost bronze.

Lemon Yellow and Cobalt Blue combine into a delicate moss green.

New Gamboge and French Ultramarine make a blue-black green.

Cadmium Orange and French Ultramarine create a rich green that is nearly brown. It's perfect for duplicating the warm darks hidden between leaves and under crevices.

"Leaf Soup"

Throughout this chapter you will see references to a basic "leaf soup" mix. Color modulations in nature can be more easily expressed by allowing pigments to mix on the paper rather than on the palette. To achieve this natural effect, you can paint with four or five different brushes in your hand at the same time, each loaded with a different color (perhaps add one for clear water).

You can use these colors to paint all leaves: Lemon Yellow, New Gamboge, Cobalt Turquoise, Cerulean Blue and Cobalt Blue. What varies is the amount of each pigment and the amount of water. For a darker hue, add French Ultramarine. To tone down a green, add Alizarin Brown Madder. For spice, add Opera or Emerald Green. Here are examples of some "leaf soup" mixes.

Lemon Yellow, New Gamboge, Emerald Green and Cobalt Turquoise make a bright green mixture.

Lemon Yellow, New Gamboge, Cobalt Turquoise and Cobalt Blue make rich greens.

Lemon Yellow, New Gamboge, Alizarin Brown Madder, French Ultramarine and Cobalt Turquoise create a deep, dark, mysterious green.

Lemon Yellow, New Gamboge, Opera and Cobalt Turquoise create bluish gray greens.

"Palette Soup"

It's made up of whatever is left on the palette after painting a while. By then, heaven knows what colors it consists of, but it will make a reliable gray that is wonderful for toning down overbright colors or putting in a background wash. It can also be combined with brighter colors to create an even wider variety in your range of colors.

Now, not only is nature infinite in her varieties, but so are the colors on your palette!

A basic "palette soup" mix

Here the soup mix flows into a mixture of New Gamboge and Cobalt Turquoise.

Seeing is believing. Here's a palette loaded with "leaf soup" mix.

Basic Leaf Shapes

The dictionary describes more than fifty different kinds of leaf forms. That's far too many for the brain to absorb and paint. To keep it simple, narrow it to the four basic shapes: circles, squares, triangles and free forms. While you may have yet to see a square leaf, there is an abundance of curved, rounded and triangular shapes in the natural world. For the purpose of this exercise, leaves are divided into five basic categories: linear, round, oval, triangular and squiggly. (Five is a little more manageable than fifty!) Use the basic "leaf soup" mix to paint each one.

Linear
The leaves of the agapanthus, gladiolus and daffodil are linear. These are just a few of the many leaves that are linear in shape. The daylily, iris, tulip and oleander are some other examples.

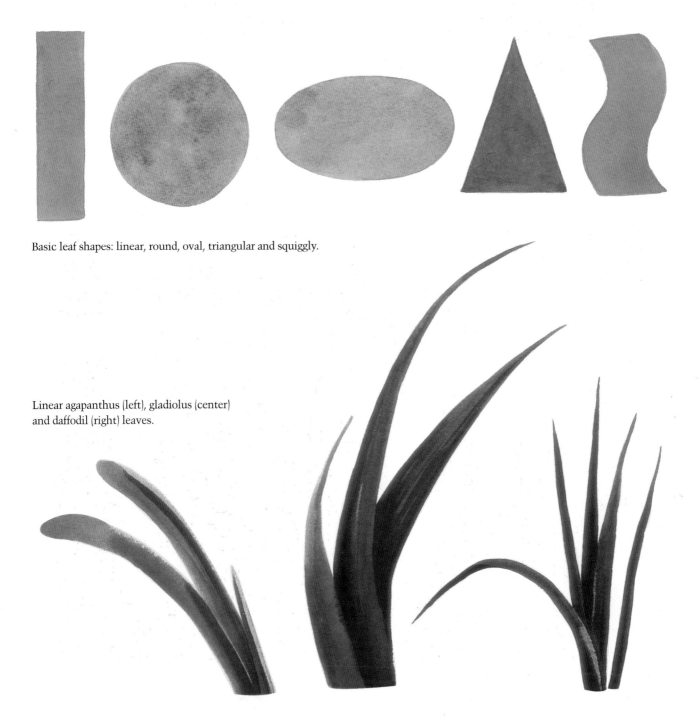

Basic leaf shapes: linear, round, oval, triangular and squiggly.

Linear agapanthus (left), gladiolus (center) and daffodil (right) leaves.

Round

You'll find round leaves on water lilies, geraniums and nasturtiums.

Round water lily (left), geranium (center) and nasturtium (right) leaves.

Here's a lovely iris showing off her linear leaves.

Oval
Hydrangeas, orange trees and roses have oval leaves.

Oval hydrangea (left), orange (center) and rose (right) leaves.

Here's an example of oval leaves at work (with some triangular ferns thrown in for good measure).

Triangular
Ivy, hibiscus and ferns have leaves that are triangular in shape.

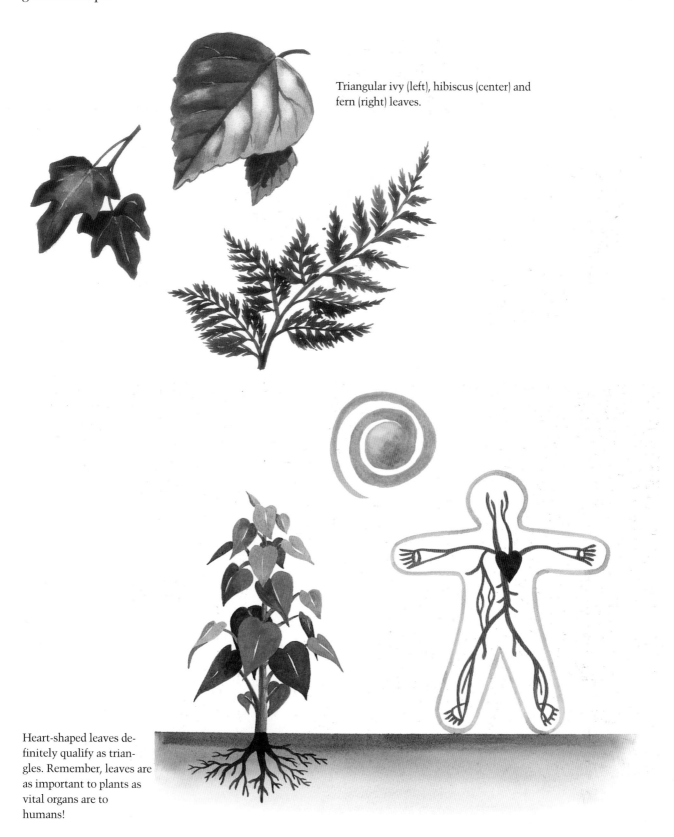

Triangular ivy (left), hibiscus (center) and fern (right) leaves.

Heart-shaped leaves definitely qualify as triangles. Remember, leaves are as important to plants as vital organs are to humans!

Squiggly

Squiggly leaves are a bit hard to categorize. They can be challenging to paint, which is why it is best to simplify them as much as possible. Squiggly leaves aren't hard to recognize—they have a lot of "stuff" going every which way! Daisies, cosmos and California poppies are good examples of plants with squiggly leaves.

Squiggly daisy (left) and cosmos (right) leaves.

These California poppies have an abundance of squiggly leaves.

All Together Now

Of course, you rarely find a garden or prairie or woodland limited to just one leaf type. Where different flowers tend to congregate, you'll also find a glorious profusion of leaf varieties. Proper portrayal of the greenery, as well as the accompanying blossoms, will make your floral paintings even more beautiful!

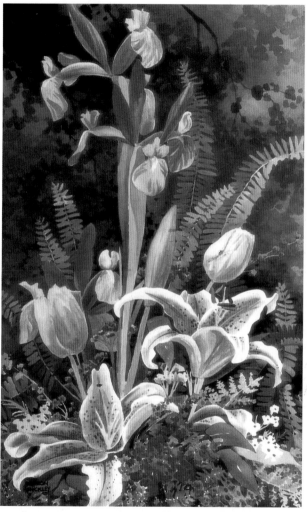

Lilies, Tulips and Iris
Sharon Hinckley
19½" × 30" (50cm × 76cm)

Merely Suggest Veins

Just because you can see the veins on a leaf doesn't mean you have to paint them (upper left-hand leaf). It can be a lot more interesting to merely suggest one or two veins (middle leaf) or to leave them out entirely and rely on the use of color to paint an accurately drawn shape (bottom leaf).

Impatiens
Sharon Hinckley
10" × 14" (25cm × 36cm)

Backgrounds

Like leaves, backgrounds don't always receive the attention they deserve. While the background is supposed to stay, literally, in the background, it's as important as any other part of the painting and needs careful consideration. In a way, designing a background is a bit like housekeeping—no one notices it when it's done properly. Only when a background doesn't work does it call attention to itself.

To properly portray mood and lighting, it's a good idea to spend some time practicing different backgrounds to get a feel for what is possible. Here are some examples.

A Warm Vignette
On a warm day you might start with a warm wash of Lemon Yellow, New Gamboge, Opera and a touch of Cadmium Orange. This background is more of a vignette, emphasizing certain areas without filling the entire picture plane.

Cool Day, Cool Wash

A cool day calls for a cool wash. The colors used here are Cerulean Blue, Cobalt Blue and Opera. In this example the entire picture plane is covered with diagonal brushstrokes. To give a moody effect, this was done while the paint was still wet.

A More Realistic Background

While the first two examples are completely abstract, this background is more realistic. First a wash of "leaf soup" mix containing Lemon Yellow, New Gamboge and Cobalt Turquoise was applied. As the wash began to dry, French Ultramarine and Alizarin Brown Madder were added to the soup for a darker second wash. While the first washes were still damp, the darker color was used to charge in some jungle leaf shapes.

Suggest Floral Shapes

Floral shapes are deliberately suggested in this background. Lemon Yellow, New Gamboge and Emerald Green create a spring-flavored "leaf soup" for the first wash. Cobalt Turquoise and Antwerp Blue are added to the soup for a deeper second wash. Next, areas of Lemon Yellow, New Gamboge and Opera are dropped in, followed by touches of Winsor Violet and Cadmium Orange. Finally, spatters of leaf soup mix are thrown on just for fun.

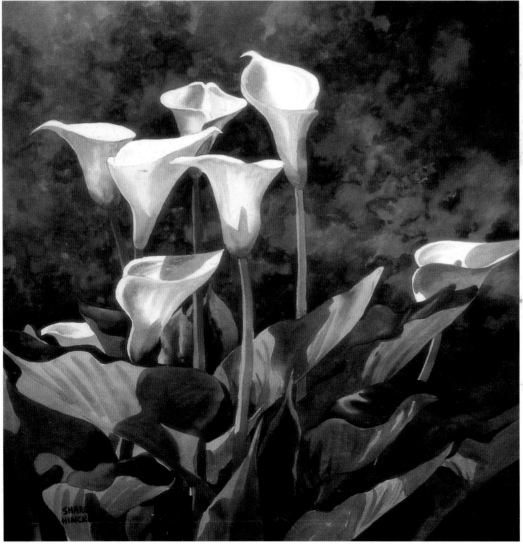

Notice how a well-integrated background creates a cool, dark, welcoming environment for these white lilies.

Although this painting has a background, it still looks flat.

A painting with no background is drained of all dimension and depth.

The answer is contrast. A dark, cool background pushes warmer, bright objects forward, creating multiple planes. The reverse is true of a warm background and cool objects.

Step-by-Step Demonstration: Radiating Petals

The Mantilija poppy, a flower with radiating petals, was once considered a weed. These flowers are hardy and able to grow in unforgiving soil. Unlike other radiating flowers, Mantilija poppies have six large, floppy petals that look and feel like slightly crumpled tissue paper. Their petals are arranged in two triads, one on top of the other.

Brushes
no. 8 or 10 round (or your
favorite brush)

Palette
Lemon Yellow
Opera
New Gamboge
Alizarin Brown Madder
Emerald Green
Cobalt Blue
Cerulean Blue
French Ultramarine

Step 1: Creating Form
Draw the outer shape of the flowers, then tone them lightly with a touch of Lemon Yellow and Opera. Paint the yellow centers using New Gamboge and Opera. Warm the upper flower's center by adding Alizarin Brown Madder. Cool the lower flower's center with Emerald Green. No two colors in nature are exactly alike; your paintings should reflect this variety.

Step 2: Repeating Colors
Repeat all of the colors used in step 1. (In fact, in the work shown, some shadow color was lifted from the underside of the petal on the upper right where it had been made too dark in step 1.)

Step 3: Begin the Background
Begin the background with a wash of Cobalt Blue, Cerulean Blue, Alizarin Brown Madder and Opera. Bring out the white of the poppies by surrounding them with color.

180

Step 4: Add Some Details

Go over most of the sky with a light wash of "leaf soup". Then paint the stems, leaves and buds. With a clean brush and clear water, lift out a bud to the left of the upper flower. Start painting secondary shadows at this point.

Step 5: More "Leaf Soup"

Using more "leaf soup", keep working on leaf shapes. Be careful to show their varied forms.

Step 6: Final Darks

Brush in some final darks, primarily with French Ultramarine, Alizarin Brown Madder and New Gamboge. These dark shadings will appear to be leaves. Add more where needed to emphasize the floral pattern. Sign your name with a medium or light green wash.

Step-by-Step Demonstration: Mexican Paper Flowers

Artificial flowers may not be what you would expect to paint for a demonstration, but these Mexican paper flowers are different. They are made by hand, and each one is unique. You'll return to the real thing with the next project, but keep in mind that the principles learned in this chapter can be applied to any subject, from paper to platypi.

Brushes
no. 8 or 10 round (or your favorite brush)

Palette
Lemon Yellow
Opera
New Gamboge
Alizarin Brown Madder
Emerald Green
Cobalt Blue
Cerulean Blue
French Ultramarine
Raw Sienna
Cobalt Turquoise
Scarlet Lake

Step 1: Start With Basic Shapes
Draw the basic flower shapes and octagonal vase. Paint lines to define the vase's shape with Cerulean Blue, Opera, Alizarin Brown Madder and Emerald Green. Vary the weight and color of your lines. Splash in the flower centers with Lemon Yellow and New Gamboge.

Step 2: Paint the Planes
Wash the sides of the vase with Lemon Yellow, Opera, Cerulean Blue, Emerald Green, Raw Sienna, Alizarin Brown Madder and Cobalt Blue. Paint each plane a slightly different hue. Wash the shadow using Cerulean Blue, Cobalt Blue, French Ultramarine, Alizarin Brown Madder and a touch of Opera. Paint the shadow warmer (redder) at the vase's base and cooler (bluer) as you move upward.

Step 3: Paint the Flower Colors
Paint the basic flower colors. The work shown used practically every color on the palette. Feel free to experiment!

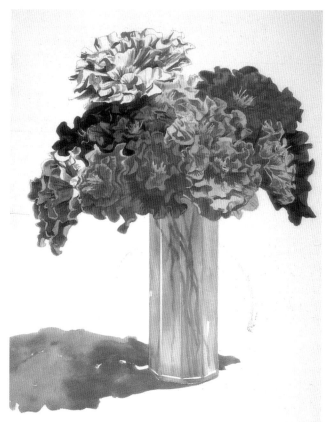

Step 4: Emphasize Each Flower Color

Continue to work on the orange and yellow flowers. Add a touch of Cobalt Turquoise and add shadows to the light turquoise flower. Emphasize the curly patterns in the paper and the individual colors of each flower.

Step 5: Define the Shadow Patterns

Define the shadow pattern on the orange flower with a mixture of Alizarin Brown Madder and Scarlet Lake. Use a mixture of Opera and Cerulean Blue on the pink flower. To define shadows on the other flowers, use a darker version of each flower's color or choose a hue from the same color family.

Step 6: Add Shadows to the White Flower

Paint shadows on the white flower. Use Cobalt Blue, Cerulean Blue and Alizarin Brown Madder for a basic white shadow mix. Enhance this with touches of Opera, Raw Sienna and New Gamboge, especially on the flower's lower-left petals. This flower provides a wonderful opportunity to play with reflected light.

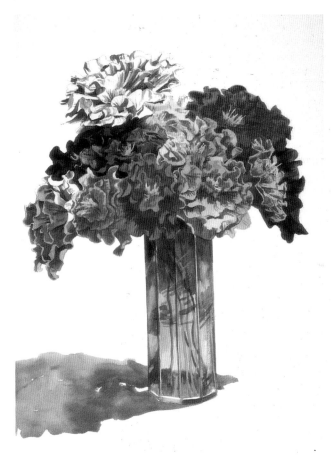

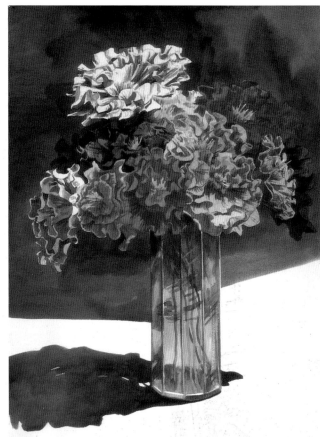

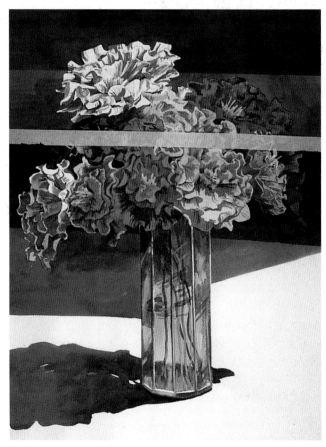

Step 7: Darken and Enhance the Vase
Darken and enhance the vase with more Lemon Yellow, Opera, Cerulean Blue, Emerald Green, Raw Sienna, Alizarin Brown Madder and Cobalt Blue. Remember, you should be able to see the cast shadow through the vase.

Step 8: Paint the Background
Paint shadows on the building and on the ground behind the vase and the flowers using a wash of Cobalt Blue, French Ultramarine, Cobalt Turquoise and Cerulean Blue. Add Alizarin Brown Madder to balance all this blue.

Step 9: Continue Painting the Background
Continue working on the shadows with these colors, adding touches of Opera and Raw Sienna for warmth. Suggest the horizontal board pattern, you can use masking tape (as shown) for even edges.

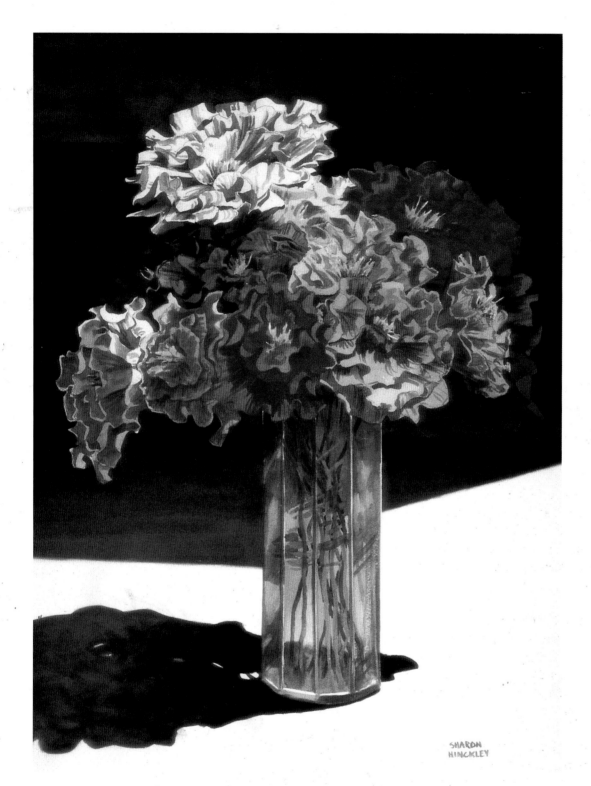

SHARON
HINCKLEY

Step 10: Finishing Touches

Finally, paint more stems using Emerald Green,
New Gamboge and Cobalt Turquoise for the lighter
stems and Cobalt Blue, French Ultramarine and
Alizarin Brown Madder for the darker stems.

Step-by-Step: Bird-of-Paradise

San Diego is the perfect place for a floral artist. The climate is mild, and it's possible to paint outdoors almost every day. The temperate weather is ideal for many kinds of flowers, including tropical flowers. Originally from South Africa, the bird-of-paradise is a striking flower. The orange blossoms do indeed look like tropical birds.

Brushes
no. 8 or 10 round (or your favorite brush)

Palette
Opera
New Gamboge
Alizarin Brown Madder
Cobalt Blue
Cerulean Blue
Raw Sienna
Cobalt Turquoise

Miscellaneous
pencil
masking tape

Step 1: Basic Shapes
Begin with a light pencil drawing of the basic shapes. Remember the four-quadrant grid? Create your focal point by placing the main blossom in the upper left with its stem reaching up through the bottom left and along the centerline, into the right. To paint the blossom, mix New Gamboge with Opera for a vibrant orange, dotting a little more yellow here and there. Add Alizarin Brown Madder to create depth. For the stem, use a standard "leaf soup" mix starting with New Gamboge and Cobalt Turquoise. Use plenty of Cobalt Blue and Alizarin Brown Madder to model the rounded shape.

Step 2: Paint the Leaves
Begin painting the foreground leaves and lower-right blossom. Continue with the "leaf soup" mix for the foliage. The leaves are warmer on the inside, so add a little Raw Sienna to portray this.

Step 3: Add More Blossoms

For the upper-center and left-hand blossoms, continue to use New Gamboge, Opera and Alizarin Brown Madder, but in different proportions. No two blossoms should appear exactly alike. Remember, there should be both color unity and variety.

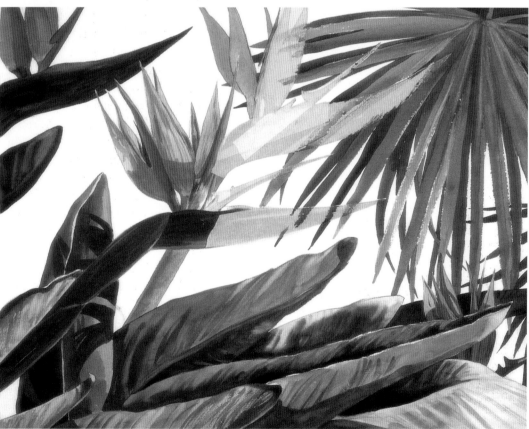

Step 4: Add Palm Fronds

Since bird-of-paradise flowers tend to grow in one direction, counter this by brushing in some palm fronds. Use masking tape for the edges you wish to keep sharp. You should have a generous amount of "palette soup" going now, so add some Cerulean Blue and Opera to paint the grayish blue areas of the palm fronds.

Step 5: Paint More Leaves and Fronds

Adjust your "palette soup" to add a warmer palm frond in the upper-left corner and a cooler frond behind the upper-center blossom. You can also paint another background leaf beneath your center of interest. Remove the masking tape and use the "palette soup" to complete the stem and leaf of the upper-center flower. Remember to include a little reflected blossom color along the leaf's upper edge.

Honor the rule of contrast by remembering that the eye will be drawn to the area where the darkest dark and the lightest light meet. Your main blossom should be in that area. The black color next to this brightest orange blossom is really just a mixture of whatever pigments were darkest on the palette.

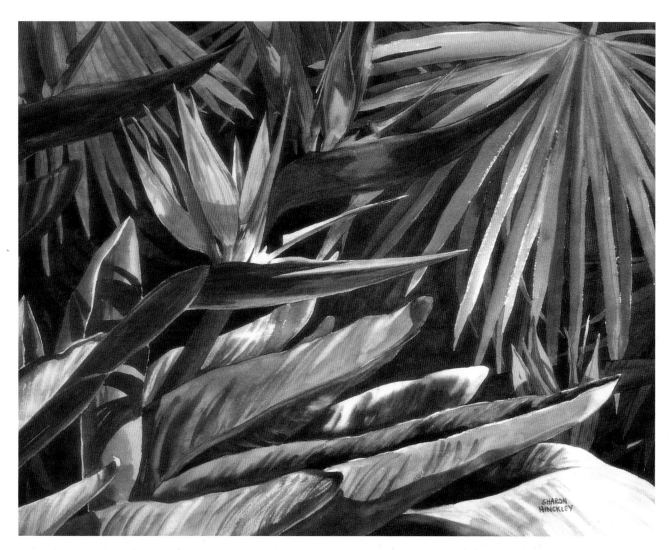

Step 6: Final Touches

Finally, paint the darkest background area, suggesting a few palm fronds in the process.

PAINTING TREES, MOUNTAINS AND ROCKS

Trees, mountains and rocks cover a huge portion of the natural landscape. They add majesty and solidity to the world.

Trees supply us with life-giving oxygen and give us cool shade and comfort while enhancing everyone's lives with their beauty.

Mountains can be a challenge for humans to climb or carve—or they can simply be enjoyed from a distance.

Rocks are the crust of the earth. You can admire their strength, mine them and even make beautiful statues out of them. Remember that Michelangelo's David began as a piece of rock.

Enjoy this tour of how to paint trees, mountains and rocks, then use what you learn to create your own masterpiece. Learn important facts to help you paint realistic and beautiful trees, mountains and rocks. Paint the step-by-step demonstrations in this chapter and you'll see amazing improvements in your next landscape painting.

Head in the Clouds
Zoltan Szabo
22" × 30" (56cm × 76cm)

Deciduous Trees—Elm

The deciduous tree group covers the land with wonderful foliage. Their color is fresh—yellow-green in the spring, deep green during summer, brightly colored yellow-orange or red in the fall—and their leaves fall off in the winter. Their foliage grows in clumps on the branches and looks like umbrellas. These clumps have light tops and dark interiors. The branches are thickest at the trunk and thinnest at the tip. Deciduous trees are the best shade trees, and they supply artists with wonderful moods.

All artwork on pages 190 to 217 was created by Zoltan Szabo.

Elm in Summer
The leaves are full of moisture in the summer. They are at their heaviest and spread the branches to the maximum. The Y is fully open.

Elm in Spring
The characteristic Y shape in spring is somewhat open because the buds are becoming fuller and heavier at this time. Their weight starts to spread the branches

Elm in Autumn
Elms remain wide in autumn, almost like in summer. The leaves are still damp and are dominated by yellows and their shaded, warm analogous colors—oranges and siennas.

Elm in Winter
The branches tighten their Y in winter because the leaves are gone and nothing weighs them down.

Oak Trees

Oak in Summer
Oaks spread their rugged branches wide. The summer foliage is full and the weight of the leaves is well supported by the powerful limbs.

Oak in Autumn
Oak leaves turn reddish brown in late autumn and drop slowly, clinging to the branches even during winter. The dry leaves supply welcome warm color amid the cool color that dominates the winter landscapes.

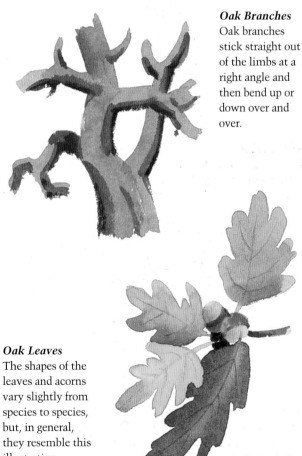

Dying Oak Leaves
Oak leaves take a long time to deteriorate. They lose color after they fall off the tree, but they retain their shape for quite awhile.

Oak Branches
Oak branches stick straight out of the limbs at a right angle and then bend up or down over and over.

Oak Leaves
The shapes of the leaves and acorns vary slightly from species to species, but, in general, they resemble this illustration.

Willow Trees

River Willow

Branches of the river willow spread in a zigzag manner. New shoots commonly grow out of the sharply bending elbows of the limbs. The foliage occupies the tips of the delicate twigs in clusters.

Pussy Willow Branch and Seeds

Here are two stages of the soft puff which contains the seeds of the tree.

using tip of the brush

using belly of the brush

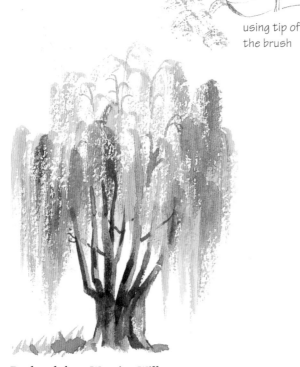

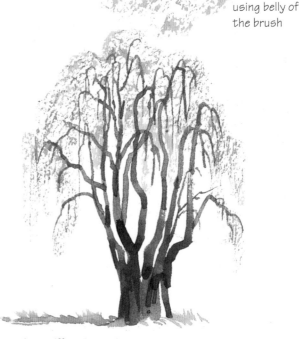

Drybrush for a Weeping Willow

Weeping willows form their leaves on long, very thin branches that bend and hang straight down from their own weight. The dry-brush technique is ideal for painting the drooping character of this tree. The tip of the brush and the hair next to it do the best job.

Weeping Willow in Spring

Young leaves on the tree have a lacy texture. The structure of the branches is clearly visible when the willow is in this condition. Drybrush to achieve this texture; hold the brush sideways and use the belly. Do not touch the paper with the point of the brush.

Dogwood Trees

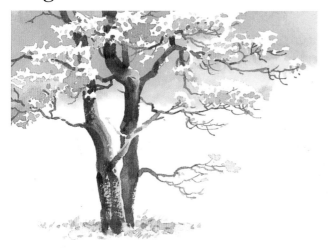

Dogwood in Spring

Dogwood trees show off a large load of blossoms in the spring. The dogwood is a Southern tree but grows as far north as Massachusetts. White, shown here, is the most common blossom color. The blossoms grow in heavy clusters, creating exciting negative patterns. The branches hold up the flowers like upturned claws.

Dogwood Flower

A single flower shows a burn mark at the end of each of four petals. Notice the slightly darker veins in the petals.

Pink Blossom

The pink blossom has the same burn marks and veins as the white flowers but in a rich pink color. The new leaves have a slight reddish point that turns green later.

Pink Dogwood

Pink dogwood blossoms are not as common as the white blossoms. Their beauty adds color to the countryside after the modest colors of winter. The structure of the tree is identical to that of the white dogwood.

Sycamore Trees

Sycamore Leaf
The sycamore leaf resembles that of the maple but is much larger.

Sycamore
The sycamore is most easily recognized by its impressive size and the dark leopard-like spots on its light bark. The branches protrude at a 90-degree angle around the trunk and curve wildly in every direction.

Base of the Sycamore
The sycamore trunk is darker at the base and lightens as it ascends. The dark leopard-like spots break up the dark color. Young shoots grow all around the base.

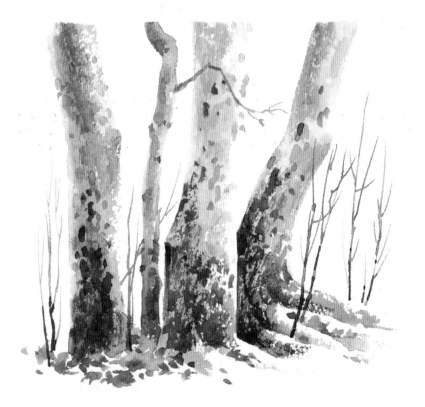

Evergreens

The word *evergreen* is self-explanatory. The color of the foliage on these beautiful coniferous trees doesn't change. They have needles rather than flat leaves like their deciduous cousins have. The size of adult evergreens varies tremendously from a dwarf-size alpine fir to a giant sequoia. Some evergreens grow in tough environments like very high mountains, while others enjoy a semitropical climate. They're as hardy as they are beautiful. The longest-living trees on Earth are evergreens, truly nature's wonders.

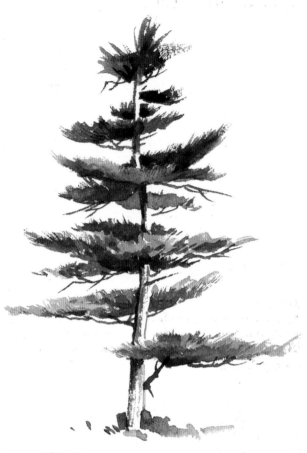

Bark on Old Pines
The bark on older pine trees is coarse. To paint it, use a dark brown base color in a tacky consistency and knife out the light spots with the heel of your palette knife.

Eastern White Pine
There are dozens of pine species, but the eastern white pine is one of the most common. The foliage clusters are composed of long needles and point upward. Pine branches start upright from the trunk and form an elbow as they turn downward carrying the heavy load of needles.

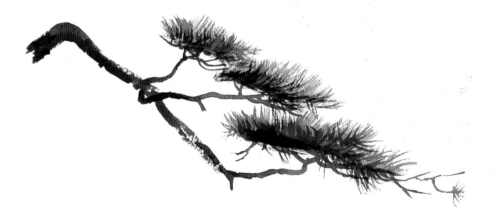

Branch With Foliage
Notice how the thin, expanding twigs of the branches hold up the foliage like a waiter's fingers hold up a tray.

Palm Trees and Tropical Vegetation

A tropical climate is too hostile for most deciduous and coniferous trees. It's a perfect milieu for palms, however. These hardy and elegant looking trees dress up a desert landscape and make an otherwise desolate terrain appear full of life and beauty. They are different from other trees, however. Rather than living in concentrated numbers such as in forests, palms are more individualistic and like more space around them. They work well as strong centers of interest or beautiful accents.

Coconut Palm
Straight up or curved trunks are natural characteristics of this family of palms. The branches consist of soft rows of pointed leaves that can withstand hurricane-strength winds and survive.

Protected Coconut Palm
When coconut palms grow in a protected area, their trunks are straight and the branches grow like cogs in a wheel.

Palm Trunk
The surface of the coconut palm trunk is smooth but shows ringlike growth marks.

Step-by-Step Demonstration: Forest's Edge

Brushes

1½-inch (38mm) soft slant
¾-inch (19mm) aquarelle
2-inch (51mm) slant bristle

Permanent Violet Bluish
Cobalt Blue Light
Cupric Green Deep

Palette

Permanent Green Yellowish
Raw Sienna

Miscellaneous

masking tape
latex masking fluid

Step 1: Masking and Background

On a dry surface mask out vertical shapes for future light tree trunks;
use strips of masking tape cut to varied widths. Also mask out a few
thin branches using latex masking fluid. After masking, wet the paper
and apply a few background colors in a very light value. Use your 1½-
inch (38mm) soft slant brush lightly filled with Permanent Green Yel-
lowish and Raw Sienna for the middle ground and Cobalt Blue Light
and Raw Sienna for the misty background mountain.

Step 2: Paint the Middle Ground

While the masking is intact, establish the midground trees using Permanent Green Yellowish with Raw Sienna for the bright green foliage and Cupric Green Deep and Permanent Violet Bluish for the darker evergreens. Before these washes dry, carefully peel off the masking tape without tearing the surface. Later when the surface is completely dry, rub off the latex as well. The light foreground trees will be exposed as pure-white negative space.

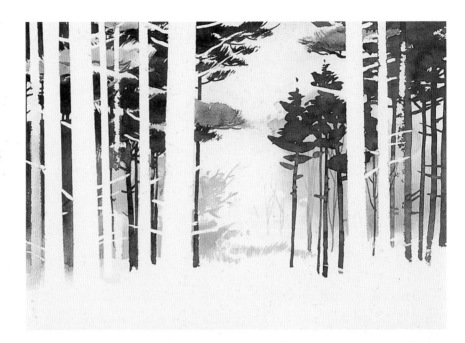

Step 3: Paint Trees in the Foreground

Using your ¾-inch (19mm) aquarelle brush, paint the tall trees with Raw Sienna and Cobalt Blue Light as a base wash and drybrush the bark texture later with Permanent Violet Bluish, Raw Sienna and Cupric Green Deep. Only the grassy foreground remains.

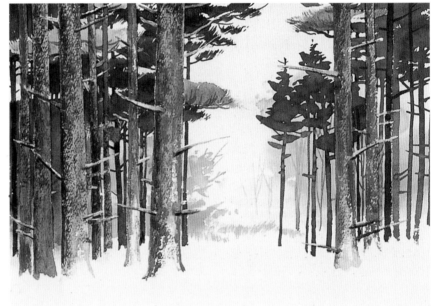

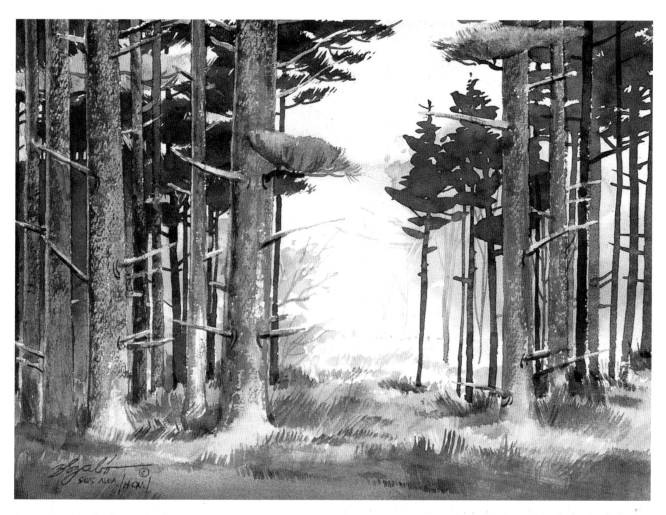

Step 4: Finish the Painting
To complete the painting, switch to your 2-inch (51mm) slant bristle brush and paint the clusters of grass. Start with a rich mix of Permanent Green Yellowish and Raw Sienna, and add Permanent Violet Bluish and Cupric Green Deep for the darker shades. Make small detail corrections as needed.

Forest's Edge
Zoltan Szabo
11" × 15" (28cm × 38cm)

Mountains

As landscape subjects mountains are unsurpassed. Because we often see them from a distance—blue and misty—they automatically add the illusion of depth to a painting. Because constant changes occur on mountains, any creative change portrayed by an artist usually feels natural and believable. Mountains can provide a great setting for closer objects or become a dramatic center of interest themselves. Distant mountains have only one enemy—detail. Atmospheric conditions simplify their shapes and filter out details, so add details sparingly. You cannot paint mountains too simply, but it's easy to paint too much detail.

Distant High Mountains
Both cool and warm colors enhance this painting. Details are at a minimum because of the distance involved. The soft, large sky was created with a wet-into-wet technique using a 2-inch (51mm) soft slant brush. The snow-covered peaks next to the dark sky stand out in high contrast and create the focal point of the painting. Scale causes a convincing illusion of depth here despite the reduced value variety.

Big Sky Country
Zoltan Szabo
22" × 30" (56cm × 76cm)

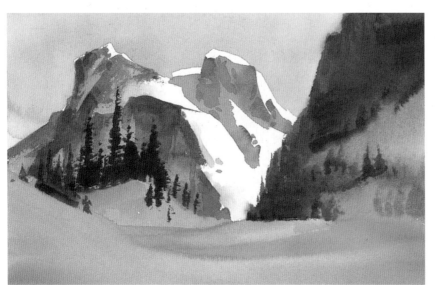

Middle Ground Mountains and Hills
This study shows a mountain at midrange rather than in the distance. Some details are hinted at here. The simplicity of the sketch is due to the colors. Permanent Violet Bluish and Cupric Green Deep supplied the blues, greens and shaded-rock colors. Orange Lake is responsible for the warm glow behind the evergreens; it provides the darkest value when mixed with the other two colors.

Tips for Painting Mountains

While there are no absolutes for a truly creative artist, there are some practical shortcuts that result from learning and experience.

1. Cool, transparent colors like Phthalo Blue, Phthalo Green, Phthalo Violet, Primary Blue-Cyan, Antwerp Blue, Turquoise Green, Cupric Green Deep and Permanent Violet Bluish work well on mountains in the middle ground because of their intensity and ability to go dark and stay clean.

2. The more misty distant mountains get a softer atmospheric feel with diluted, reflective colors like Cobalt Blue Light, Ultra-marine Deep and Cerulean Blue.

3. Earth colors supply good neutralizing complements, but only when mixed in diluted, thin liquid consistency. When reflective and earth colors are thick, they go muddy and lifeless.

4. Avoid details on faraway mountains.

5. Don't use harsh tools like a palette knife or the tip of a brush handle for distant mountains. They create hard texture that belongs only on closer shapes.

6. Above all, go simple in the distance.In each of the illustrations here the colors are severely limited and tonal value becomes the most important component. On three the mountains are represented with negative shapes (light against dark). On the other three they are positive (dark against light).

A three-color palette was used here, a combination of two warm colors and one cool: Permanent Yellow Deep, Verzino Violet and Cupric Green Deep. The sketches were started on dry paper to get sharp edges. Washes were applied so quickly that they easily blended with each other. For the tree shape, very little green and a lot of yellow were used.

Verzino Violet, Cobalt Blue Light, Permanent Green Yellowish and Cupric Green Deep are the colors used in this study. For the sky area the colors were wet-charged into each other and left as they oozed.

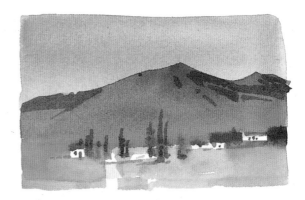

For this study, Cobalt Blue Light, Verzino Violet and Cupric Green Deep were used. Blue remained the dominant color even though a little green and violet were wet-charged into the sky.

The Cobalt Blue Light sky was painted first. After it dried the mountain was painted with Cupric Green Deep. The darkest shapes are a mixture of all three colors with the violet the strongest.

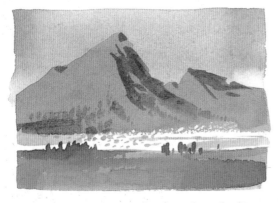

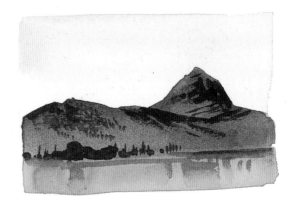

This mountain scene was started with a pale wash of Permanent Violet Bluish for the sky. After this dried, the shapes of the mountains were painted using a mix of Cupric Green Deep and Permanent Violet Bluish. The green foreground is Cupric Green Deep and Burnt Sienna. After everything was dry the little orangy-color patches were made with a Burnt Sienna glaze.

This study was created using two light colors and one dark: Permanent Yellow Deep, Permanent Green Light and Permanent Violet Bluish. The sky was wet-charged with a pale wash of green and yellow. After drying, violet was added to the mix and the mountains were painted in medium value with the violet dominant. The foreground is green and yellow in a stronger value than the sky. For the rocky modeling on the mountain, all three colors were used with violet the strongest.

Step-by-Step Demonstration: High Spring

Brushes
1½-inch (38mm) soft slant
1-inch (25mm) aquarelle
1½-inch (38mm) slant
 bristle

Palette
Permanent Green Yellowish
Burnt Sienna
Permanent Violet Bluish
Cobalt Blue Light
Cupric Green Deep

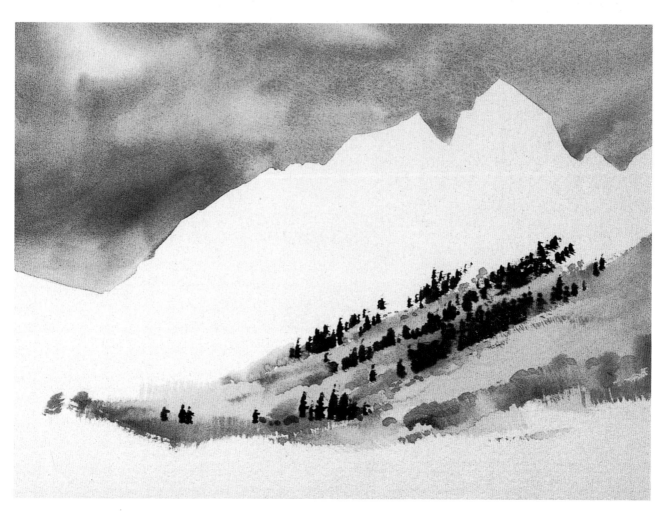

Step 1: Paint the Sky and Middle Ground
On dry paper, paint the sky as a light and very wet shape using your 1½-inch (38mm) soft slant brush. Apply the wash rapidly after defining the edge of the mountains. Use Cupric Green Deep and Permanent Violet Bluish for the blue portion and Cobalt Blue Light and Burnt Sienna for the darker cloudy area.

Next paint the springlike colors of the middle ground using light washes of Permanent Green Yellowish, a touch of Burnt Sienna and some Cupric Green Deep, using the same soft slant brush. While this wash is still wet, switch to your 1½-inch (38mm) slant bristle brush and dip the long end in a very dark mix of Burnt Sienna, Cupric Green Deep and a little Permanent Violet Bluish. Turn the brush so that the long end is at the bottom, and with quickly repeating contact, suggest the rows of evergreens.

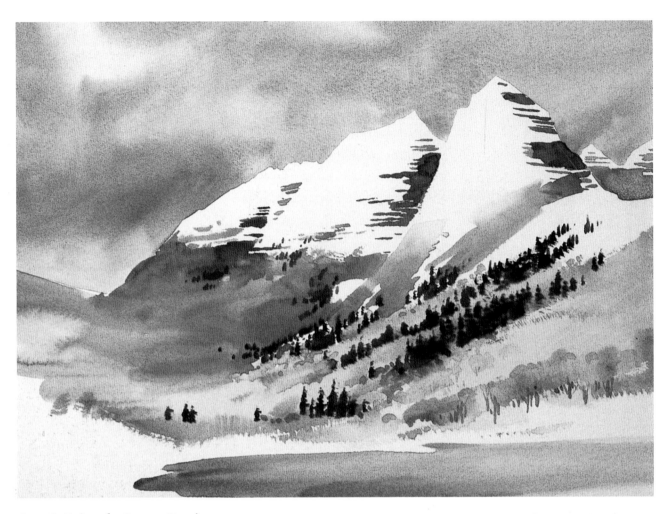

Step 2: Paint the Lower Portion

Paint the exposed rocky part of the mountains up to the snow line.
Carry the same color over to the left side slope as an underpainting
using your 1-inch (25mm) aquarelle. After changing colors to
Cupric Green Deep, Cobalt Blue Light, Permanent Green
Yellowish and a touch of Burnt Sienna in varied combinations,
paint the portion of the lake.

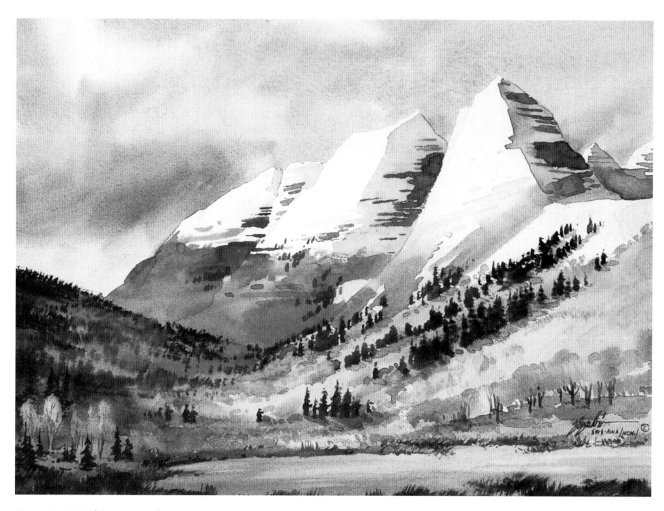

Step 3: Finishing Touches

With your 1½-inch (38mm) slant bristle brush, paint the dark forest on the left side. Apply the dark grassy edges of the lake with the same brush using the same colors as for the evergreens on the other side. Paint the shaded sides of the mountains as well as the cast shadows of the trees over the sunny ground color. Mix this evenly applied wash with Cupric Green Deep, Cobalt Blue Light, and a touch of Permanent Violet Bluish in your aquarelle brush. Complete the painting with a few light green trees and their shadows just above the lake with Cobalt Blue Light and Permanent Green Yellowish.

High Spring
Zoltan Szabo
11" × 15" (28cm × 38cm)

Rocks

Painting rocks means painting geological history. Their strength has fascinated mankind since the cave paintings through David's encounter with Goliath, from the pyramids to the marble statue of Pieta. When you use our Earth's oldest material for a painting subject, the treatment should allude to its solidity, age, majesty and permanence. Rocks come in all colors from white to black. Some are smooth from erosion; some are jagged. Some are big (cliffs), and some are small (pebbles). Because they're everywhere, they can serve as a complement or center of interest in a landscape painting.

Jagged Rocks

For basic jagged rocks, paint the dark shape of the rocks with a ¾-inch (19mm) aquarelle brush filled with a thick wash of Burnt Sienna and Primary Blue-Cyan. While this wash is still tacky moist, scrape off the excess paint by pressing the heel of your palette knife into the paint repeatedly. Because the blue is more staining than the sienna, the shapes you knife out will stay blue.

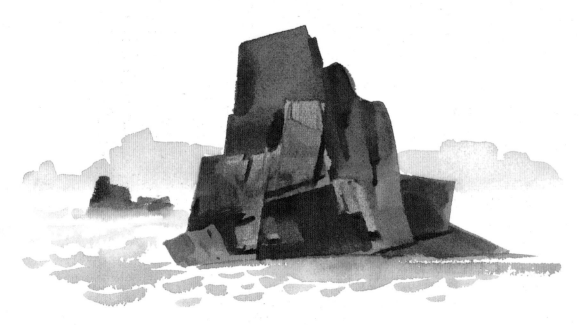

Tightly Fused Units

Occasionally, jagged rocks appear in a large, tightly fused unit. For this study, use a ¾-inch (19mm) aquarelle brush and Cupric Green Deep, Burnt Sienna and Permanent Violet Bluish together as a dark wash. To prevent monotony you can vary the dominance of the thick wash from spot to spot. Also, scrape off the light sides of the rocks with the heel of your palette knife before the color has a chance to dry.

208

Rounded Rocks

Paint the shapes of these rocks using a rich, dark wash of Permanent Green Yellowish, Ultramarine Deep and Verzino Violet in a 1-inch (25mm) aquarelle brush. As soon as you put down the brush, scrape off the light texture. Hold the knife firmly, keeping the wide part upward. It's important to move the knife with an even speed from left to right for each rock shape.

Glacial Rocks Covered With Moss

This study was painted with Verzino Violet, Green Blue, Raw Sienna and Permanent Violet Bluish. For the base wash, the rock area was covered with a medium-light wash of Green Blue, Raw Sienna and a touch of Permanent Violet Bluish. To create a little form, this was shaded with Permanent Violet Buish and it's complement, Raw Sienna. Once this was dry, the dotted texture was sponged on with a natural sponge. Four separate glazes were used with all four colors in varied combinations; each application was allowed to dry thoroughly before the next one was applied. The cracks on the rocks were painted last.

Complex Rocks
These rocks were painted exactly the same way as the two previous examples, except
for the colors. Burnt Sienna, Ultramarine Deep and Permanent Violet Bluish were used
for the rocks, and a little Cupric Green Deep was added to the glazes of the water.

Add Boldness
The strength of stone is a
psychological attraction and
usually adds boldness to a
painting.

Step-by-Step Demonstrations: Cuddlers

Brushes

2-inch (51mm) soft slant
¾-inch (19mm) aquarelle
1-inch (25mm) slant bristle
no. 3 script liner (rigger)

Burnt Sienna
Permanent Violet Bluish
Cobalt Blue Light
Cupric Green Deep

Palette

Raw Sienna

Miscellaneous

palette knife

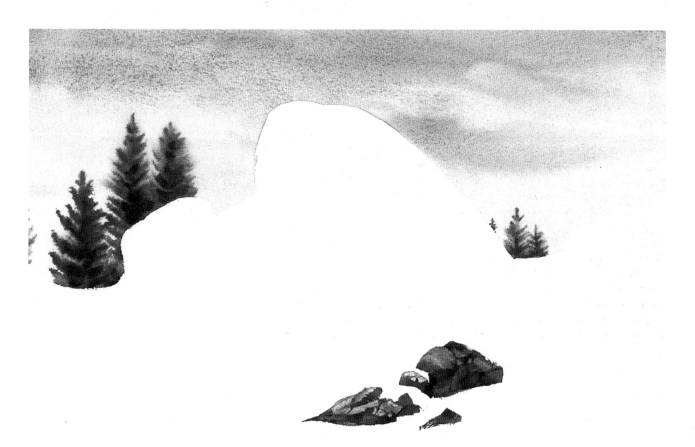

Step 1: Paint the Background and Small Rocks

On a dry surface, paint the sky shape right down to the edge of the future boulders with a very wet wash of Raw Sienna in a pale value. Into the wet wash, suggest the clouds with Cobalt Blue Light and Burnt Sienna using your 2-inch (51mm) soft slant brush. Into the still-moist color, paint the evergreens with rich paint using your 1-inch (25mm) slant bristle brush. Touch the surface of the paper with the edge of your brush separately for each branch. Switch to your ¾-inch (19mm) aquarelle and paint the silhouette of the foreground rocks with Cobalt Blue Light, Burnt Sienna and Permanent Violet Bluish in a thick consistency. With the heel of your palette knife, squeeze off the wet color and create the light modeling on the rocks.

Step 2: Paint the Large Rocks

Repeat the procedure for the larger rocks one at a time, making sure to lift off the damp color before each shape has a chance to dry. Protect the snow-covered area as you apply the color with your ³⁄₄-inch (19mm) aquarelle brush.

Lost-and-Found Technique

When a brushstroke is hard on one side but blended away on the other, it is called a lost-and-found edge. To create this edge, use a 1-inch (25mm) slant bristle brush, thirsty moist, with its long-hair tip pointing to the edge you want to blend. Drag the brush parallel to the edge of the paint, actually touching the wet color. (Never drag the brush away from the paint or it will spread the color too far.) The thirsty brush moistens the paper next to the wet color and soaks up some of the color simultaneously, allowing the remaining paint to spread into the wide moist area and blend away to nothing.

Step 3: Shade the Snow and Add Branches

After these shapes are dry, shade the snow around the rocks using Permanent Violet Bluish, Cupric Green Deep and a touch of Burnt Sienna. Apply the wash with the same aquarelle brush, using the lost-and-found technique (see sidebar). At the top edge of the snow-covered rock on the right side, add a few branches of deciduous trees with your no. 3 script liner. With the aquarelle brush add a light tone for the branches.

Step 4: Finishing Touches

To finish the painting, expand the shading on the snow similar to step 3 for the smaller shapes. For the bottom edge, continue with the same colors but change to your 2-inch (51mm) soft slant brush in order to apply the color quickly.

Cuddlers
Zoltan Szabo
11" × 15" (28cm × 38cm)

Rocks Next to Water

Near and Distant Rocks

The west coast of North America is sprinkled with spectacular rocks. The sky was painted with a wash of Raw Sienna, Ultramarine Deep and some Burnt Sienna. About two-thirds down, the edge was blended into the white paper. While the paper was still wet, pale rocks with the same colors in a slightly darker value were dropped into the middle ground.

The darkest rocks in the foreground came next. Ultramarine Deep, Burnt Sienna and Permanent Violet Bluish were used in varied dominance for the rocks and their reflection. The same colors that were used for the sky were used for the sandy foreground but were carefully painted around the white reflections using rapid, horizontal brushstrokes. The sparkling edges were created with dry-brush touches.

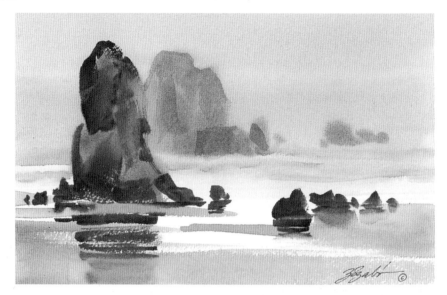

Rocks From a Distance

For this quick study from the coast of Oregon, five colors were used. The gray sky is a light wash mixed from Cobalt Blue Light and Burnt Sienna (with a drop of Cupric Green Deep charged in spots). After this dried, the distant mountain was glazed with Cobalt Blue Light and Burnt Sienna. When this wash was dry, the big, dark rocks were superimposed using Burnt Sienna, Cobalt Blue Light and a little Permanent Violet Bluish. The water is a combination wash of Cobalt Blue Light, Cupric Green Deep and Burnt Sienna. The sandy beach is Raw Sienna, Burnt Sienna and Cobalt Blue Light. While this wash was still wet the white foam was lifted out with a thirsty brush.

Step-by-Step Demonstration: Floating Castle

Brushes
2-inch (51mm) soft slant
¾-inch (19mm) aquarelle
1½-inch (38mm) soft slant

Palette
Cadmium Yellow Lemon
Verzino Violet
Permanent Violet Bluish
Cobalt Blue Light
Cupric Green Deep

Step 1: Wash in the Background

Start on wet paper with Cadmium Yellow Lemon and Verzino Violet for the horizon. Use your 2-inch (51mm) soft slant brush and spread the orange color up into the sky as well as down into the reflecting water. Simultaneously paint the dark northern sky starting at the top with the same brush, using Cupric Green Deep and Permanent Violet Bluish and adding Verzino Violet near the horizon to blend with the warm colors. Use a similar approach for the dark sky reflections in the foreground. While the entire paper is still quite damp, wipe off the shape of the iceberg and its reflection and recover most of the light paper.

Step 2: Paint the Iceberg and Reflection

Use your ¾-inch (19mm) aquarelle brush to paint the base washes for the iceberg using mostly Cupric Green Deep, but adding Permanent Violet Bluish and some Cobalt Blue Light. Next paint the deep reflection with the same colors in a much darker value.

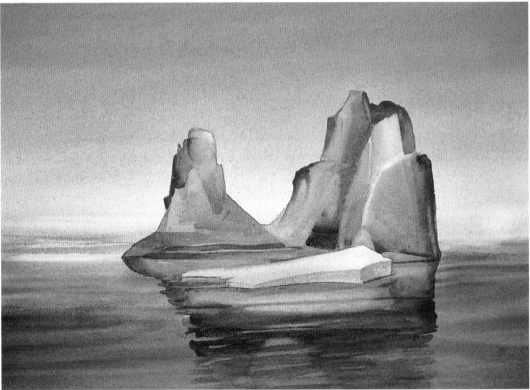

Step 3: Lift Out Light Shapes

Continue to create definition on the iceberg as well as on the reflection. Lift out more light shapes from the right side of the largest part of the iceberg and lighten the reflection of the sky between the two points.

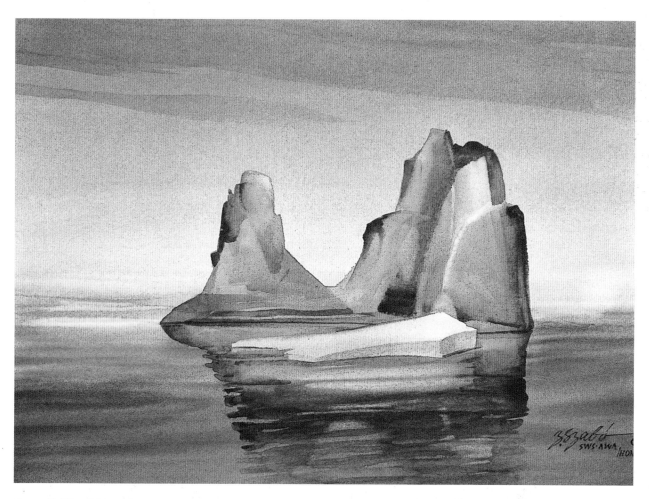

Step 4: Final Touches

Make a few adjustments as necessary to show medium light in the reflection. Then mix a neutral wash of Permanent Violet Bluish, Cupric Green Deep and just a touch of Cadmium Yellow Lemon. Using your 1½-inch (38mm) soft slant brush, paint with the neutral wash a few gently glazed shapes to the top of the sky, indicating clouds.

Floating Castle
Zoltan Szabo
11" × 15" (28cm × 38cm)

WINTER REFLECTIONS

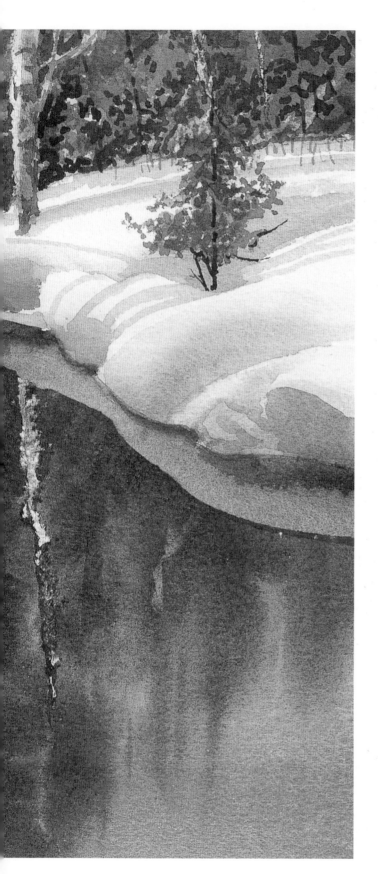

PAINTING SNOW AND WATER

Snow and water are wonderful subjects to paint because they can be found in many forms. There are sunny snowscapes with crisp blue shadows, soft-edged snow banks along a still river, the rushing white water of a turbulent mountain stream, mirrorlike reflections of sky and trees on a northern lake, the mesmerizing crash of breakers on coastal rocks, and much more.

On the following pages are several demonstrations as well as helpful information for painting snow and water. The palettes used for the demonstrations are limited. Look around you, become inspired by nature and use this information to create your own beautiful watercolor paintings.

Winter Reflections
Jack Reid
11" × 15" (28cm × 38cm)

Step-by-Step Demonstration: Painting Shadows on Snow

Transparent watercolors are a powerful medium for expressing the feelings of translucent, transparent snow. With just a few colors you can create an illusion of softness, hardness or brightness.

Colors bounce around when they hit snow and tend to become exaggerated, seen as colors that don't really exist. This Quebec scene shows the power of placing rather dull-colored buildings next to a luminous-colored sky, thus suggesting both strong sunlight and shadows. The colors in the palette that hold those luminous qualities are Rose Madder Genuine, Aureolin Yellow and Cobalt Blue.

All artwork on pages 218 to 243 was created by Jack Reid.

Paper
300-lb (650gsm) cold-pressed watercolor paper

Brushes
1/2-inch (12mm) flat
no. 12 lettering
no. 8 round

Palette
Aureolin Yellow
Burnt Sienna
Cobalt Blue
Rose Madder Genuine
Ultramarine Blue
Viridian

Miscellaneous
utility knife

Step 1: Paint the Hills and Shadows
Mix a purple-blue wash with Rose Madder Genuine, Aureolin Yellow and Cobalt Blue. Using your 1/2-inch (12mm) flat, paint the distant hills, as well as the shadows between the buildings.

Step 2: Paint the Roof
Use the same brush and the purple-blue mix to paint a graded wash on the roof of the building. Let dry.

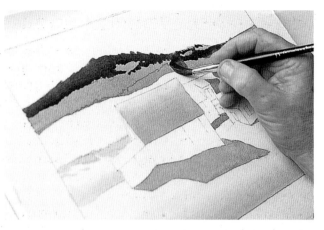

Step 3: Paint the Foreground
Continue with the same mix and paint a graded wash in the foreground.

Step 4: Add the Tree Line
Mix a wash of Ultramarine Blue, Burnt Sienna and Viridian. Use your no. 8 round to paint the tree line behind the hill, carrying it down the hill.

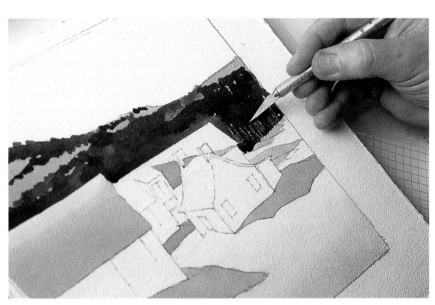

Step 5: Score the Wet Paint
Score the wet paint with a utility knife to suggest the trunks of trees on the right-hand side of the barn.

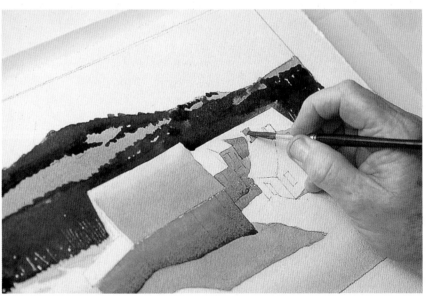

Step 6: Create a Gradation
In the closest part of the main barn, paint a Burnt Sienna wash using your no. 12 lettering brush. Charge this with a wash of Burnt Sienna and Ultramarine Blue to create a gradation. Repeat this on the barn behind the main barn.

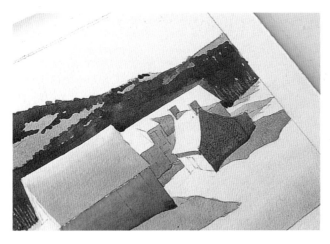

Step 7: Define the House
Mix Burnt Sienna, Ultramarine Blue and Rose Madder Genuine. With your no. 12 lettering brush, paint the main structure, boards and windows of the house. Add a pink tinge of Rose Madder Genuine to the base of the house.

Step 8: Wash In the Sky
Mix a luminous yellow-orange wash from mostly Aureolin Yellow and Rose Madder Genuine. Place the picture upside down and use your ½-inch (12mm) flat to paint the yellow-orange wash quickly across the sky. Mix a gray-brown wash for clouds by adding Cobalt Blue. Turn the picture sideways, and use your no. 8 round brush and wet-into-wet to brush clouds in the sky.

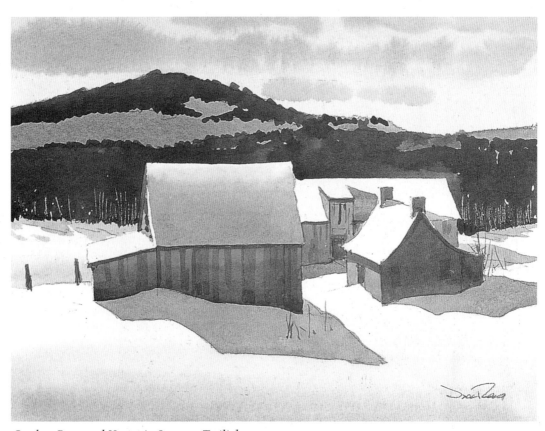

Quebec Barn and House in Snow at Twilight
Jack Reid
9" × 12" (23cm × 30cm)

222

Step-by-Step Demonstration: Painting Heavy Snow

In this painting, strength is achieved by contrasting the shocking white snow against the dark trees behind the bench. The weeds poking through the snow, painted with a no. 3 script liner, complete the picture. Be careful you don't get "rigger remorse." That happens when people get picky with the script liner (rigger) and paint far too many details.

Paper
300-lb (650gsm) rough
 watercolor paper

Brushes
no. 3 script liner
no. 12 round
no. 12 lettering

Palette
Burnt Sienna
Cobalt Blue
Ultramarine Blue

Miscellaneous
utility knife

Step 1: Wash In the Background
Mix a luminous gray wash from Cobalt Blue and Burnt Sienna. Set it aside for a minute. Now turn the painting upside down, and using your no. 12 round and very clean water, paint a graded wash on the left-hand side around the top of the snow-covered bench.

Step 2: Add the Shadow
Turn the painting right side up and, using the same brush with the gray wash from the previous step, paint the shadow under the bench.

Step 3: Deepen the Wash

Deepen the wash and paint a graded wash along the edge of the bench with your no. 12 round. Start with clear water and add pigment to create a soft gray. This is a bit tricky, so take your time and pay attention; it's very rewarding once you bring it off.

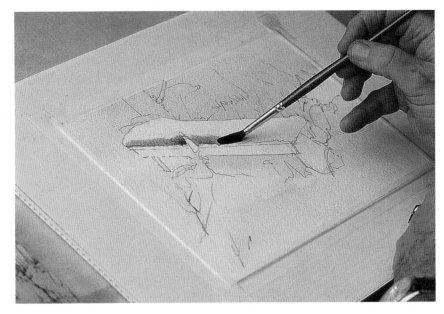

Step 4: Paint the Horizontal Top

Now mix a brown wash from Burnt Sienna and Ultramarine Blue. Use your no. 12 lettering brush to paint the horizontal top of the bench up to the edge of the snow. Leave a bit of white on the snow-covered bush in front of the bench. You may find it helpful to turn the painting upside down for this step.

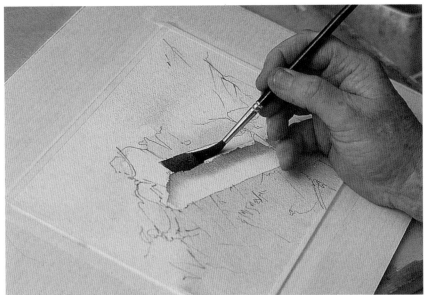

Step 5: Score the Wet Paper

Create a wood-grain texture on the bench by scoring the wet paper with a utility knife.

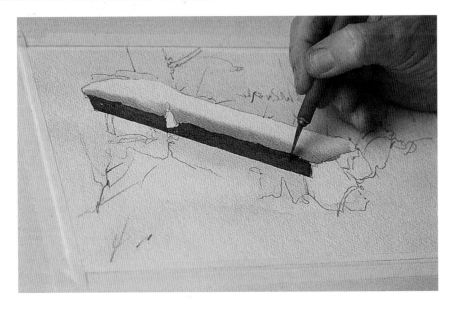

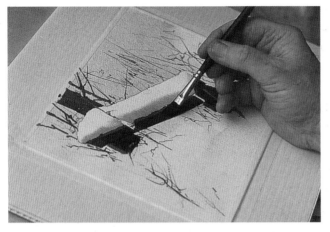 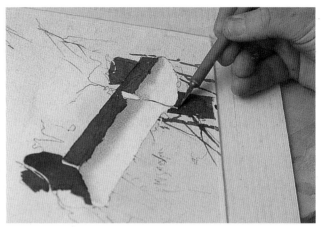

Step 6: Finish the Bench and Add the Tree
With your no. 12 lettering brush and the brown mix, paint the exposed parts of the bench, leaving white space for weeds, as shown. Also paint the tree trunk. Notice how the brown background causes the snow on top of the bench to stand out.

Step 7: Finishing Touches
Suggest the texture of bark on the tree by scoring the paper with a sharp utility knife while the paper is still wet. Add Burnt Sienna to the wash, and use your no. 3 script liner to paint dried grasses.

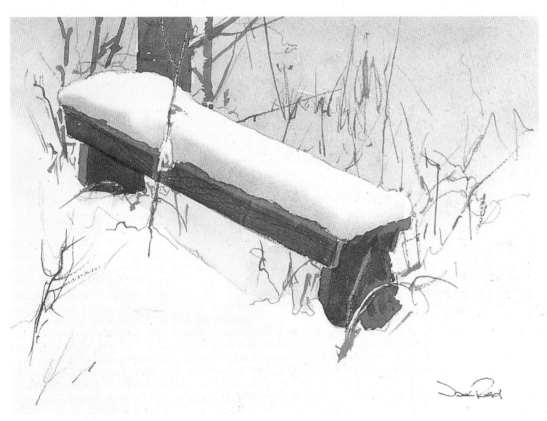

Snow-Covered Bench
Jack Reid
7" × 10" (18cm × 25cm)

Step-by-Step Demonstration: Painting Falling Snow

What would be the best way to paint falling snow?

The most important thing is to keep things simple. In this case, simplicity is two or three simple graded washes on the cluster of trees in the left foreground, a wash that suggests drifting snow, and everything in the picture diffused.

Paper
300-lb (650gsm) rough watercolor paper

Brushes
no. 8 round
2-inch (51mm) hake
½-inch (12mm) flat
no. 3 script liner

Palette
Burnt Sienna
Cobalt Blue
Raw Sienna
Ultramarine Blue

Miscellaneous
tissue

Step 1: Mix a Soft Wash
Mix a soft gray wash of Cobalt Blue and Burnt Sienna. To create the illusion of distant trees disappearing just off to the right, turn the picture upside down and use your 2-inch (51mm) hake to wet the entire piece of paper with clean water. Still using the hake, carry the wash right across the paper. With the paper upside down, the paint will run toward you.

Step 2: Deepen the Wash
While the paper is still wet, deepen the gray wash. With your hake, blast in the impression of a distant tree line.

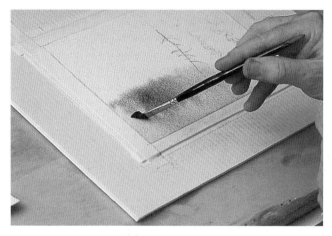

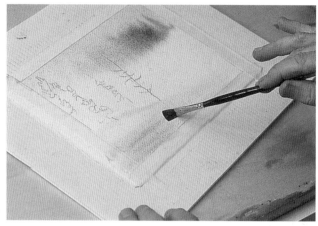

Step 3: Strengthen the Tree Line
Still with the paper upside down, deepen the wash again. Switch to your ½-inch (12mm) flat brush and strengthen parts of the tree line.

Step 4: Sweep a Graded Wash
Turn the picture right side up. Sweep a graded gray wash under the tree line and across the foreground on the left-hand side of the picture.

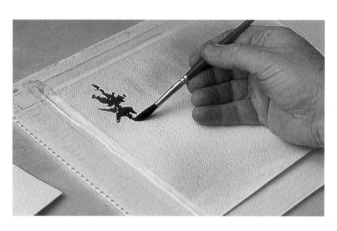

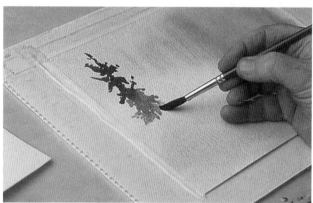

Step 5: Add the Trees
Mix a dull gray wash with Ultramarine Blue, Burnt Sienna and Raw Sienna. With your no. 8 round, paint the spruce tree, working quickly from the top down. As you reach the bottom, make a graded wash by adding water. Then quickly paint in the second tree on the right. With a tissue, move quickly and lift some of the paint (as shown) to create the illusion of snow drifting up in a cloud in front of it. Let dry.

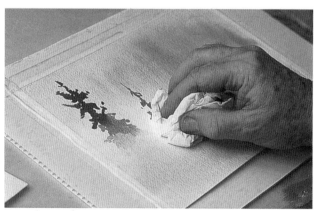

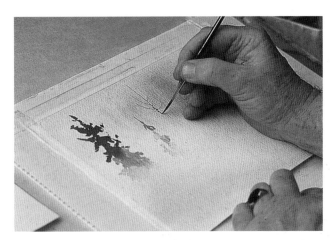

Step 6: Lift Color From the Base
Mix a gray wash of Burnt Sienna and Ultramarine Blue. Using your no. 3 script liner, paint the standing dead tree to the middle right and then a couple more in the distance. Again create the illusion of the trees disappearing in drifting snow by lifting color from the base of the tree with a tissue.

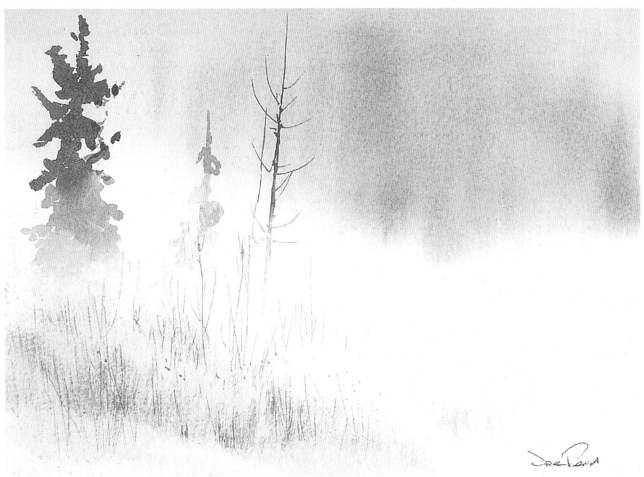

The Illusion of Falling Snow
Jack Reid
7" × 11" (19 cm × 28cm)

Lifting Nonstaining Pigments
You can lift nonstaining pigments by wetting the area with clean water, agitating it with a scrub brush and lifting with a tissue, but only when you're painting on good-quality paper.

Step-by-Step Demonstration: Fresh Snow on a Cordwood Pile

Fallen snow magnifies and changes the shapes of objects. For example, this painting illustrates how the dark color and grainy texture of the shed and logs depicted stand out after a snowstorm. For paintings like this one with very soft diffused light, Cobalt Blue and Burnt Sienna make the perfect soft gray. When they dry, Cobalt Blue and Burnt Sienna create a soft, luminous feeling, making this mix ideal for soft shadows. Use Ultramarine Blue for stronger blues.

Paper
300-lb (650gsm) rough watercolor paper

Brushes
no. 8 round
1-inch (25mm) flat
no. 12 lettering
no. 4 round
no. 3 script liner

Palette
Burnt Sienna
Cobalt Blue
Raw Sienna
Ultramarine Blue

Miscellaneous
utility knife
tissue

**The Pencil
Value Study**

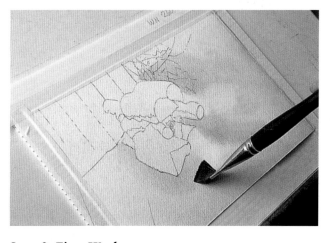

Step 1: Sketch the Pencil Drawing
Be careful and spend a bit of time sketching; it helps when you apply the paint.

How to Do a Pencil Drawing
When you're doing a pencil drawing in a painting, minimize the amount of drawing you do. As you become skilled with handling the brushes, you will be able to draw with the brush. The drawing should simply indicate the elements that will be in your painting. As you develop confidence, you won't need more than a simple sketch. Be patient– it will come in time.

Step 2: First Washes
Mix a soft gray wash using Cobalt Blue and Burnt Sienna. Using your no. 8 round, lay down a wash of clean water over the paper, moving carefully around the cordwood. Then using wet-into-wet and your 1-inch (25mm) flat, paint the gray wash.

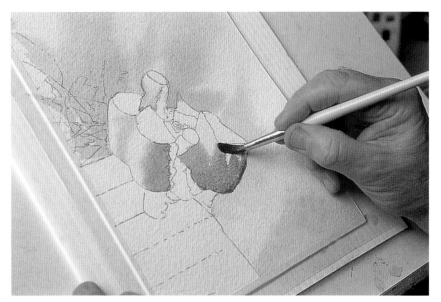

Step 3: Deepen the Wash

Deepen the wash slightly and use your no. 8 round to paint graded washes on the woodpile. Paint one section at a time, remembering to leave areas white for the exposed firewood. As you paint, feel free to move the paper to any angle that feels comfortable.

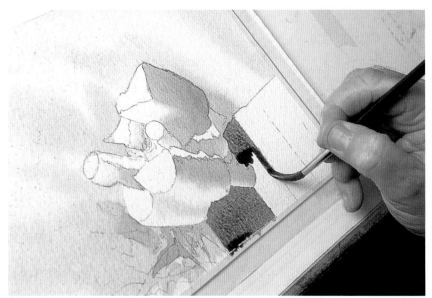

Step 4: Paint the Boards

Mix a dark brown wash with Ultramarine Blue and Burnt Sienna. Turn the painting upside down, and with your no. 12 lettering brush, paint the boards on the shed behind the woodpile, one at a time.

Step 5: Score to Create Texture

While the work is still wet, drop in pure Burnt Sienna and score each area with a utility knife to create the texture of wood. Let dry.

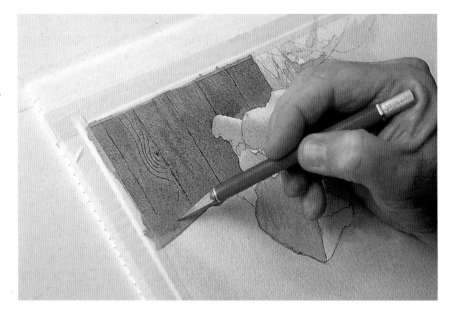

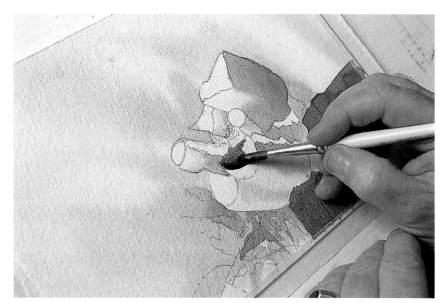

Step 6: Paint the Exposed Firewood

Mix a dark brown wash from Ultramarine Blue and Burnt Sienna. With your no. 8 round, paint the exposed portions of the firewood.

Step 7: Create More Texture

Drop pure Raw Sienna and Burnt Sienna onto lighter portions of the wood and again score with the knife to create wood textures. If areas seem excessively dark, lift some of the color with a tissue.

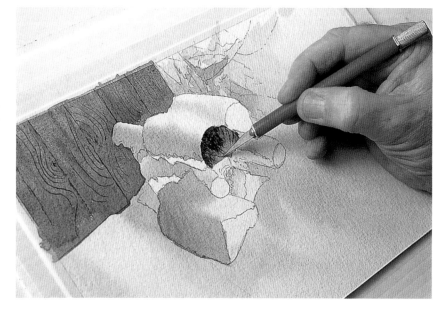

Step 8: Lift Dark Areas

If areas seem excessively dark, lift some of the color with a tissue.

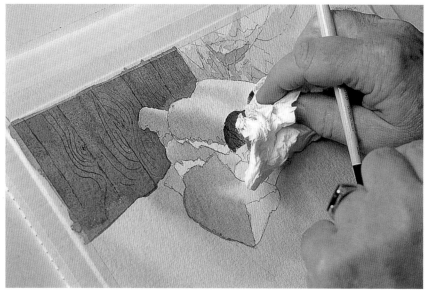

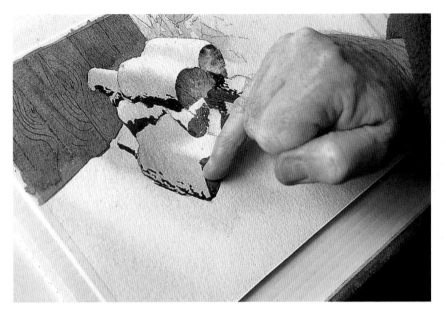

Step 9: Use Your Little Finger
To create a woodlike texture on the end of each log, press your little finger into the wet paint.

Step 10: Practice Drybrushing
To test your drybrushing technique before applying it to the painting, practice on scrap paper. Load your 1-inch flat with paint and brush it along the paper until it begins to run out of paint.

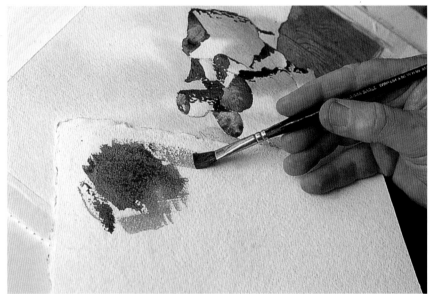

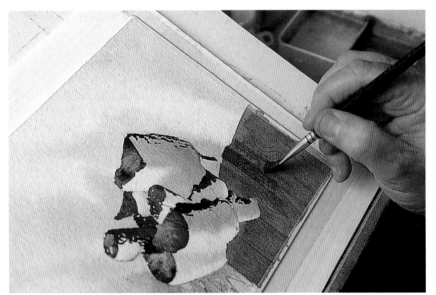

Step 11: Drybrush Texture
Proceed to drybrush to define additional texture on exposed parts of the logs and the shed. Switch to your no. 4 round and paint the cracks between the dark portions of the boards.

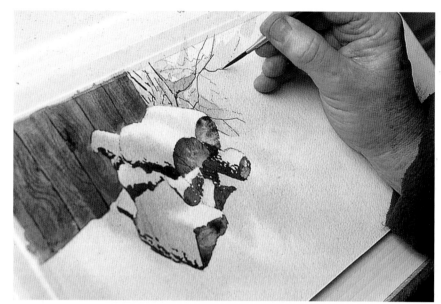

Step 12: Final Touches

With the same brown mix and your no. 3 script liner, paint the bushes and shrubs sticking out behind the shed. Notice how when you do this the white on the log becomes very strong. This creates a lovely clean edge along the snow on top of the logs. Use your no. 4 round to tickle in texture on the wood, as well.

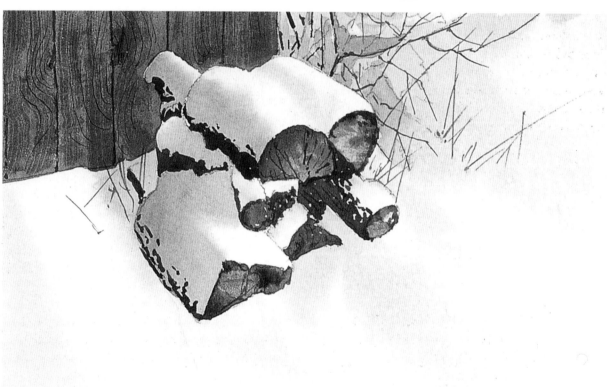

Fresh Snow on a Cordwood Pile
Jack Reid
7½" × 11" (19cm × 28cm)

Step-by-Step Demonstration: Painting Still Water

Watch water and you'll notice it's always changing. One minute a mountain stream may be flowing smoothly and the next it's a roaring iridescent white foam crashing over rocks, only to return once again a few yards away into it's former soft, serene flow. What is most exciting about water is its transparent nature; there isn't a better medium for painting it than transparent watercolor pigments.

This painting is more about water than snow. Notice how the edges of the tree and snow reflections on the water are hard.

Brushes
no. 8 round
scrub brush
no. 3 script liner

Palette
Burnt Sienna
Raw Sienna
Ultramarine Blue

Miscellaneous
tissue

Step 1: Begin With Washes
Mix a blue-gray from Burnt Sienna and Ultramarine Blue. Using your no. 8 round, begin a series of graded washes beginning in the upper left. Start with clean water and add blue-gray gradually. Repeat graded washes along the upper-right side of the pond, the islands on the left, and the sweep of shadow along the edge of the snow. If the value seems too dark, simply lift with a tissue. To create hard-edged reflections, paint flat washes with a stronger value of the same blue-gray wash with your round. Let dry.

Step 2: Paint the Pond

Now mix a medium-value brown-gray wash using Ultramarine Blue and Burnt Sienna. Paint a flat wash across the pond as shown. While the wash is still wet, use your no. 8 round and drop in pure Burnt Sienna, as well as Burnt Sienna mixed with Ultramarine Blue. Let dry.

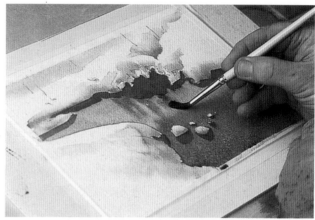

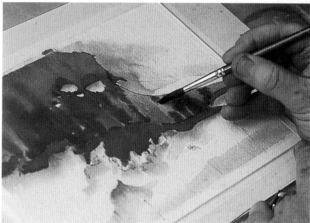

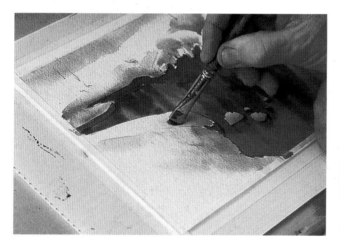

Step 3: Lift Highlights

Use a scrub brush to lift highlights on the snow on the lower left.

Mix More Paint Than You Need

There's nothing worse than running out of pigment before you've finished painting an area, so always mix a larger wash than you think you'll need. It's virtually impossible to remix a wash exactly.

Step 4: Paint More Reflections

Flip the paper upside down. With your no. 8 round and the same brown-gray wash used for the pond in step 2, paint more reflections.

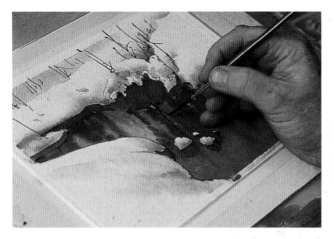 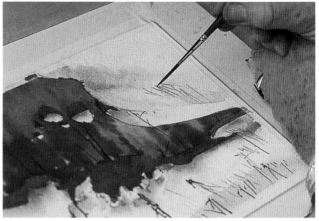

Step 5: Paint the Vegetation and Reflections
Using the same brown-gray wash and your no. 3 script liner, paint vegetation around the pond. Then paint reflections on the pond.

Step 6: Paint the Grass
Mix a wash from Raw Sienna, Burnt Sienna and Ultramarine Blue. Turn the painting so you're comfortable. With your no. 3 script liner, paint grass in the background and in the foreground snowbank.

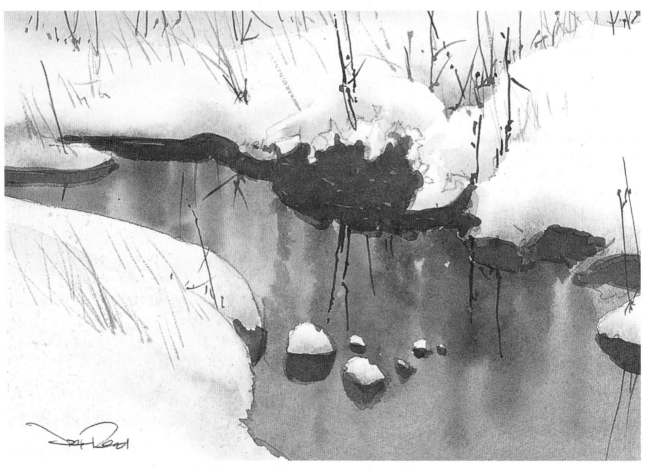

Reflections in a Winter Pond
Jack Reid
7" × 11" (18cm × 28cm)

236

Step-by-Step Demonstration: Painting Breaking Surf

The key aspect to completing a good seascape is to capture the mood. This painting portrays the tremendous force of an enormous wave breaking close to the shoreline. To make it work, leave lots of white to represent foam and contrast it with hard rocks.

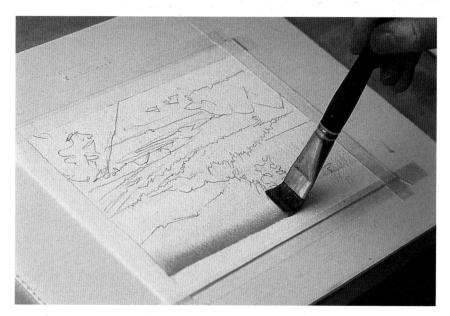

Brushes
no. 8 round
1-inch (25mm) flat

Palette
Aureolin Yellow
Cobalt Blue
Burnt Sienna
Ultramarine Blue
Viridian

Miscellaneous
utility knife
tissue

Step 1: Begin With Washes
Flip the paper upside-down. Using your 1-inch (25mm) flat, begin with a graded wash of Aureolin Yellow, then paint Cobalt Blue to the top of the paper, wiping off the beaded edge. Let dry. Mix a gray wash from Cobalt Blue and Burnt Sienna and, using a graded wash, paint the distant mountains. Reduce the value where they meet the sea.

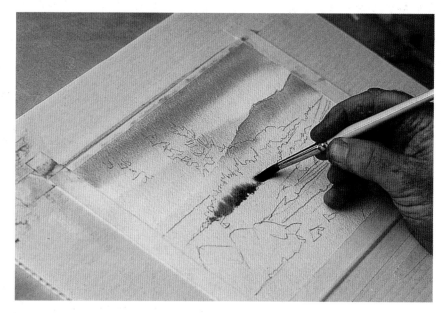

Step 2: Paint the Fold of the Wave
Mix a wash of Cobalt Blue and Viridian. Using a graded wash and your no. 8 round, paint the fold of the wave. Reduce the wash up toward the foam, making sure you don't lose the white on the upper edge of the breaker. Let dry.

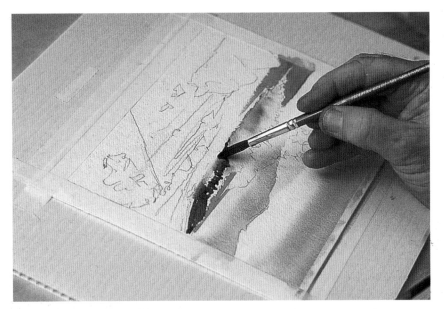

Step 3: Create Haze
Render in the water against the headland; use your no. 8 round and paint carefully around the wave. Make sure to leave lots of white. Deepen the Cobalt Blue and Viridian wash and paint the edge of the big breaker on the right. As you reach the bottom edge of that wash, create a bit of haze by lifting color with a tissue.

Step 4: Add the Background
Mix a brown wash from Burnt Sienna and Ultramarine Blue. Use your no. 8 round to paint the headland behind the crashing wave. Turn the paper so you're comfortable and add Viridian so the wash becomes a dark green-black. Paint the rocks and evergreen trees.

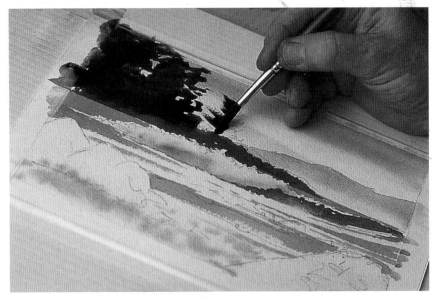

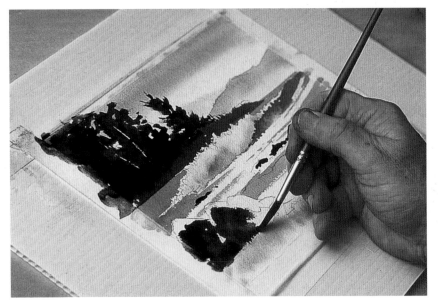

Step 5: Paint the Rocks
Mix a brown wash from Burnt Sienna and Ultramarine Blue. Using your no. 8 round, paint the rocks just before the wave and the ones in the foreground. Paint quickly. Let dry.

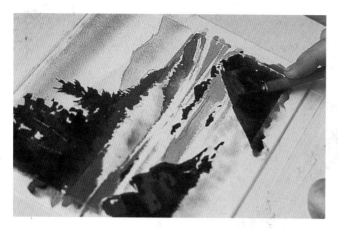
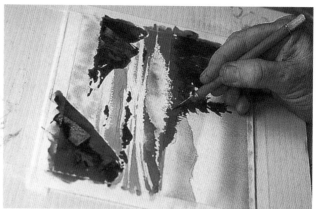

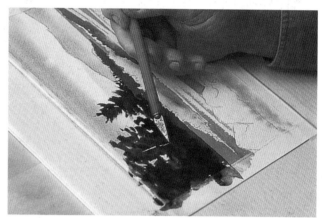

Step 6: Finishing Touches

As shown in these three photos, use a utility knife to add the finishing touches. Lift out suggestions of tree trunks along the headland, and with the same knife placed on it's edge, scrape some highlights on the rocks in the foreground.

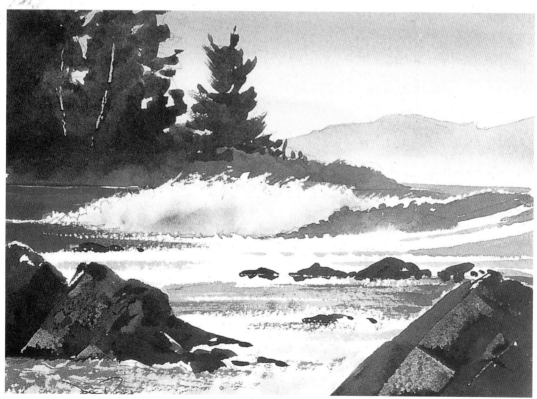

Breaking Surf, Rocks and Mountains
Jack Reid
7" × 11" (18cm × 28cm)

Step-by-Step Demonstration: Painting Waterfalls

Waterfalls seem to be the most popular subject
students want to paint. Painting huge rocks is
important to create the illusion of foam and mist
and crashing water. Again, use graded washes and
leave lots of white paper. Be careful not to lose
the whites in the waterfall!

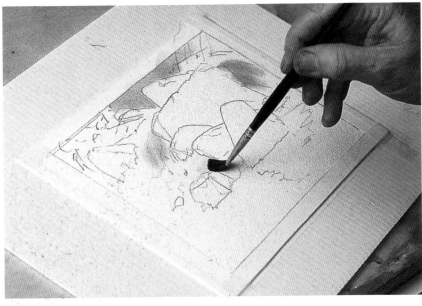

Paper
300-lb (650gsm) rough
 watercolor paper

Brushes
½-inch (12mm) flat
no. 8 round

Palette
Aureolin Yellow
Burnt Sienna
Cobalt Blue
Rose Madder Genuine
Ultramarine Blue
Viridian

Miscellaneous
tissue

Step 1: First Wash
Moisten the paper with clear water. Using wet-
into-wet and your ½-inch (12mm) flat, paint a
wash of Cobalt Blue.

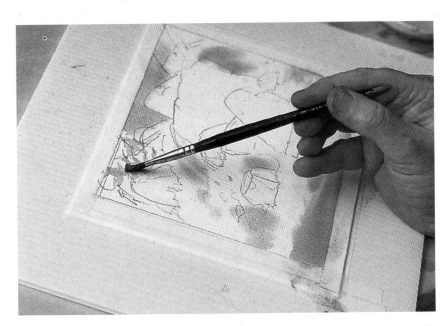

Step 2: Paint the Lit Areas
With a wash of Aureolin Yellow
and your no. 8 round, paint the
lit areas of the trees in the upper
left-hand side.

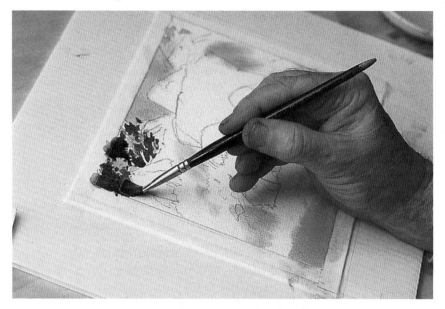

Step 3: Paint the Dark of the Tree
Mix a strong-value wash of Viridian and Ultramarine Blue darkened with a touch of Burnt Sienna. Use your no. 8 round to paint the dark portions of the tree line.

Step 4: Paint the Rocks
Mix a wash from Burnt Sienna and Ultramarine Blue. Using your ½-inch (12mm) flat, start at the top of the center rock and paint the large flat rock shapes with quick strokes. Drop in a touch of Rose Madder Genuine to create a pink cast.

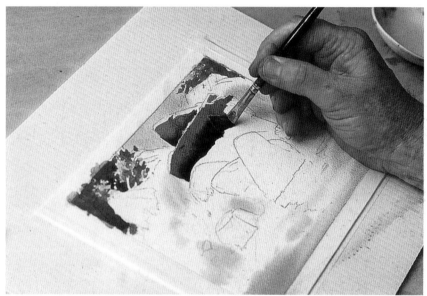

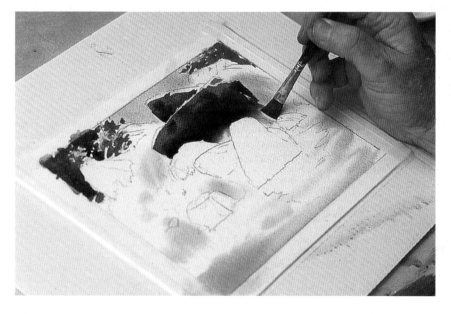

Step 5: Darken the Rock
Using wet-into-wet and your ½-inch (12mm) flat, gradually add a mix of Ultramarine Blue and Burnt Sienna to the rock's front.

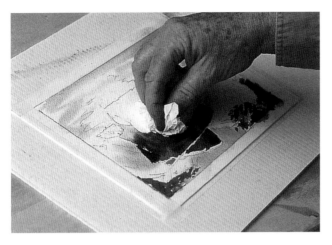

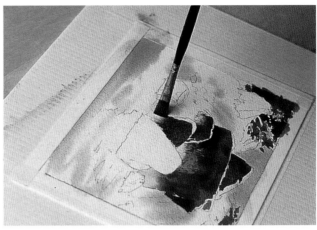

Step 6: Create the Illusion of Foam
Lift the excess paint with a tissue to reduce the value and create the illusion of foam around the rocks.

Step 7: Paint the Foreground Rocks
Using a mix of Viridian and Ultramarine Blue with a touch of Burnt Sienna, use your ½-inch (12mm) flat to paint the two large rocks in the foreground. Paint the rocks on top of the waterfall with the same mix but in different values.

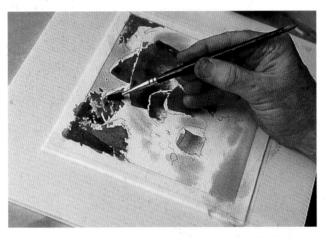

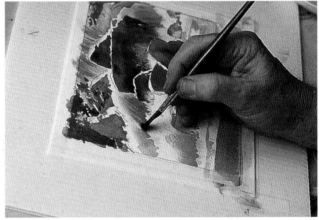

Step 8: Paint the Side Rocks
Use your no. 8 round to paint the rocks on either side of the waterfall using the same colors but in a much lighter value. Remember to paint graded washes at the bottom of all rocks.

Step 9: Suggest the Gradation of the Falls
Mix a wash of Cobalt Blue with a touch of Viridian and use your no. 8 round to create some graded washes around the rocks and into the foam. Begin with clean water to suggest the gradation of the falls, ending with a hard edge. Repeat for the rocks in the foreground, drybrushing at the base.

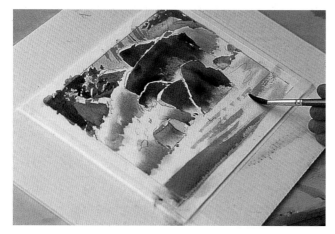

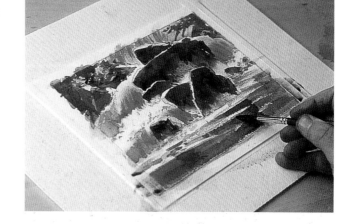

Step 10: Drybrush
Using Cobalt Blue and the same brush, drybrush over portions of the water in the foreground, as well as the water reflections.

Step 11: Final Touches
With your no. 8 round and the same pigments used for the rocks, use the wet-into-wet technique and drop in the reflections of the rocks in the foreground as shown in these two photos.

Waterfall and Rocks
Jack Reid
7" × 10" (18cm × 25cm)

PAINTING REALISTIC BIRDS

Birds were born (hatched?) to be painted. They come in all sizes and shapes. Birds wear not only every color imaginable but every combination of colors, too. Some birds appear very plain at a distance but reveal beautifully patterned feathers up close. Many birds have special decorations on their heads, necks, bodies, tails, feet or wings. Feathers give the body texture—from the softest head feathers to the boldest wing or tail feathers.

In this chapter you will learn basic facts about birds as well as everything you need to know to create a beautiful bird painting. Several step-by-step demonstrations walk you through and help to reinforce this information.

All artwork on pages 244 through 269 was created by Shirley Porter.

Winter Window
Shirley Porter
34" × 24" (86cm × 61cm)

How Shape Is Related to Lifestyle

Shape is the first clue to the identity of a bird because you see more birds at a distance than close up. You can easily tell you are looking at a bird even if only the simplest shapes can be seen. When you see an animal with an oval body, a smaller oval head and a rectangular tail, you think "bird." Add a small cone-shaped bill to the round head and add a couple of stick legs underneath and your vision says, "definitely a bird."

Identifying a Particular Bird

You can make a simple color identification—the bird is blue, red or black. But if you want to know if a bird is an owl or an ostrich, a bluebird or a blue jay, look more carefully at the overall shape of the bird, paying attention to such distinguishing features as short or tall and thick or thin. Is the body rounded or oval? Is the breast pronounced?

Next look closely at the detail of individual body parts—how they are shaped and their proportions to other parts of the body. Is the tail wide or narrow? Long or short? Is the beak thick or long and slender? Does it end in a hook or a blunt spoonlike shape? Are the legs and feet thick and powerful or thin and delicate?

Lifestyle

Like other creatures, a bird is built to accommodate his lifestyle. A look at just a few water birds reveals that, though they all live and feed in a water environment, the way they feed demands great differences in their basic construction. A bird that feeds while swimming has a different foot than a wader. A shallows wader has shorter legs than one that wades deeper to feed. A bird that catches fish has a very different beak than one whose food comes from filtering water through its beak. While it's not necessary to know a bird's habitat or what it eats in order to make a good drawing or painting, you'll find that becoming aware of these differences will help you capture the essence of your bird. The more you know about a bird, the more you will see and remember when you observe and sketch. When something in your drawing doesn't look right, it will be easier for you to identify the error.

Other factors, such as mating rituals, make important contributions to appearance, too. Just look at the peacock! It's important to remember that not all birds fit neatly into a generalization of "form follows function," but the majority do, giving you a good place to begin.

Categories

Birds can be placed into seven groups according to their feeding preferences and habitats. These groups—perchers, waders, swimmers, divers, predators, insect catchers and tree-trunk clingers—are based on generalizations about some birds that are familiar and are meant to help the beginner see similarities and differences in the appearances of various birds. The groups are not scientific classifications. For example, perchers include Tyrannidae (flycatchers), Hirundinidae (swallow and martins), Paridae (chickadees and titmice) and many more. In this chapter, the emphasis is on how the bird looks and some of the factors that influence its appearance.

Extremely rare stick bird.

Proportional Comparisons

You might say that the bald eagle's beak is large and broad in comparison to his head or that a crane has long legs. The eagle's beak-to-head proportion seems large because its beak is bigger than the beak of more commonly seen birds such as the house sparrow. The crane's legs look long because they're so different from those of a cardinal or starling. A bird is large or small only in comparison to another. Its beak or legs are thick or long against the standard of some other bird. Usually the birds you use as a basis for size, shape and detail comparisons are perching birds. Though many birds perch, the term perchers is used very loosely here to mean those familiar tree-sitters common to yards, parks and woods.

Because so many perching birds (often called songbirds) are well known to us, they are a good measure for making observations about other, less familiar birds. Remember, however, that within any group, including perchers, there is also a lot of variation in shape, size and detail. Otherwise, all the birds in a group would look alike.

Keep the pine warbler and other perchers in mind as you look at the examples from other bird groups. Compare overall body shapes. Are they round or elongated? Look at leg lengths, beak thicknesses and neck lengths and widths. Some tails are short and blunt; others are long and tapered. Wings may be broad or delicate, rounded or sharp. Each difference, whether significant or subtle, helps distinguish one bird from another. Comparing the outline drawing to the detailed drawing will help you see the shape of each bird's body more clearly.

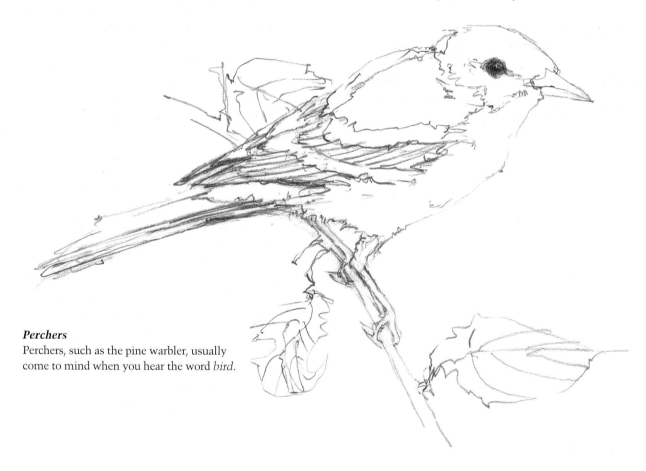

Perchers
Perchers, such as the pine warbler, usually come to mind when you hear the word *bird*.

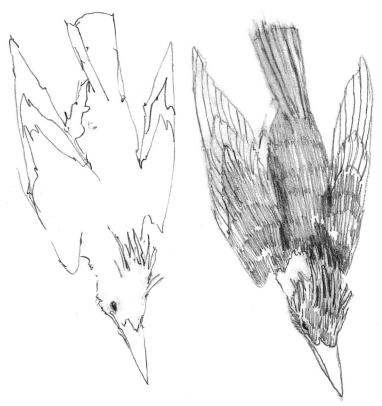

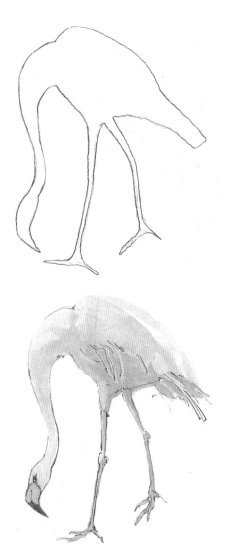

Divers
More compact and less round than the duck, the belted kingfisher's body allows it to make fast dives.

Waders
Waders, like this flamingo, need long legs to keep their bodies above the water. A long neck allows it to dip its beak into the water from such a height.

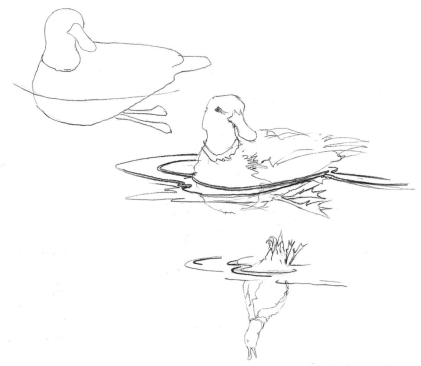

Swimmers
Many swimmers have short legs and wide, paddlelike feet. This mallard's body is compact. As it feeds, it bobs in and out of the water, much like a cork on a fishing line.

248

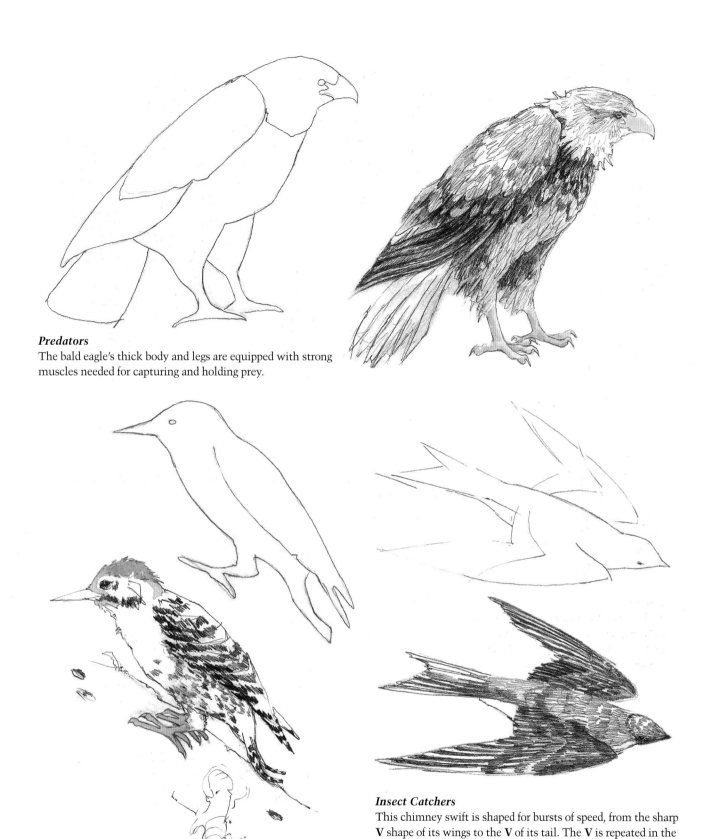

Predators
The bald eagle's thick body and legs are equipped with strong muscles needed for capturing and holding prey.

Insect Catchers
This chimney swift is shaped for bursts of speed, from the sharp **V** shape of its wings to the **V** of its tail. The **V** is repeated in the tip of the wing.

Tree-Trunk Clingers
Strong toes and a thick, pointed beak enable the red-bellied woodpecker to bore holes while clinging to the side of a tree. Its compact body gets additional support from bracing its short tail against the trunk.

Familiar Position and Silhouette

Certain positions are so strongly associated with particular birds that they become quick recognition aids, even from a distance. A bird's stance is an integral part of its shape. A hunched-down bird who looks almost neckless may be easily identified as an owl. One sitting with its head below its shoulders is usually a vulture. (Remember your mother telling you not to slouch?) Any unique feature in a bird's outline helps you recognize it. The line drawings here describe certain birds by using a combination of their basic structures with the way they sit and stand. Pay attention to the outline, or silhouette, surrounding the details.

Great Blue Heron
A long, thin neck folded on itself and a body held high above the water suggest an egret or heron.

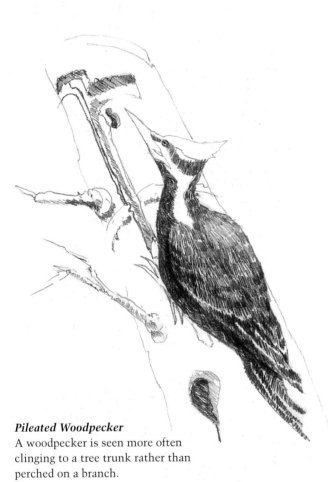

Pileated Woodpecker
A woodpecker is seen more often clinging to a tree trunk rather than perched on a branch.

White-Breasted Nuthatch
Nuthatches like tree trunks, too, but are usually seen head down.

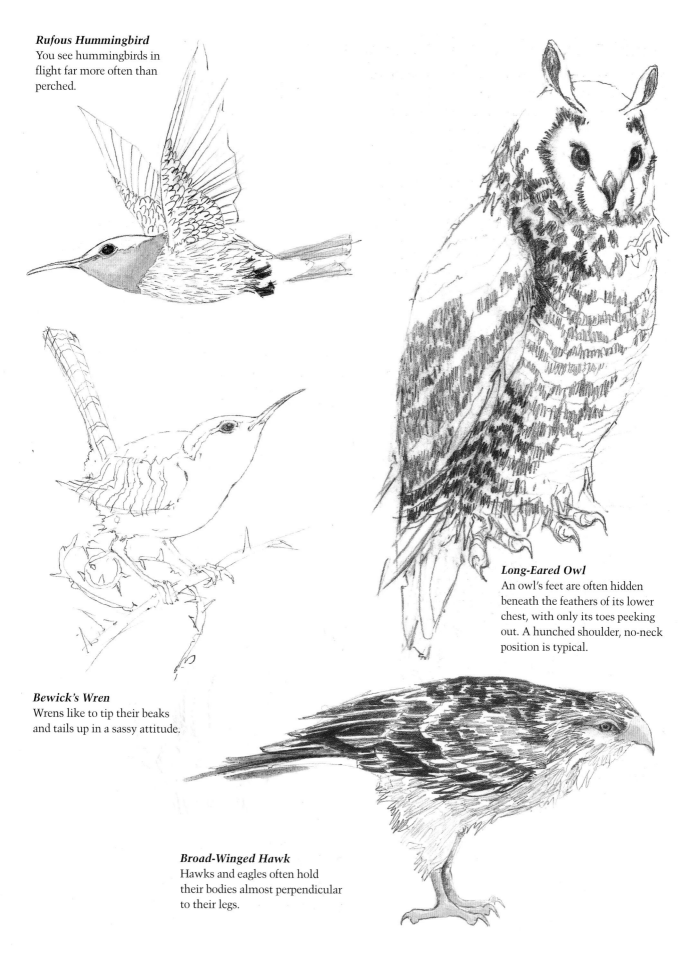

Rufous Hummingbird
You see hummingbirds in flight far more often than perched.

Bewick's Wren
Wrens like to tip their beaks and tails up in a sassy attitude.

Broad-Winged Hawk
Hawks and eagles often hold their bodies almost perpendicular to their legs.

Long-Eared Owl
An owl's feet are often hidden beneath the feathers of its lower chest, with only its toes peeking out. A hunched shoulder, no-neck position is typical.

251

Beaks

Beaks come in a fascinating variety. They are large or small, thick or thin, straight or curved, blunt or pointed, plain or decorated. This makes the beak especially useful in describing a bird.

Cardinal
The cardinal's bill, thick and large in proportion to its head, is made for opening tough seed shells.

Rose-Breasted Grosbeak
The size and thickness of the grosbeak's beak is very pronounced, hence its name. This bird is a very strong seed cracker.

Brown Pelican
The pelican's silhouette is very much its own whether its famous beak is empty or full.

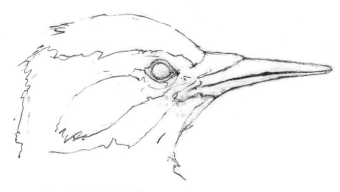

Red-Bellied Woodpecker
The red-bellied woodpecker's thick, pointed bill is its hole-chiseling tool. The beak grows as it's worn down.

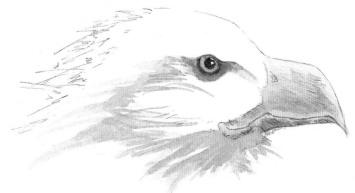

Bald Eagle
The bald eagle's beak is a major part of its head, reflecting its role as a hunter. The beak ends in a sharp, pointed hook.

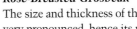

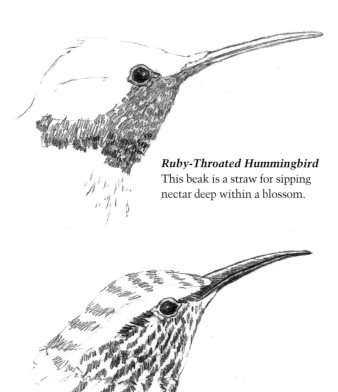

Ruby-Throated Hummingbird
This beak is a straw for sipping nectar deep within a blossom.

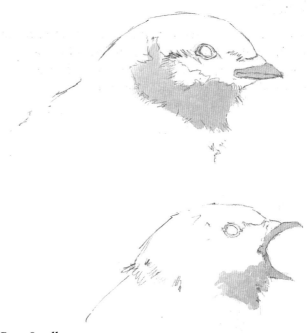

Barn Swallow
The swallow's tiny beak doesn't look adequate for large insects, but its jaw opens extra wide, providing a pocket shape that surrounds the bug.

Sedge Wren
A long, thin beak enables a good grasp on a fairly large insect.

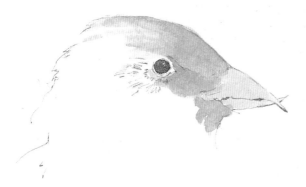

Belted Kingfisher
This long, flat bill gets a good grip on a slippery fish. The beak is a major part of the kingfisher's body.

White-Winged Crossbill
The crossed ends of this beak give a firm grip on the seed while the pointed ends help to open it.

Legs and Feet

Legs and feet strongly reflect lifestyle. Some legs are thin and delicate; others are thick and powerful. Legs may be stiltlike or so short that they are almost invisible. Feet might have long delicate toes or large talons or may even be webbed. On some birds the back toe plays an important role, while on others it is almost nonexistent. Four toes are common, with one toe often pointed to the back. However, exceptions do exist (for example, the ostrich has two toes).

White Ibis
The ibis, like the heron and egret, is a wader. Its long legs are almost fully extended. This holds its body above the water. Many waders have very long toes.

Downy Woodpecker
Long toes and talons give the downy woodpecker a firm grasp on a tree trunk. Two toes forward and two back strengthen its grip.

House Finch
The legs of the house finch are short and thin, typical of perchers. Its long, thin toes are designed for wrapping around a small branch.

Red-Tailed Hawk
The upper leg of the red-tailed hawk is covered with long feathers, adding to this bird's thick, stocky look. Thick toes with pronounced talons are built for strength and reflect the hawk's hunting life.

Mute Swan
Short legs, short toes and webbing make a very efficient paddle for this swimmer. The back toe is high and small.

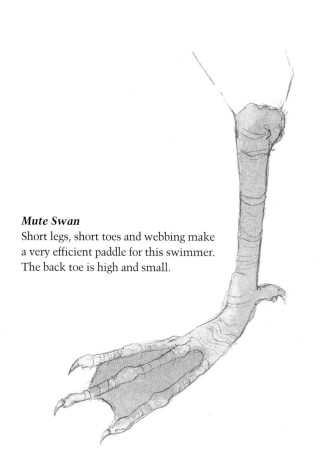

Out on a Limb
Placing a percher on a limb can be difficult, especially since it is hard to get a close look at just what the foot is doing. On a broad surface the bird opens its foot so it rests on top of the perch. But how does he stay up-right on a small branch or wire?

Incorrect
A bird's foot is not constructed to allow it to squeeze down to tightly enclose a tiny limb.

Correct
On a small branch, the foot rests on the top of the branch and the toes bend at the joints. The rear toe locks in place. There is a space between the toes and the limb.

Eyes

The simple generalizations made about body shapes, beaks and feet do not apply to eyes. The similarities and differences in birds' eyes don't fall into neat or obvious groups. Looking at only the eye without seeing the proportion of the eye to the head, the color of the eye or the markings around the eye can make it hard to distinguish a sparrow's eye from that of a duck or woodpecker.

As you look at different aspects of birds' eyes—shape, proportion, markings and color—you find that changes occur as much from bird to bird as they do from group to group.

Shape of Eyes

You can simplify the eye to a basic oval shape that will serve you well for most purposes. There are a few obvious exceptions, such as owls. Their eyes are also slightly oval but can appear rounded, due in part to the markings around the eyes. Barn owls have a much rounder appearance to their eyes than horned owls, whose eyes are partially covered by a ridge above them. In owls, skulls are shaped differently from those of most other birds, resulting in frontal positioning and closeness of the eyes. This contributes to the large, staring look we associate with owls. Like other birds, owls' eyes look very different if the lids are partially closed.

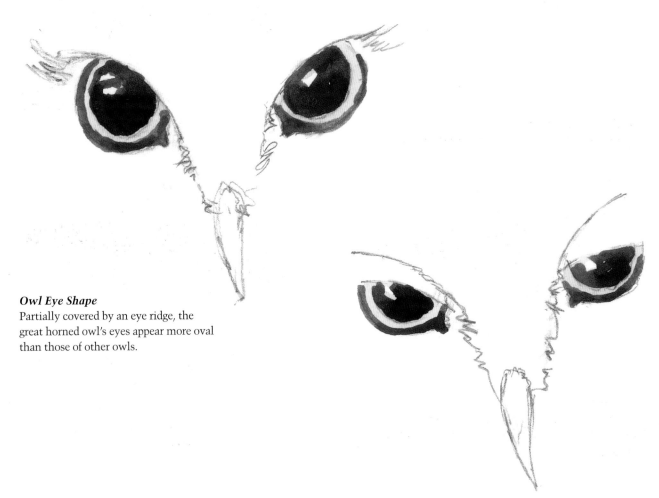

Owl Eye Shape
Partially covered by an eye ridge, the great horned owl's eyes appear more oval than those of other owls.

Partially closing the lid changes the appearance of a bird's eye.

Proportion of Eye to Head

Proportion is a good place to look for differences, but again it is hard to make generalizations. You need to look at individual birds. Some perchers (such as hummingbirds) have large eyes compared to their head sizes, but so do many predators (hawks, for example). Of course, the proportion of eye to head stands out in owls.

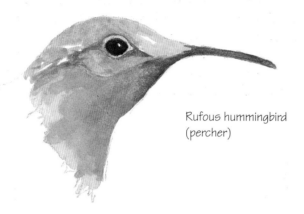

Rufous hummingbird
(percher)

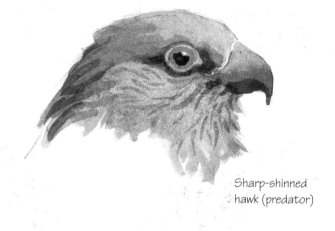

Sharp-shinned
hawk (predator)

A Percher and a Predator

The eyes of this percher and predator are large in proportion to their heads.

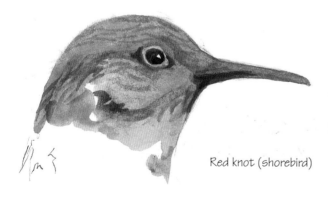

Red knot (shorebird)

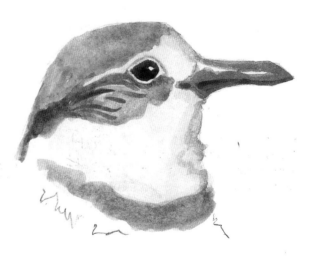

Wilson's plover
(shorebird)

Two Shorebirds

The proportions of eye to head in these two shorebirds differ. The red knot has a medium-sized eye, while the Wilson's plover has a large eye.

More on Eyes

Markings Around the Eye

Some predators, such as the bald eagle, appear to have a pronounced ridge above the eye when viewed from the front. Others, like the American kestrel, have a less pronounced ridge. This ridge can become more or less noticeable depending on the markings around the eye.

The markings around the eye usually account for the different look from face to face. These markings vary greatly even within each species, so much so that bird watchers find them extremely useful in making specific identifications. In each case (especially where you need a totally accurate eye) refer to a reliable source such as bird-watchers' guidebooks.

Eye Ridges

The American kestrel's eye ridge is less prominent.

The bald eagle has a pronounced ridge above its eyes.

Eye Markings—Variations in Five Sparrows

House sparrow

White-throated sparrow

Fox sparrow

Chipping sparrow

LeConte's sparrow

258

Color of the Eye

Many predators have brown eyes, but some, such as the bald eagle, have yellow eyes. The golden eagle and even an immature bald eagle have brown eyes. A few birds from each group have pink eyes.

Position of the Eye

Like other eye features, placement varies greatly. Again, the owl is an example of the extreme in eye placement. However, as with body shape, perchers can be used as models. A percher's eyes, when viewed in profile, are usually a little above and forward of the center of the head. When you see the bird head-on, the eyes look very thin and tip inwards slightly at the top.

Don't Despair!

Even though there's so much variety that it's difficult to make many generalizations, most of the birds you'll paint won't be close enough for their eyes to be a major concern. So keep eyes simple and undaunting wherever possible. The simple oval eye shown in the color examples will serve most of your needs. When the eyes are very small, getting the proportion accurate matters more than other factors. Where accuracy in shape, proportion, markings and color are important, use a reference source.

Position of eyes

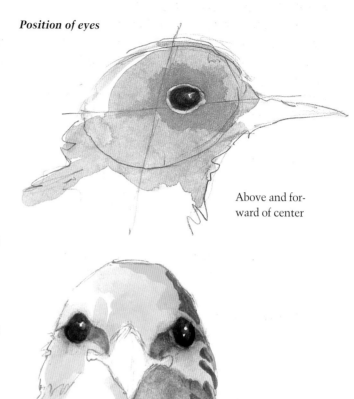

Above and forward of center

Elongated oval
Tipped slightly inward at top

Color
Eye color varies within each group.

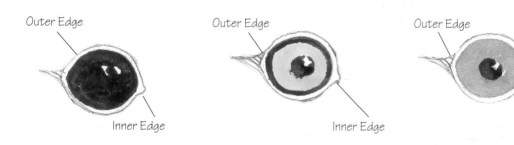

Outer Edge / Inner Edge

	Brown Eyes	Yellow Eyes	Pink Eyes
Swimmers	Ruddy duck	Tufted duck	Wood duck
Predators	Golden eagle	Bald eagle	Cooper's hawk
Perchers	Vermilion flycatcher	Brown thrasher	Red-eyed vireo

Wings

When wings are not in use, the bird folds them tightly against its body for maximum comfort and movability. Three joints allow a wing to fold and open quickly and efficiently. It's helpful to think of the joints in a human arm—shoulder, elbow and wrist. A bird's finger bones of the wing support the large feathers at the tip of the wing.

Folded Wing

Partially Open Wing

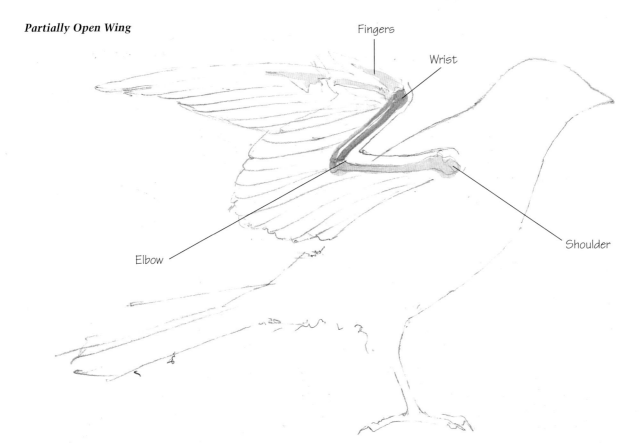

260

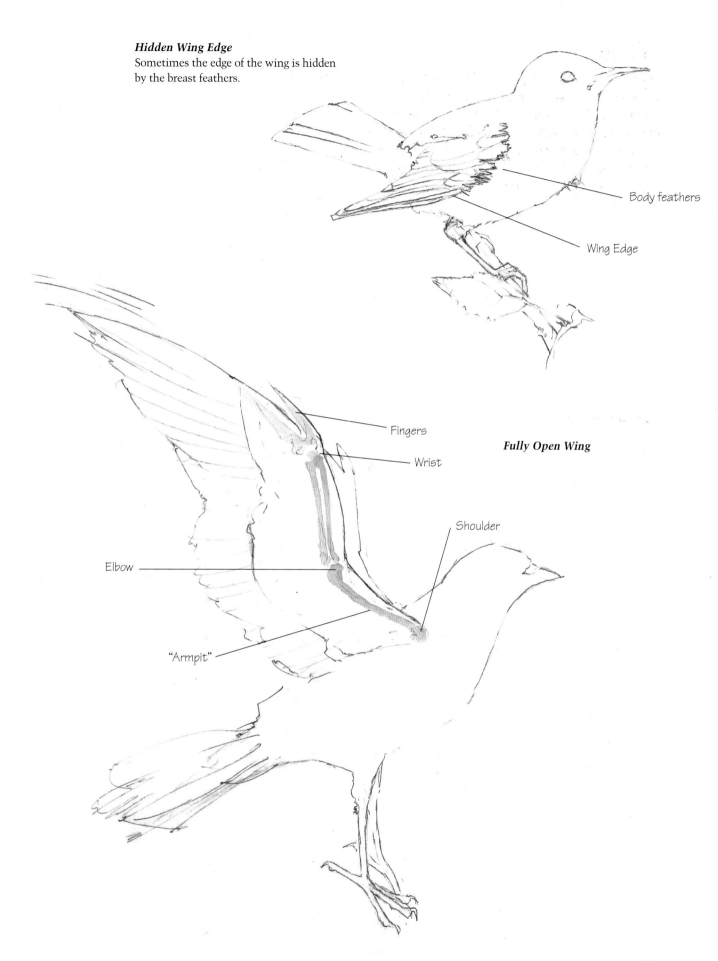

Hidden Wing Edge
Sometimes the edge of the wing is hidden
by the breast feathers.

Body feathers

Wing Edge

Fingers

Wrist

Fully Open Wing

Shoulder

Elbow

"Armpit"

Feathers

Feathers are unique to birds. Feathers give birds protection, aid them in flight and come in many beautiful colors and patterns. The colors of feathers vary not only from bird to bird but also from feather to feather on the same bird. A single feather may have several colors forming an intricate pattern. Body feathers are shorter, softer and more rounded than wing feathers. Wing and tail feathers are larger and more pointed.

Body Feathers
Body feathers are short and soft. The tips are often round or modified points, while the base is soft and fuzzy.

Feathers overlap like tiles on a roof.

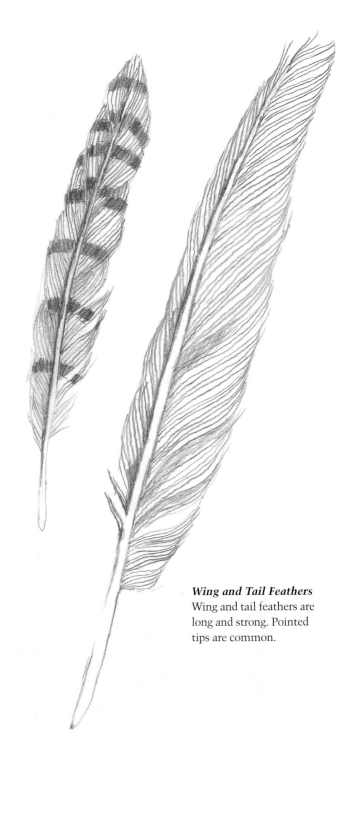

Wing and Tail Feathers
Wing and tail feathers are long and strong. Pointed tips are common.

Placing Feathers on a Wing

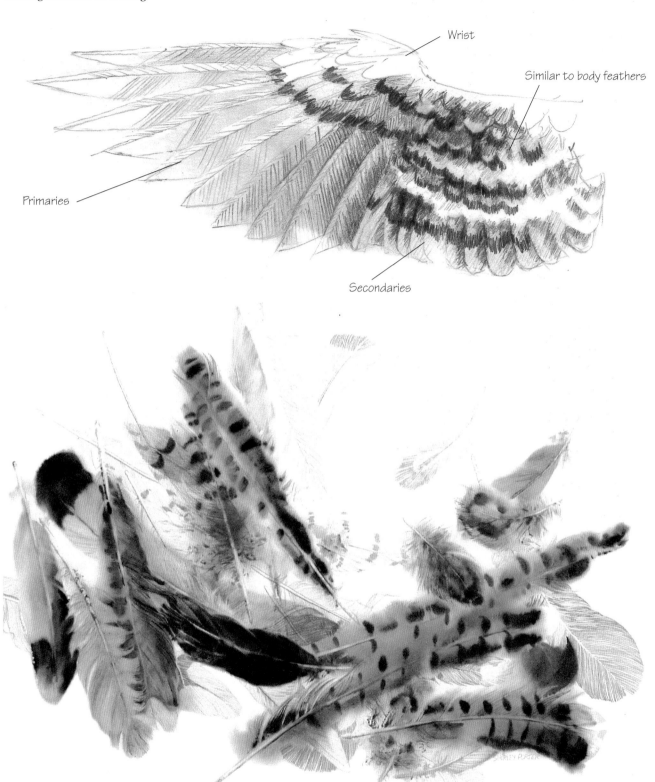

Wrist

Similar to body feathers

Primaries

Secondaries

Five Jay Feathers
Shirley Porter
32" × 52" (81cm × 132cm)

Step-by-Step Demonstration: Cardinal (Female) Nesting

A cardinal built and tended her nest over a period of several weeks. When the last of her fledglings was gone, she left a beautiful nest, complete with a silver gum wrapper and some twine. Notice how the cardinal's body fits into the nest without spare room around her. This snug fit helps hold body heat against the incubating eggs. Her tail tips up to clear the back edge of the nest.

Paper
Arches 140-lb. (300gsm)
 cold-pressed watercolor
 paper

Brushes
nos. 7, 3, and 0 rounds

Palette
Alizarin Crimson
New Gamboge
Yellow Ochre
Winsor Red
Phthalo Green
Burnt Umber
Hooker's Green

Miscellaneous
pencil
masonite board

Complete Drawing
Draw a female cardinal in pencil.

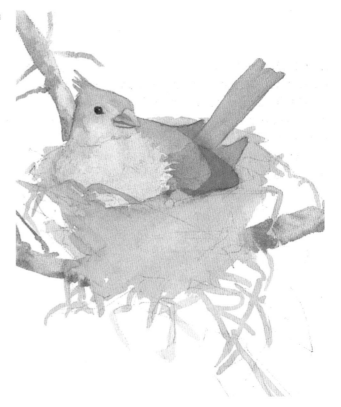

Step 1: Underpaint the Body
Soak and drain your paper, and place it on your Masonite board. Drain the excess water. Using your no. 7 round, paint the breast area with a mix of New Gamboge and Yellow Ochre. Wash in the entire head and body with a mixture of Winsor Red and Phthalo Green. Use your no. 3 round to paint the beak with a Winsor Red and New Gamboge mix. An Alizarin Crimson and Phthalo Green mix painted with your no. 0 round gives a rich black for the eye.

Step 2: Underpaint the Nest
Wash in the nest and branches with a yellowish brown mixture of Yellow Ochre and Burnt Umber using your no. 7 round. Vary color from yellower to browner to give form.

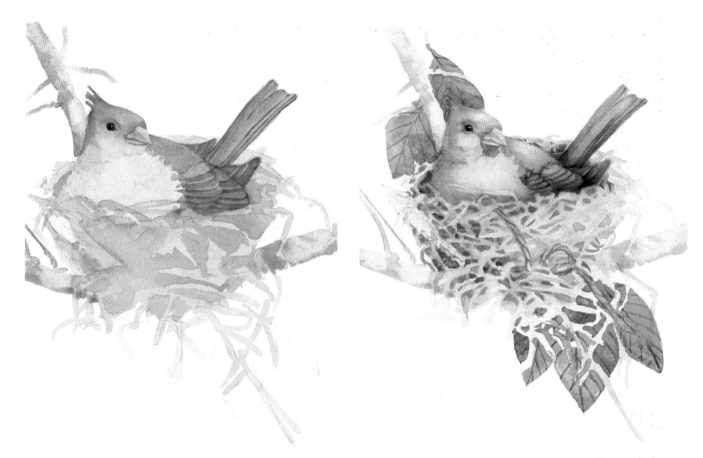

Step 3: Define Feathers

Suggest wing and body feathers using your no. 3 round with the gray mixture of Winsor Red and Phthalo Green from step 1. Add depth to the nest with more Yellow Ochre. Add gray to the back of the neck and to the head. Darken the Winsor Red on the head and tail.

Step 4: Add Details

Model the bird's body and the nest with darker mixtures of the colors already used in each area. Using your no. 3 round, paint in leaves with a varied mix of Hooker's Green, Yellow Ochre and Winsor Red. Paint the veins with the same mix. Use Burnt Umber to paint the dark areas of the nest and the string.

Nesting Cardinal
Shirley Porter
12" × 9" (30cm × 23cm)

All Nests Are Not the Same

If you're painting the bird in a nest, make sure it's the right kind of nest for that bird. Some birds build nests on the ground or in low growth such as reeds. Some birds use stones or clay to build their nests; others use twigs or grasses.

Step-by-Step Demonstration: American Redstart

This background has shapes that are identifiable as leaves and berries, but they are depicted loosely (as opposed to realistically). Use color freely in this painting.

Paper
Arches 140-lb. (300gsm) cold-pressed watercolor paper

Brushes
½-inch (12mm) flat
nos. 7, 3, and 0 rounds

Palette
New Gamboge
Alizarin Crimson
Hooker's Green
Permanent Blue
Burnt Sienna
Burnt Umber

Miscellaneous
pencil
paper towels

Complete Drawing
Draw a redstart in pencil.

Step 1: Paint the Background
Mix New Gamboge, Alizarin Crimson and Permanent Blue to paint in a warm orange background with your ½-inch (12mm) flat. Save the bird and branch so they don't get lost. Once this dries completely, add more Alizarin Crimson to the mix and paint in the bird's body and wing markings with your no. 0 round, adding New Gamboge in places for variety.

Step 2: Paint the Body

Mix black from New Gamboge, Alizarin Crimson and Permanent Blue. Use the black to paint the eye with your no. 0 round, saving a highlight. Use your no. 3 round to paint the body and tail black. Blot a highlight with a paper towel on the head, cheek and breast. You may choose to save a light eye ring, even though the redstart doesn't have one, so that the eye will be more visible.

Use a thinned gray version of the black mix for the underbelly. Use additional layers of gray on the bottom edge to model. Paint the legs with the black mix and the no. 0 round. Fill in the small orange area next to the leg with your no. 0 round also.

Step 3: Begin the Leaves

Mix a yellow-green from Hooker's Green, New Gamboge and Alizarin Crimson to paint the leaves with your no. 7 round. Mix a yellow-orange using the same three colors and add it to one of the leaves. Do this while the green color is still damp so that the colors will mix. Mix a redder orange from the same colors and add it and some Burnt Sienna to the damp leaf. Proceed from one leaf to the next while they're still damp.

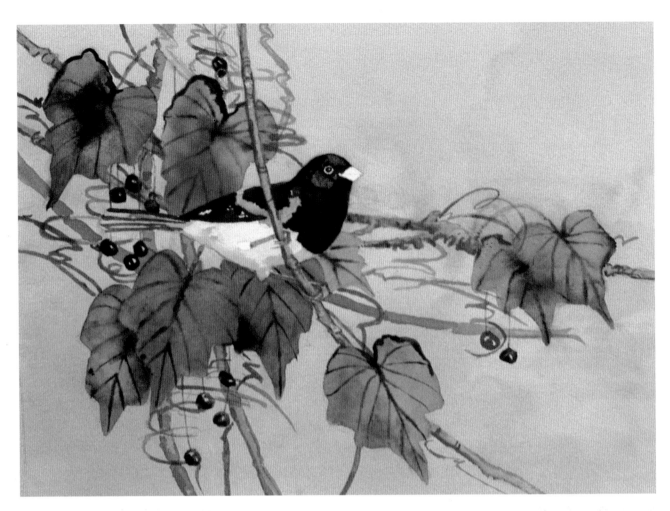

Step 4: Paint the Branches and Berries
Use your no. 3 round to underpaint the branches
with New Gamboge, then overpaint with your gray
mix from step 2. Mix Alizarin Crimson with Perma-
nent Blue and paint in the berries. Add new
branches with Burnt Umber to fill in the design
around the bird. Mix Burnt Sienna with Hooker's
Green to detail the leaves.

Step 5: Final Details
Model the bird's underbelly with your no. 3 round
and additional layers of gray. Paint in its beak with
the black mix from step 2, leaving a highlight.

American Redstart
Shirley Porter
9" × 12" (23cm × 30cm)

FOCUSING ON PEOPLE

Most people think of faces as either white, black, brown or yellow, depending on ethnic heritage. As an artist you must look carefully and apply the basics you've learned about color and value to any subject— including portraits.

Though they are thought to be difficult, portraits are no more difficult than other subjects. The problem is that errors are more noticeable in a portrait than in a landscape or still-life painting.

This chapter offers a short introduction to fleshtone colors and is filled with step-by-step demonstrations for you to apply what you have learned so far in this book to painting people. You will be amazed at your results.

Lauren
Butch Krieger
5½" × 3¼" (14cm × 8cm)

Focus on Fleshtone Colors

You have probably tried several palettes throughout this book. As you begin to paint fleshtones, you may want to streamline your color choices to those which best depict fleshtone colors. Following is a strategic system of pigments that is specifically geared to fleshtones. It is aligned with the primary colors (red, yellow and blue).

This palette requires twelve colors of paint: Rose Madder Genuine, Alizarin Crimson, Quinacridone Sienna, Burnt Sienna, New Gamboge, Quinacridone Gold, Yellow Ochre, Raw Umber, Cobalt Blue, Ultramarine Blue, Indanthrone Blue and Burnt Umber. This gives you four reds, three yellows and three blues. The two browns, Raw Umber and Burnt Umber, serve as convenient ready-made dark blends.

When you are first learning to do fleshtones, this restricted palette will simplify things for you. Such a focused palette can also teach you to think of flesh tones in terms of the three primary colors. Later, when you begin to expand your palette to include the secondary and tertiary colors, think of these as ready-made mixtures of the primary colors.

Ease Your Fears

Before you attempt your first exercise or painting in this chapter, do several experimental sheets of each concept that is introduced. You will find that you will learn the best when you are working with just one concept at a time. The best time, for example, to learn to mix fleshtones is *not* when you are working on a portrait—especially not when you are working on your *first* portrait. Everything you do in a painting—whether it be color mixing, glazing, washes or whatever—should be something that you already know how to do. There are no exceptions to this rule—and no way around it. The best investment of time and money that you can make is in this preparatory practice.

When you do an actual painting, keep a "sacrifice sheet" alongside it. This is a piece of paper or board that is identical to the one you are painting on. With this sacrifice sheet you can pretest anything that you are about to do to the painting to make sure you've got it right. Let's say, for instance, that a fleshtone mix looks too red, or perhaps too dark. With a sacrifice sheet you will discover the error and avoid putting it on your painting. This will do much to reduce mistakes and keep you in control.

The artwork on pages 272 through 279 was created by Butch Krieger.

Looking Ahead

There are many wonderful pigments on the market. The spicy quinacridone colors, for example, make excellent flesh tones—especially when you are painting the effects of bright sunlight on skin. Two of these colors are used in this chapter: Quinacridone Gold and Quinacridone Sienna. Other good examples of quinacridone colors are Maimeri's Avignon Orange and Golden Lake, and Sennelier's Chinese Orange.

Many beautiful earth colors are available in addition to the four that we use here (Raw Umber, Burnt Umber, Burnt Sienna and Yellow Ochre). The earth pigments are refined from ore that is extracted from mines, and they make wonderful fleshtones. Some of them will even render natural-looking skin colors right out of the tube, without having to be mixed with other colors. They usually have names that include words such as earth, umber, sienna (except Quinacridone Sienna) and ochre. There is a wonderful world of fleshtone colors just waiting for you when you are ready to expand your palette.

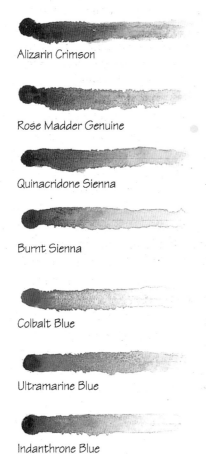

Alizarin Crimson

Rose Madder Genuine

Quinacridone Sienna

Burnt Sienna

Colbalt Blue

Ultramarine Blue

Indanthrone Blue

New Gamboge

Quinacridone Gold

Yellow Ochre

Raw Umber

Burnt Umber

Warm and Cool in Fleshtones

Here are the twelve colors arranged into groups of the three primary colors and browns. You will find it helpful to make this chart for yourself. From what you have learned about warm and cool colors, observe the differences in temperature within this palette. The slightly bluish Alizarin Crimson, for instance, is cooler than the Rose Madder Genuine. The orangish Quinacridone Sienna, on the other hand, looks warmer. This warm vs. cool distinction is fundamental when painting fleshtones.

Same Name, Different Colors

Colors with the same or similar names are not necessarily inter-changeable. The comparison at left is an example of this. On the left is Daniel Smith's Raw Umber, used in this chapter. Next to it are Holbein's and Winsor & Newton's Raw Umbers. You can see that they are not the same. If they did not have the same name—Raw Umber—you might not even know that they were all the same pigment. This is not a matter of right vs. wrong or of which brand is the best. All three are excellent colors; you just need to treat them as separate and distinct colors. Never assume anything about the color of your paints; you don't want any displeasing surprises. This is particularly true when dealing with fleshtones, where the balance of hues is so essential.

A Fleshtone Value Scale

Explore the possibilities of the fleshlike orange combination mixed from Rose Madder Genuine and New Gamboge. By building a nine-step value scale you can discover how the mixture will look at its different values—from the very lightest to the very darkest.

The Initial Wash

On 300-lb. (640gsm) Arches coldpressed paper, a pencil was used to block out the scale band in the form of a long rectangle. The rectangle was then divided vertically into three sections. An initial wash was applied uniformly across the fleshtone band. A generous puddle of the base fleshtone was mixed on the palette (first tested on a sacrifice sheet to make sure the mixture was correct).A second puddle was made by taking a few drops of the mixture and diluting it with water.

More Layers are Added

After the first wash dried thoroughly, the scale was developed further. Another wash was layered over the first one, stopping about one-half inch (12mm) to one inch (25mm) short of the left edge. This stage was repeated, stopping just short of the endpoint of the previous wash. Thus values were built up on one end of the band by gently adding subsequent applications of the wash. Each application of paint was completely dry before the next layer was added. Very light washes were used. If a previous application of paint was too light, another wash was layered over it. As the glazes began to accumulate, care was taken not to lift up previous layers by scrubbing them with the brush. Occasionally more of the initial paint mixture was added to the wash puddle to make it darker.

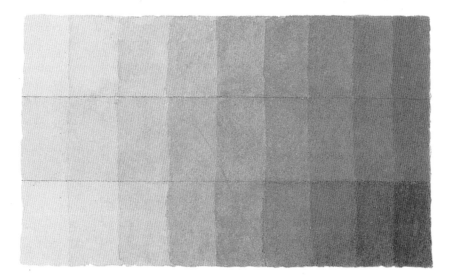

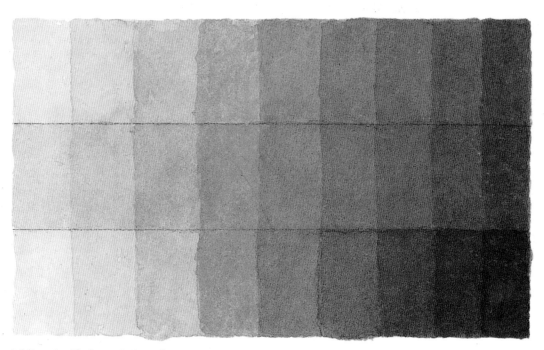

Adding the Fleshtone's Complement

The fleshtone's possibilities were explored a bit further by glazing over it with varying layers of its color complement, Cobalt Blue. The top section of the band was left as is. A light glaze of the blue was used in the next section to evenly cover the entire length of the band. In the third section, the blue was used to darken the lower values of the scale. Notice that the blue not only darkens the fleshtone even more but also neutralizes it and tones it down. This scale can now be used as a permanent reference chart. More charts can easily be made with other red-yellow-blue combinations.

Portrait of Chuck Fuchser (Version 2)
Bruce Krieger
10" × 7" (25cm × 18cm)

Likeness and Lifelikeness

Creating a likeness simply means that your painting looks like the person that you are portraying. There is no special secret to getting a good likeness. It is just a matter of doing a careful underdrawing, because a person's likeness is defined by the shapes that together constitute a face. If you can accurately chart those shapes, you will get a good likeness. Here are a few suggestions to keep in mind if you want to get a credible lifelikeness.

First is the proper proportion and placement of features. Every visual feature of your model must be the right size and in the right place. This is of specific importance, of course, in your subject's face, where it helps to define the likeness. But is also important in the greater anatomy of the subject's body. The arrangement and size relationship of the subject's head and shoulders, for instance, must be correct. An arm must appear to bend in the right place; otherwise, the model's anatomy will look awkward and unnatural.

Remember also that lifelikeness requires natural looking colors, particularly in the fleshtones. Your choice of hues for the skin must look right within the given color scheme of your painting. You are not restricted by any means to only a skin-toned palette; sometimes vivid colors add excitement to a painting (as demonstrated by the painting on the previous page). But use discretion; pasty or bizarrely colored skin will only make your painting most unpleasant to look at.

Just as important as the choice of colors is the proper contrast in tonal values. One of the telltale signs of an amateur portraitist is the flat, volumeless appearance of faces and figures. If you want your portraits to be lifelike, they must have a three-dimensional quality. Representational art is, after all, the art of illusion. You must know how to paint a nose so that it seems to really project out from the person's face. Eyeballs have to look like they are set back into their sockets, and they must be genuinely round—even though you can see only a small part of them. This is, by the way, why it is best not to use photos taken with flash cameras. The flash usually washes out the face with a flood of frontal light and translates into a portrait that looks disturbingly flat.

Liz
Bruce Krieger
12" × 8½" (30cm × 22cm)

Underdrawings

An underdrawing is a pattern of pencil guidelines that you draw directly on to your painting surface before you do the actual painting. This framework serves as a map of the major landmarks to guide you as you apply the watercolors. An underdrawing can easily be created from a value drawing or from a photograph.

Use a graphite pencil for your underdrawings. A good choice is an Ebony Jet Black Extra Smooth, which has a medium-soft lead, but you may prefer a regular no. 2 pencil, which is not so dark. Either way, just be sure to keep your pencil sharp and to draw with a light touch.

Drawings vs. Underdrawings

An underdrawing is different from a regular drawing. Below left, for example, is an impromptu sketch of a dancer that was drawn from life. In the middle is an under-drawing done from that sketch. On the right is the watercolor painting painted over the underdrawing. Unlike the original sketch, the underdrawing has no shading. The areas to be shaded are outlined in the underdrawing but left blank, to be filled in later with paint.

Using Proportional Dividers

To ensure proportion and placement accuracy when working from photos or from life, you may want to make use of a pair of proportional dividers. You can use this tool to enlarge or reduce an image by using the settings on the two crisscrossing dividers. For example, you can set the dividers at a two-to-one ratio to reduce an image by one-half (see explanation below).

You can also tighten up the accuracy of your underdrawings with vertical and horizontal alignments. For instance, assume you have finished a subject's eyes and nose satisfactorily and you must decide how wide to draw the mouth. To place the corner of the mouth, find the part of the eye directly above it by holding a pencil vertically in your line of sight while looking at that part of your model. Place and proportion each ear by finding what part of the face is directly across from the part of the ear you are drawing. Do this by holding your pencil horizontally in your line of sight as you look at that part of your model, then determine with your proportional divider how far out to place the ear.

You can use proportional dividers to take comparative measurements between your photo and your underdrawing to ensure proportion and placement accuracy. For example, to reduce an image by one-half, set the dividers to a two-to-one ratio. Take a measurement from your reference photo with the wider side of the dividers, then turn the dividers to the narrow side to draw a proportionately accurate but reduced line or area on your underdrawing. To enlarge an image, use the smaller end on the reference and the larger end on the underdrawing.

Step-by-Step Demonstration: Use Color and Value to Paint a Face

Now is your opportunity to apply what you have learned in this book. Use the following demonstrations to incorporate your knowledge of techniques, color and value. You will soon be creating your own successful paintings of people. The young model for this project is Michael, who lives in Albany, Oregon.

Since the human head is egg shaped, you can learn a great deal by studying the color on this simple shape. A paper nose and ears have been glued onto the egg to make it appear more human.

Artwork on pages 280 through 285 was created by Jan Kunz.

Brushes
no. 8, 10 or 12 round
1-inch (25mm) flat

Palette
Permanent Alizarin
 Crimson
New Gamboge
Burnt Sienna
Winsor Green (Blue Shade)
Burnt Umber
Winsor Blue (Green Shade)
Cadmium Red
Cobalt Blue

The Head is Egg Shaped
The front of the egg, which is slightly turned from the light, is cooler in color temperature than the sunlit side. The nose projects into the sunlit area. The shadow side of the egg is 40 percent darker than the sunlit side, and you can see reflected light along the outer edge. Notice the same distribution of color and value on Michael's face.

Shadow side—40 percent darker than sunlit side

Sunlit side

Turned from light

Reflected light

Reference photo

Step 1: Sketch the Figure

The lines inside the facial outline locate areas turned from the light. These shapes help model the face. You may not want to include them in your drawing, but it's important to notice they outline differences in color temperature and value.

Step 2: First Washes

Begin with Permanent Alizarin Crimson and add New Gamboge a little at a time until you arrive at a warm skin color. Keep the value light. Paint the entire face, over the eyes and down the neck. Check for value when the passage has dried.

Prepare three new mixtures in your palette:

1. Permanent Alizarin Crimson and Burnt Sienna
2. Permanent Alizarin Crimson and a small amount of Cobalt Blue
3. New Gamboge slightly cooled with Winsor Green (Blue Shade)

Mixtures one and two should be toward red and 40 percent darker than the skin color you've painted.

Read these instructions through before you continue. In this step you'll paint the entire shadow side of Michael's face, so you must know exactly where to put the color before you begin. Use a good quantity of water in you brush so you won't have to rush.

Paint the shadow side of the forehead with the cool red mixture, and add yellow-green near the temple to suggest reflected light. Immediately dip into the warm red mixture, and paint the shadow side of the cheek. Add the reflected light (New Gamboge) along the outside edge. Remember that reflected light is light, but the place where the sunlit area and shadow meet is where the 40-percent value difference occurs.

Finish by softening the edges on all rounded surfaces—but the important thing is to control the value. Good edges will come with practice.

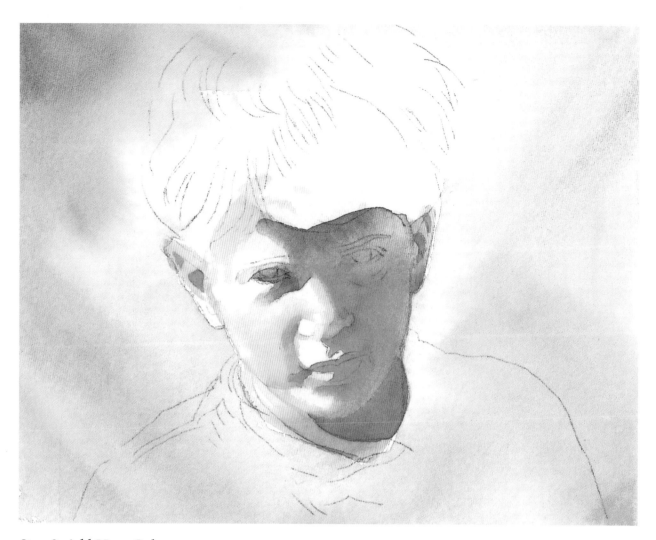

Step 3: Add More Color

To make the sunlit cheek appear rounded, paint a stroke of Cadmium Red along the outer edge followed immediately with a stroke of clear water. Let this dry, then repeat the process in the center of the cheek by first dampening the area. Then, starting in the outer corner of the mouth, bring the color in an inverted arc over the outside edge of the cheek. Refer to the photograph and drawing often so you can see exactly where to place your brush.

Wet the background with clear water and float passages of Winsor Blue (Green Shade) and Permanent Alizarin Crimson over the shirt and into the hair while avoiding the face.

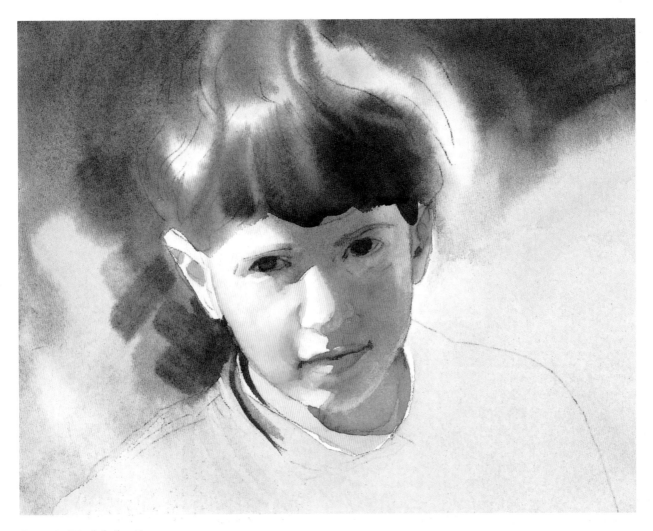

Step 4: Model the Features

Use the colors already on your palette to model the features on the shadow side. Look for shapes. Paint only what you see. There's a dark crevice (Permanent Alizarin Crimson and Burnt Umber) between the lips. You can use this same dark color to paint the eyes. Go slowly; remember, you are just painting shapes.

Use clear water to re-wet the background and across the top of the head. With little water on your brush, paint the hair and out into the background with various strokes of Burnt Sienna, Permanent Alizarin Crimson and Winsor Blue (Green Shade).

Carefully paint around the cheek. Also, be sure you have the same 40-percent value difference between the sunlit and shadow sides of the hair as in the rest of the portrait.

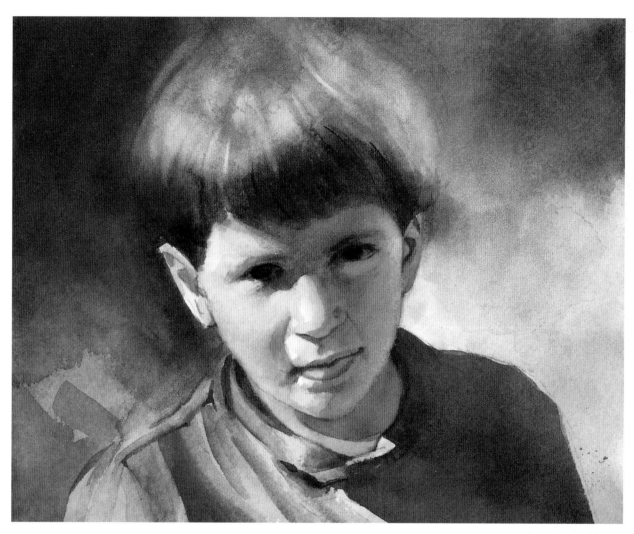

Step 5: Finish the Portrait
Finish the portrait by adding color to the shirt and making whatever corrections are needed.

Tip
Painting the hair and background at the same time has more to do with technique than with color. Hair should never appear rigid. By letting the hair disappear into the background, you will avoid a pasted-on appearance.

Step-by-Step Demonstration: Dark Fleshtones

Your next model is Whitney Bennett. This photograph was taken from a family video. This is an excellent way to get reference photos for your watercolor portraits. In this shot, the very pronounced catchlights in Whitney's eyes accent the enchanting gleam of her personality.

For this demonstration you will use a surfactant. A surfactant is also known as a *flow release* or *flow improver*—which allows water-based paint to spread more easily across the surface. Use it to model facial features in your portraiture without an unpleasant buildup of hard edges. Hard edges can form when an application of watercolor solution dries. This is not always a problem—the lines often create a desirable effect. A single hard edge can be softened with a brush and some clear water, but when modeling facial features, hard edges can accumulate and become unpleasantly cluttered. The surfactant will prevent the hard edges, making it easier to model the face.

The artwork on pages 286 to 297 was created by Butch Krieger.

Brushes
large round
medium round
no. 4 round

Palette
Burnt Sienna
New Gamboge
Cobalt Blue
Raw Umber

Miscellaneous
surfactant

Reference photo

The top of Whitney's hair was filled out by using some of the other reference photos of her. Observe how only the major tonal shapes in her hair have been delineated. It would be futile and frustrating to try to render every strand of her hair. The "floating head" effect was avoided by including a suggestion of Whitney's shoulders.

286

The palette for painting Whitney consists of four colors. Regard Raw Umber as a combination of the three primary hues. Painting a model with a very dark base fleshtone is different from painting a model with light fleshtones. To avoid a thick over-accumulation of paint from too many layers, you must model the tonal values with a pigment that is dark to begin with. Thus, with Whitney, you will use Raw Umber as the base flesh color and modify it with a cool greenish blue and a warm reddish brown. You will have one pigment mixture: Cobalt Blue with a touch of New Gamboge.

Don't neglect to practice and experiment with these colors and make color-reference charts before you begin the portrait. Caution: You will be working with earth pigments, which can lift easily.

Surfactants

You will be using a surfactant in this demo. Surfactants are a flow release or flow improver. They help to prevent the hard edges that accumulate when applying many layers of paint. They were originally intended for use with acrylic paints, but also work well with watercolor. Winsor & Newton, Golden and Daniel Smith all manufacture surfactants.

Step 1: Model Base Fleshtone
With a large round, tone the face and hair with washes of Raw Umber without surfactant. Cover the entire form except for the teeth and the whites of the eyes.

Step 2: Model Forms
Add a few drops of surfactant and use your no. 4 round to model the tonal shapes. As you accumulate layers of paint, take care to remember that Raw Umber is an earth pigment and can therefore lift unexpectedly. If accidental lifting should occur, just correct it and keep going.

Step 3: Introduce the Cool Modifying Tone

Make a cool greenish blue by mixing a dab of New Gamboge into Cobalt Blue; add surfactant. Use the mixture sparingly because you want only to alter Whitney's brown fleshtone, not turn her blue. With a medium round, glaze faint washes to model the frontal planes, the hair, the face and the area just below the neck. Use a slightly denser wash to countertone the Raw Umber of the hair, thereby hinting to the observer that the hair is black rather than brown. It isn't necessary to paint the hair with an actual black pigment; use blue to paint the shadow that is falling on the otherwise unseen right collar and to indicate the presence of the left collar.

Step 4: Introduce Warm Modifying Tone

Make a solution of Burnt Sienna with surfactant. As with the greenish blue in the previous step, use it sparingly. Still using a medium round brush, glaze the Burnt Sienna over the areas of Whitney's form that are to the right side, including the side of the nose. Then use some of it to countertone the blue in the collar. Use it to paint the vermilion parts of the lips. At this point you can do any necessary lightening by lifting or by using a white charcoal pencil. With this, your portrait of Whitney is finished.

Whitney
Butch Krieger
10" × 6" (25cm × 15cm)

Step-by-Step Demonstration: Modeling the Head

The model for this demonstration is Charles "Chuck" Fuchser. He has a most impressive appearance. With Chuck you will learn how to paint facial hair and how to work with a slightly fuzzy photo.

This photo was taken with a new automatic camera. Because the light in the room was so low, the camera automatically chose a slower shutter speed (the automatic flash was off). Because the camera could not be held still enough for the slow shutter, the image is fuzzy with slightly blurred edges. It isn't so fuzzy, though, that you can't paint a portrait from it.

Reference photo

In the underdrawing, Chuck's portrait has been limited to his head and coat collar. The contours in the photo were fortunately not so blurry that they could not be drawn. This solution to a hazy-border problem, by the way, would not work if the edges were much more blurry than this.

For Chuck's portrait, you will work with a three color palette. You will use the fleshtone color blend to paint the facial hair. No surfactant is needed; you will be modeling this portrait with bolder, more decisive strokes.

The photo of Chuck on the previous page gives you a general idea of his fleshtone range, but the colors in the photograph are not accurate enough for you to try to match them. You will learn how to work around this obstacle. You will also discover the broad artistic license that you have when painting flesh and hair tones.

Another Version

This second version of Chuck Fuchser was rendered using the same palette you will use for the following demonstration. This painting was done after completing the demonstration to see if it would be better to have you paint his facial hair as dark as it is in real life. The second painting is a better work, but the first one is better for this demonstration.

Don't hesitate to do a painting over again from scratch, if that is what it takes to get it right.

Brushes
no. 6 or 8 round
¼-inch (6mm) flat
½-inch (12mm) flat

Palette
Rose Madder Genuine
New Gamboge
Cobalt Blue

Miscellaneous
paper towels

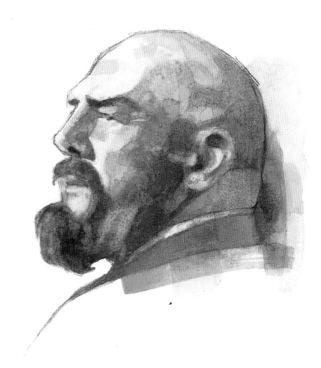

Thought

Most professional artists are not hesitant to repeat a painting from scratch if that is what it takes to get it right. This is part of being a conscientious artist.

Step 1: Tone and Model Form

Begin your painting of Chuck with a light wash of the base fleshtone, a mixture of Rose Madder Genuine and New Gamboge. With a medium round, fill in the entire head, including the facial hair. Let some of the facial hair go a little beyond the back of the head and neck.

Step 2: Model Form

Add surfactant and with a round brush, use the fleshtone wash to establish the major tonal shapes of the head and beard. As you do, occasionally carry more of the fleshtone mix out behind the head. Paint the beard the same way you paint every other part of the head. Regard it as a single shape that is defined by the contrasts of tonal values. It may not seem like this should work, but it will.

Step 3: Split Fleshtone

Now you can split the fleshtone by bringing in its component colors—Rose Madder Genuine and New Gamboge— separately. Use the Rose Madder Genuine to further darken the lower tonal values. Layer the New Gamboge into the broadside planes of the head. This will serve as a yellow reflected light that will make the skin surface more interesting and lively. Try using your flat (whichever size works best for you) to paint some of the tonal shapes. Try to do as many of them as you can with single strokes. (You can clearly see such strokes—the one on the edge of Chuck's forehead, for example— in the second version.) If you fear that you might accidentally make a bad stroke, practice a bit on some scrap paper. Also, you can keep a crumpled paper towel handy to dab out unwanted strokes immediately before they dry (allow the surface of the board to dry before you try again). Sometimes let the red and yellow overlap the back of the head.

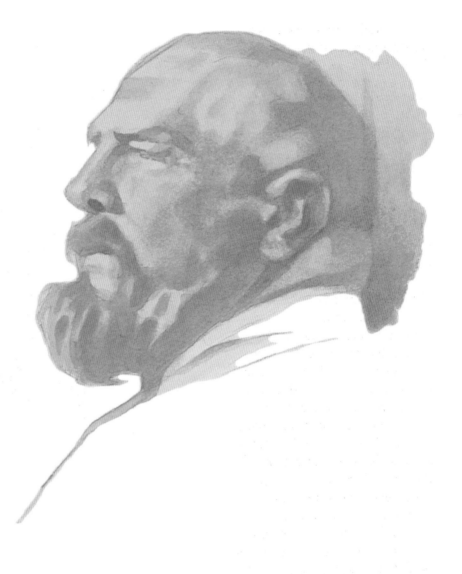

Step 4: Add Finishing Colors

For the finishing touches, bring in Cobalt Blue. Continuing to use single brushstrokes as much as you can, layer the blue into the very deepest of the tonal shapes. Glaze some of it over the surface planes to the right of each of the ones that you have already painted yellow. This will appear to be more reflected light coming from a different direction. (Look at the second version to see what this means.) Layer some over the receding planes at the back of the head, again letting some of it spill over. Leave the back part of the neck at the base of the skull lighter than the back of the head to suggest reflected light from an unknown source behind Chuck.

Use the blue for the eye and coat collar. Blend some of it with the Rose Madder Genuine for the shadow that falls on the front of the white shirt collar. Finally, for consistency, lay some of the New Gamboge into the parts of the shirt and coat collar that coordinate with the yellow planes of the head. Likewise, paint some extra blue in the collar that coordinates with the blue planes of the head. You can see this in the illustration, as some of the New Gamboge has been painted with a single downward stroke of a flat brush.

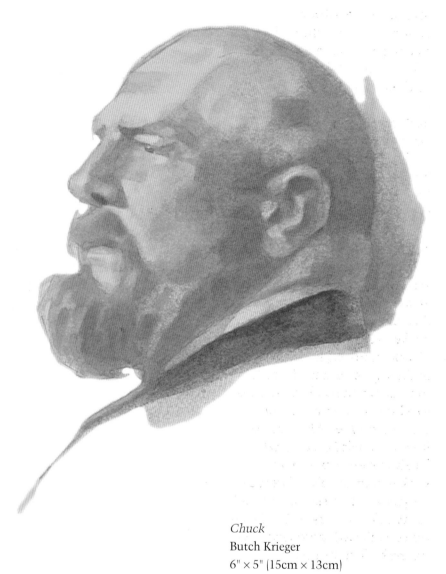

Chuck
Butch Krieger
6" × 5" (15cm × 13cm)

Pause and Review

Before proceeding to the next portrait, pause to review what you have done up to this point and see what you have accomplished. Lay the previous portraits out on a flat surface or—better yet—lean them up against something. Assess your progress. Then compare the painting of Chuck to the reference photo. You have not just imitated the reference photo; you have gone well beyond the limits of photography and even real life. You used your artistic license and skill to improvise the fleshtones. Look at the variety of fleshtones that you have achieved in this portrait with just three pigments. Notice how you have augmented the sense of mass and volume using the contrasts of color and tonal values. Your painting is much more vivid, vibrant and vivacious than a photograph—or even real life—could ever be. This is what makes you an artist.

Step-by-Step Demonstration: Two Figures and Complex Poses

For this demonstration you will work from a drawing (actually two drawings) instead of a photograph. You will see how to convert a pre-existing sketch on regular drawing paper into a watercolorable form. You will also deal with more complex postures, seated figures and foreshortened limbs.

This demonstration will also introduce you to a more spontaneous approach to painting people and portraits. In this sense, the demo painting will show you how to take your first few steps on the wild side—to experience the exhilaration of impromptu watercolor sketching—but it will explain how to do so in a way that minimizes your fear of failure. You will learn how to get started in candid sketching without entirely leaving the secure comfort zone of a preplanned and cautious watercolor procedure.

Your subjects this time are two swimmers drawn on two different pages of a sketchbook. The man's head was facing directly forward, but he was probably dozing while hidden behind his sunglasses. The direct frontal view of his face worked compositionally when merging the two sketches into a single painting.

You will use a simple palette once again—this time just the three primary colors, hot red, yellow and blue. They will be just right for portraying a scene drawn on a bright summer day.

Brushes
no. 10 or 12 round
no. 6 or 8 round
no. 4 round
1/4-inch (6mm) flat
1/2-inch (12mm) flat

Palette
Indanthrone Blue
Quinacridone Sienna
Quinacridone Gold

Miscellaneous
paper towels

These are sketches of two swimmers one sunny summer afternoon. The sketches are shown here at their actual sizes. To convert them to watercolorable form, treat them just as you would a photograph.

In this painting, you will be introduced to a more freewheeling approach to watercolor sketching. It will be a safe introduction, one which will not require you to entirely depart from the security of your structural underdrawing. You can draw on the wild side just enough to get the feel of it and see if you like it.

Step 1: Combine the Sketches

On watercolor board, combine the two sketches into a single composition, filling in details, such as the legs of the man's chair. Don't worry about ambiguities in some of the details, particularly in the man's big towel. This was, after all, an impromptu sketch.

Step 2: Establish Tonal Shapes

Throughout this demonstration, use the largest brush (round or flat) that allows you to stay loose and relaxed. Using Indanthrone Blue to develop the tonal values of the picture as you have done with the previous paintings. This time, though, be a little more relaxed in the way you apply the layers of paint. You still have the security of the underdrawing (see page 295) to eliminate guesswork, but don't feel so tightly bound by it. Loosen up a bit. You really have nothing to lose but your inhibitions. Examine the above version of the underpainting. Look at all the places where the brushstrokes overshot the mark. Take particular note of the dark freehand stroke just under the woman's right arm. This was an accident—a surprise. When it was brushed on, the brush hairs still had some undiluted paint hidden in them. (The artist liked the way it looked, so he left it there.) If you are still afraid of making terrible mistakes, do this underpainting with a crumpled paper towel in your free hand. If you don't like a particular brushstroke, you can quickly dab it out before it begins to dry. Remember that this is just a sketch—not a tight, meticulous rendering. The flesh areas were also glazed over with an orange mixture of Quinacridone Sienna and Quinacridone Gold. Shadows were added to the woman's arms and legs to make them more consistent with the shadows on the man.

Step 3: Introduce Warm Tones

Continue to develop the tonal values throughout the scene with the orange mixture. Be sure to use plenty of it in the shadows of the man's towel. Use it as the base fleshtone. Don't be too restrained with your brushstrokes.

Swimmers
Butch Krieger
6" × 10"
(15cm × 25cm)

Step 4: Split Warm Tones

To finish the sketch, use the pure red and yellow. Add the red to the woman's towel and to the man's swimming trunks. Notice that the red glaze over the blue underpainting makes his swimming trunks look violet. Now glaze the yellow in his towel and her swimsuit. Notice that the yellow over the blue underpainting makes it look green. The shadows in the man's towel do not look green, however, because of the glazes of orange between the blue underpainting and the yellow overpainting. You can add a few brush-strokes of the different colors to the space between the chairs to better integrate the two figures into a single composition. Isn't it surprising the variety of hues you can create with just three pigments?

Keep on Painting

When you have finished this book, the best advice for you to follow is to keep going. There is a wide, wide world out there for you to paint. Experience is the best teacher. Practice will be required for you to get as good as you want to be. Do lots of paintings of your own. If you want to work from photographs, try to find some (or shoot some yourself) that you could paint in the same way that you did one of the paintings in this book.

If you are not already proficient in your drawing skills, check out some of the many excellent drawing books that allow you to practice on your own time, or take a beginning drawing class and/or workshop. Be sure the instructor teaches old-fashioned drawing techniques in which you learn to accurately draw. The "responsive" and "interpretative" approaches won't help you much here. You would probably get your best instruction from a professional artist. Many professors and instructors in the academic system have degrees in art but no professional skills, and they can't teach what they don't know. If you study with professional artists rather than merely degreed teachers, you will also have the advantage of learning about the business side of art.

There are excellent books and videos on the market by some of the best professionals—North Light publishes many of them. Broad exposure to different artists, writers and instructors can take you in new directions and help you to explore and develop a style of your own.

Inspiration may come from unsuspected places. Stay attuned to the world around you, read art magazines, surf the web (there are many informative artist's web sites), and just keep yourself motivated. But most of all—paint!

Symphony
Jan Kunz
35" × 16" (89cm × 41cm)

INDEX

The best in Watercolor instruction comes from North Light Books!

Susan Harrison-Tustain casts new light on painting watercolor flowers. You'll learn her unique method for creating vibrant colors, realistic textures and lively light. Through three complete step-by-step painting demonstrations and 14 mini-demos you'll discover how easy it is to paint your favorite garden flowers that glow with life.
ISBN 1-58180-389-3, paperback 128 pages, #32444-K

Create startling works of art that glow with color and light! Jan Fabian Wallake shows you how to master special pouring techniques that allow pigments to run free across the paper. There's no need to worry about losing control or making mistakes. Wallake empowers you to trust your instincts and create glazes rich in depth and luminosity.
ISBN 1-58180-487-3, paperback, 128 pages, #32825-K

Create alluring works of art through negative painting - working with the areas around the focal point of the composition. Through easy to follow step-by-step techniques, exercises and projects, you'll learn to harness the power of negative space. Linda Kemp's straight forward diagrams for color and design as well as troubleshooting suggestions and secrets will make your next watercolor your most striking work yet!
ISBN 1-58180-376-1, hard cover, 128 pages, #32390-K

Create your own artist's journal and capture those fleeting moments of inspiration and beauty! Erin O'Toole's friendly, fun-to-read advice makes getting started easy. You'll learn how to observe and record what you see, compose images that come alive with color and movement, and make a travel kit for creating art anywhere, at any time.
ISBN 1-58180-170-X, hardcover, 128 pages, #31921-K

These books and other fine art titles are available from your local art & craft retailer, bookstore, online supplier or by calling 1-800-448-0915 (US) or 01626 334555 (UK).